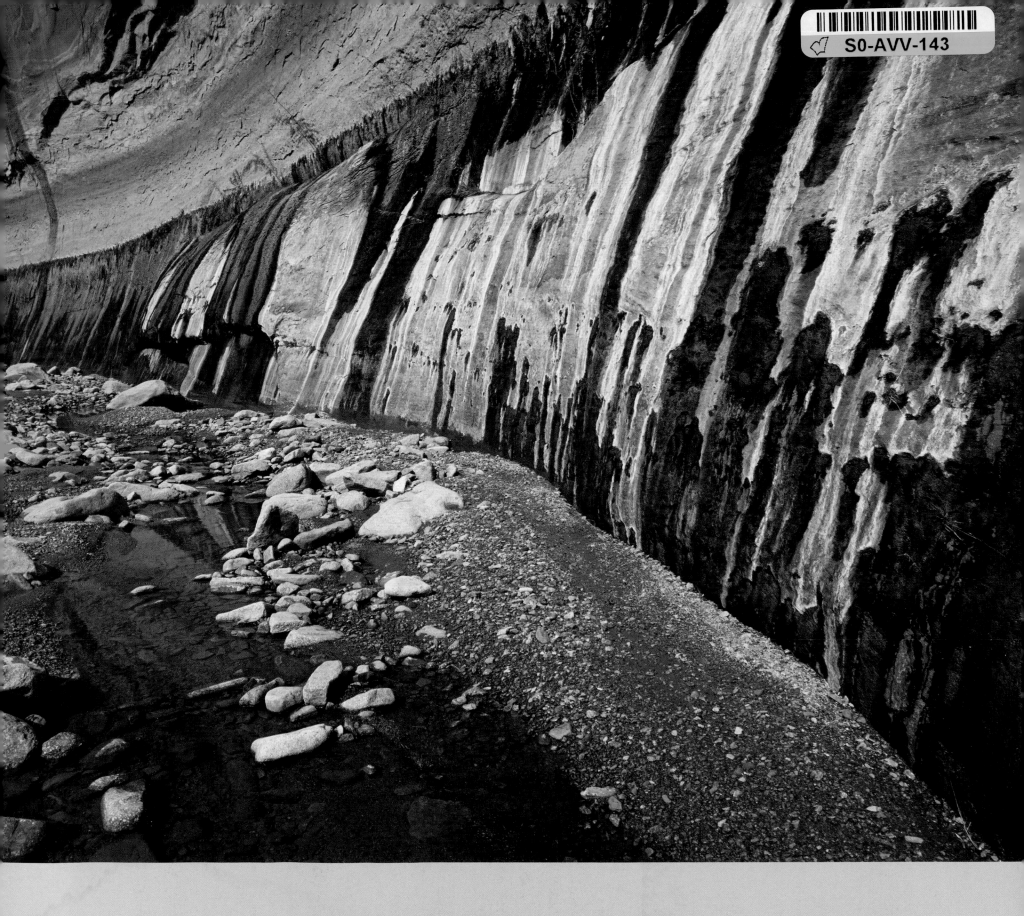

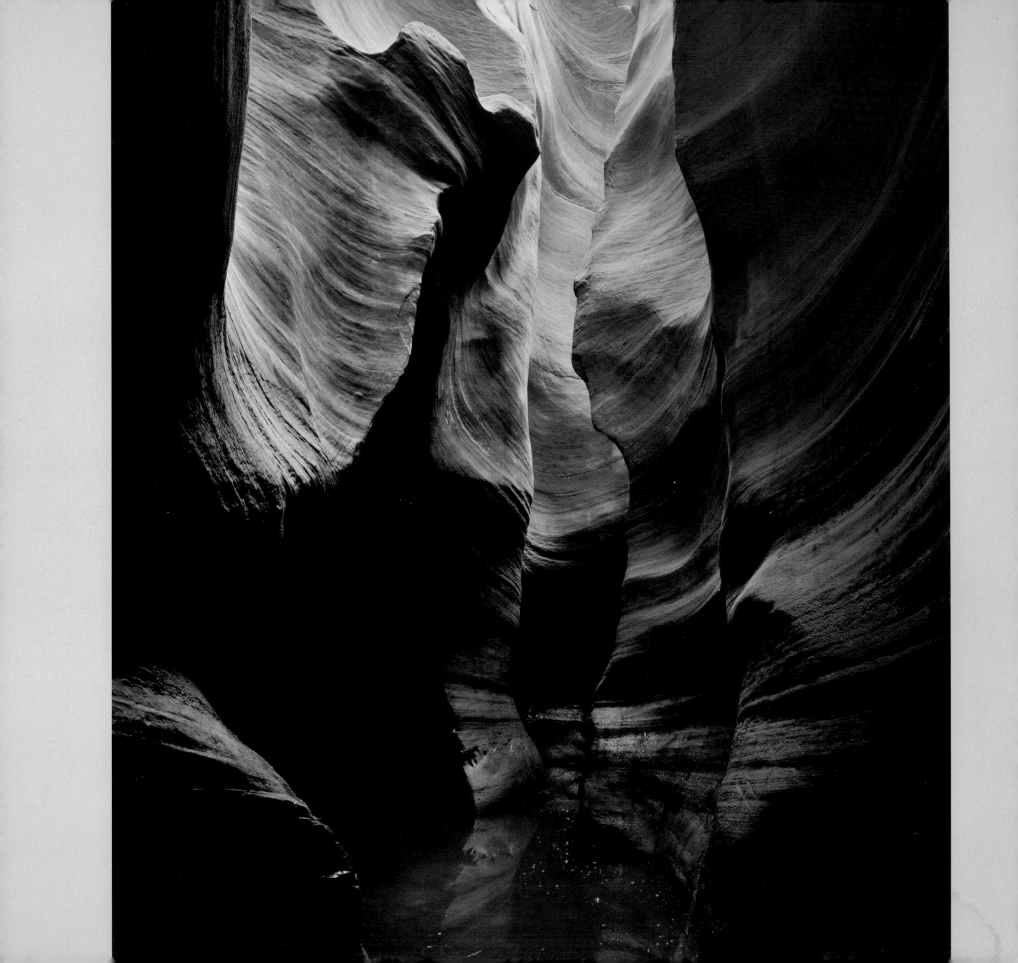

Resurrection

Glen Canyon
and a New Vision for the
American West

BY Annette McGivney
WITH PHOTOGRAPHS BY James Kay
FOREWORD BY Bill McKibben

BRAIDED RIVER

WITH SUPPORT FROM THE GLEN CANYON INSTITUTE

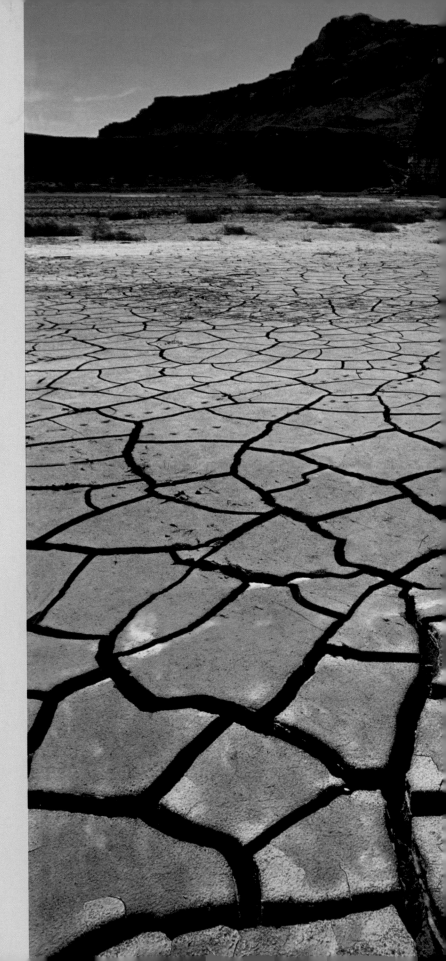

This book is dedicated
to my son Austin, my inspiration.
You hiked in restored
Glen Canyon when you were eight;
may you hike there
when you are eighty.

—A. M.

I would like to dedicate
this book to my wife Susie
who has served as my bedrock
for more than 32 years.
Her companionship has added
immeasurable value
to my life.

—J. K.

The dried-up bed of Lake Powell bakes in the sun beyond the end of the Hite Marina boat ramp. When the reservoir is full, this location is 95 feet below the reservoir's surface. April 2003.

Contents

Glen Canyon once encompassed 186 miles of the Colorado River's
main channel and nearly two hundred side canyons.

The vast drainage straddling the Arizona–Utah border was the
ecological heart of the Southwest's river systems, where the Green, San Juan,
Dirty Devil, and Escalante all converged.

Glen Canyon harbored more prehistoric Native American
archaeological sites than almost anywhere else in the Southwest (nearly
three thousand were found during a hurried 1950s pre-dam survey).

The Colorado River and its major tributaries are the lifeblood
of the American West, serving as a primary water source for seven states
and thirty million people.

From headwaters in the snowcapped Rocky Mountains of Wyoming
and Colorado, the Colorado River drops 11,000 vertical feet and drains
108,000 square miles before landing in the Sea of Cortez.

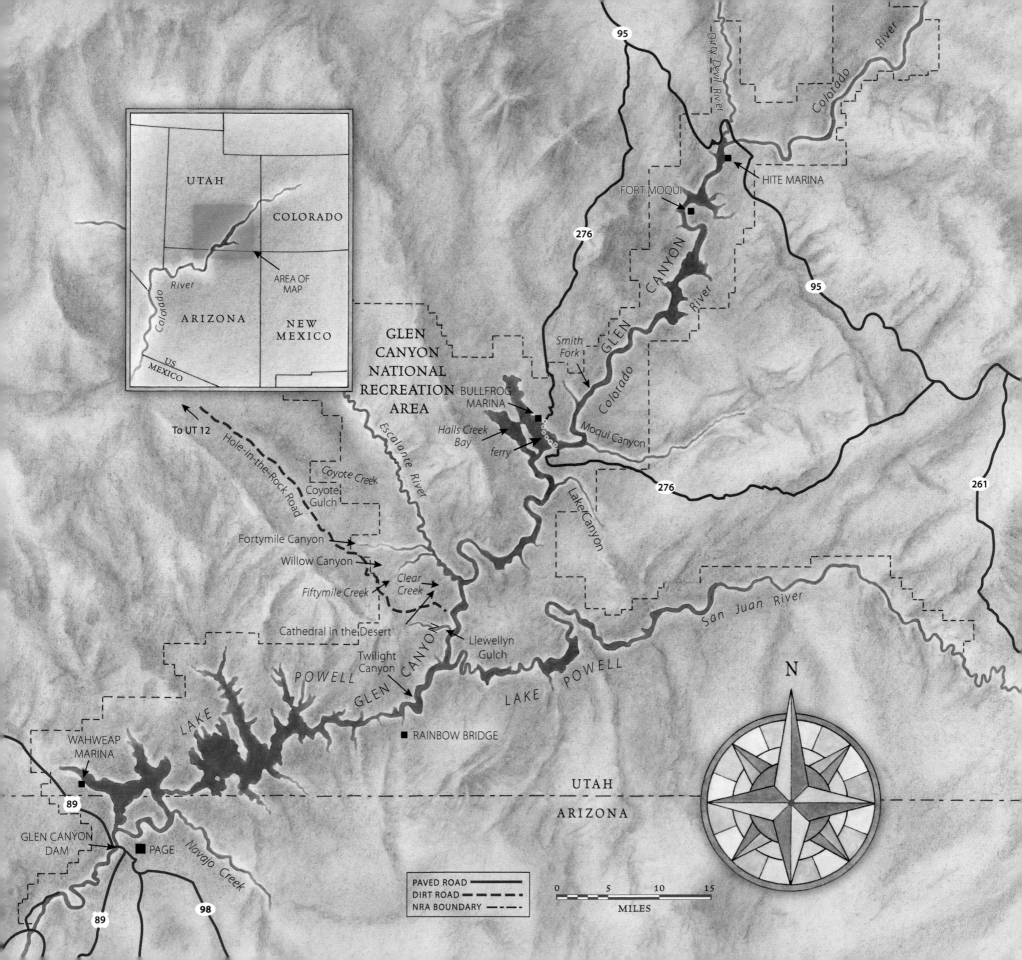

UTAH

COLORADO

AREA OF
MAP

River

Colorado

ARIZONA

NEW
MEXICO

US
MEXICO

95

Dirty Devil River

Colorado River

HITE MARINA

FORT MOQUI

276

95

GLEN CANYON NATIONAL RECREATION AREA

Smith Fork

GLEN CANYON

Colorado River

Moqui Canyon

BULLFROG MARINA

Halls Creek Bay

ferry

Lake Canyon

276

261

Escalante River

To UT 12

Hole-in-the-Rock Road

Coyote Creek

Coyote Gulch

Fortymile Canyon

Willow Canyon

Fiftymile Creek

Clear Creek

Cathedral in the Desert

San Juan River

Twilight Canyon

GLEN CANYON

Llewellyn Gulch

LAKE POWELL

POWELL

LAKE

GLEN CANYON

RAINBOW BRIDGE

N

LAKE

WAHWEAP MARINA

UTAH

ARIZONA

89

GLEN CANYON DAM

PAGE

Navajo Creek

89

98

PAVED ROAD
DIRT ROAD
NRA BOUNDARY

0 5 10 15
MILES

Preface Helen Cherullo

BEGINNING IN THE 1950s, during the height of the dam-building era in the growing American West, wilderness groups—including the Sierra Club and The Wilderness Society—began to address these monolithic threats to the Colorado River, its tributaries, and the canyons it had carved out over millennia. In 1956, conservationists successfully opposed the construction of a dam in Dinosaur National Monument, but in return for the preservation of that iconic area agreed to not challenge the proposal for a dam in Glen Canyon— a 170-miles-long ecological wonder stretching across southern Utah and northern Arizona.

David Brower, then executive director of the Sierra Club, floated through the canyon after construction on the dam had already commenced—and immediately regretted his part in the deal to allow the canyon's loss. After seeing photographs of Glen Canyon by Eliot Porter, Brower decided to produce a book as homage to an ecological treasure about to disappear. By the time *The Place No One Knew* was published in 1963, the waters of a manmade lake had consumed the sinuous, red rock curves of Glen Canyon, swallowing ancient petroglyphs, cottonwoods, willows, plunge pools, and side canyons. In the decades that followed, the loss of Glen Canyon became a symbol to environmentalists of the struggle between reverence for the natural world and technological arrogance.

Today, after a series of drought years, Lake Powell has diminished in capacity and Glen Canyon has reemerged. We now have the unprecedented opportunity to prevent a second loss of Glen Canyon.

Resurrection is our collective tribute to *The Place No One Knew*. Sensitive photographs by James Kay evoke the burnished red beauty of the canyon, and before-and-after shots illustrate Lake Powell's massive drop in water level. Annette McGivney's expertise shines through as she explores the damming controversy, the history of water politics in the American southwest, and the astonishing reappearance of the canyon. Like Brower and Porter's 1963 photographic paean to Glen Canyon, this book aims to instill in the reader an abiding love of the canyon, a desire to secure its protection, and a regard for the importance of its recovery to a healthy environment— now and for future generations.

In producing this beautiful book, Braided River has partnered with the Glen Canyon Institute (GCI), a nonprofit organization founded in 1996 to "restore a healthy Colorado River through Glen Canyon." In Spring 2007, GCI proposed the re-designation of the Glen Canyon National Recreation Area as a national park—to honor the area as a national treasure and preserve it for future generations.

Braided River engages new audiences—beyond the traditional environmental community—to protect western North America's last wild places and create a sustainable future. This new branch from The Mountaineers Books combines the arts of photography, literature, and journalism to create books, multimedia presentations, and museum exhibits that build broader public support for wilderness preservation campaigns—and inspire public action.

Driven by the work of talented and committed nature photographers, each of our projects starts with a book addressing a critical threat to wilderness. Braided River collaborates with partner organizations to develop a range of media tools that reach beyond the printed page and connect with audiences outside the traditional environmental core. These tools include photographer presentations, publicity and outreach, and traveling museum exhibits created in partnership with the Burke Museum of Natural History and Culture in Seattle, Washington. By connecting with a broad audience, we build awareness and inspire action that results in on-the-ground victories for the environmental community.

In concert with the Braided River mission to encourage greater environmental awareness, *Resurrection* stresses the need for a new model of living in the Ameican West. The Colorado River is over-allocated, increasingly unable to meet the escalating human demand for its water sources. Even if the river floods in successive years and refills the lake, the latter will still drain with alarming rapidity. Lake Powell is simply an inefficient reservoir: situated in the high desert in a porous sandstone canyon, it loses a significant amount of water to evaporation and the canyon walls. The Department of the Interior's water policy needs to evolve to meet new needs—and Americans must live more sustainably, especially in the arid West.

This book is a wake-up call: will we—both citizens and the government—adopt a long view and begin to live within natural limits, or will we continue to forge blindly down our currently wasteful path? If we choose to save Glen Canyon, we commit ourselves to the former—and begin to positively re-vision our relationship with the environment.

It is not often that we, as a society, are presented with the opportunity to undo a historical mistake: let us seize the chance and take it one step further—to Glen Canyon National Park. For the most current information on what you can do to make a difference, please visit www.BraidedRiver.org.

Helen Cherullo is the Executive Director of Braided River.

Foreword Bill McKibben

THERE ARE DAYS WHEN IT SEEMS to me I'm in the obituary business. After a quarter century of writing and fighting about global warming, it sometimes gets to be too much. The loss of the Arctic's sea ice, of the permafrost tundra, of the coastlines ravaged by rising seas, of the species pushed over the brink, of the people left in the path of malarial mosquitoes. Too much.

This is why this book has given me more pleasure than anything I've read in ages. It's the opposite of a eulogy; it's a birth notice, or a rebirth notice, for one of the central landscapes in the American imagination. Annette McGivney's sage, balanced, and beautiful prose and James Kay's informative and inspiring photographs provide a strong hit of that caffeine we most need right now: hope, real honest-to-God hope that someplace in the world is getting greener, not browner—better, not worse.

Glen Canyon, of course, has been a favorite of writers and photographers for two generations. I've just finished compiling an anthology of American nature writing since Thoreau. I could have filled all 900 pages with paeans for this great chasm, most notably David Brower's landmark book, *The Place No One Knew,* and Ed Abbey's essay, in *Desert Solitaire,* about his float down the Colorado River during the river's last free-flowing days through Glen Canyon. His story serves as a perfect miniature of our historical treatment of this continent's natural wealth. As with the prairie, which we sacrificed to monoculture agribusiness, and the great eastern forest which we leveled, we looked at the river and asked one question: How can we make some money here?

Quick money, of course. The money that came from the construction of the dam, decades of motorboat-rentals (before the reservoir silted up), and the quick expansion of cities—all of which have grown beyond any rational size. We thought short-term, and we imagined that the short-term would go on forever. But it never does. Nature, thinking long-term, trumps human ingenuity—with climate change and soil erosion. Folly is always folly—yet this one is rare in that the mistake of damming Glen Canyon became clear within the lifetimes of the people responsible.

But it's also rare in that, here, we may really get a second chance. If the Glen Canyon Institute and others have their way, we'll bypass this dam, fill Lake Mead, and designate Glen Canyon a national park. Before we know it, the miracle captured in this book's images will mature beyond its current infancy. When that happens, the drained Lake Powell and the resurrected Glen Canyon will be emblematic not of our folly but of the graciousness with which nature is still willing to meet

our adolescent species halfway. It will be a monument to the possibility that we haven't totally screwed up the planet forever, that we might still be able to back off a little and make our peace with the rest of Creation.

I had the good luck to know both Brower and Abbey, and each was considered to be a great radical. In reality, they were men of deep hope. I remember Brower telling me that the twenty–first century would need to be an epoch of "restoration and repair," and I think he'd be happy to add "resurrection" to his list. And Abbey—a so-called extremist because he opposed this most extreme act of aggressive engineering in the desert he loved— would not be surprised to see what is happening now. Indeed, years ago in a book titled *Slickrock*, he nailed it perfectly. "Don't believe people who say Glen Canyon is gone forever," he insisted. "I say, give Nature a little time. In five years, at most in ten, the sun and wind and storms will cleanse and sterilize the repellent mess. The inevitable floods will soon remove all that does not belong within the canyons. Fresh green willows and tamarisk, box elder and redbud will reappear; and the ancient drowned cottonwoods (noble monuments to themselves) will be replaced by young of their kind. With the renewal of plant life will come the insects, the birds, the lizards and snakes, and the mammals. Within a generation—thirty years—I predict the river and canyons will bear a decent resemblance to their former selves. Within the lifetime of our children Glen Canyon and the living river, heart of the canyonlands, will be restored to us. The wilderness will again belong to the people."

Bill McKibben is the author of The End of Nature *and* The Bill McKibben Reader, *and an educator and environmentalist.*

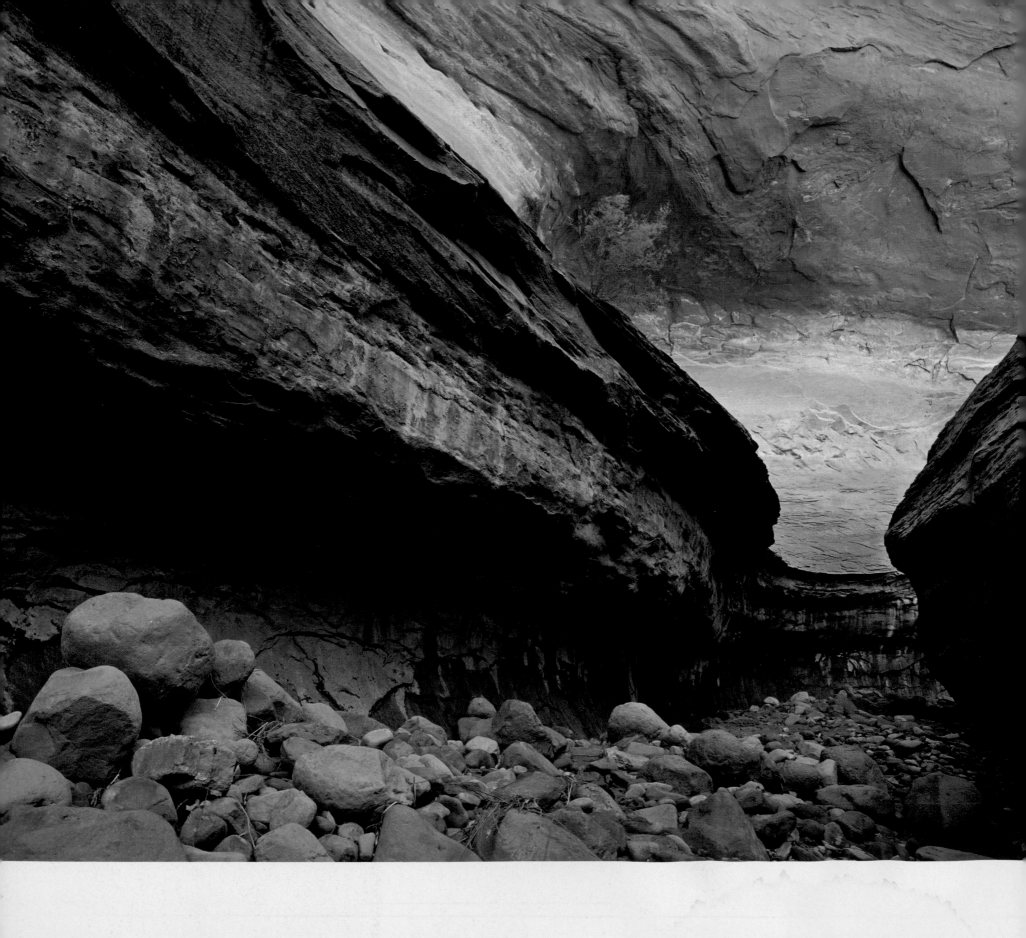

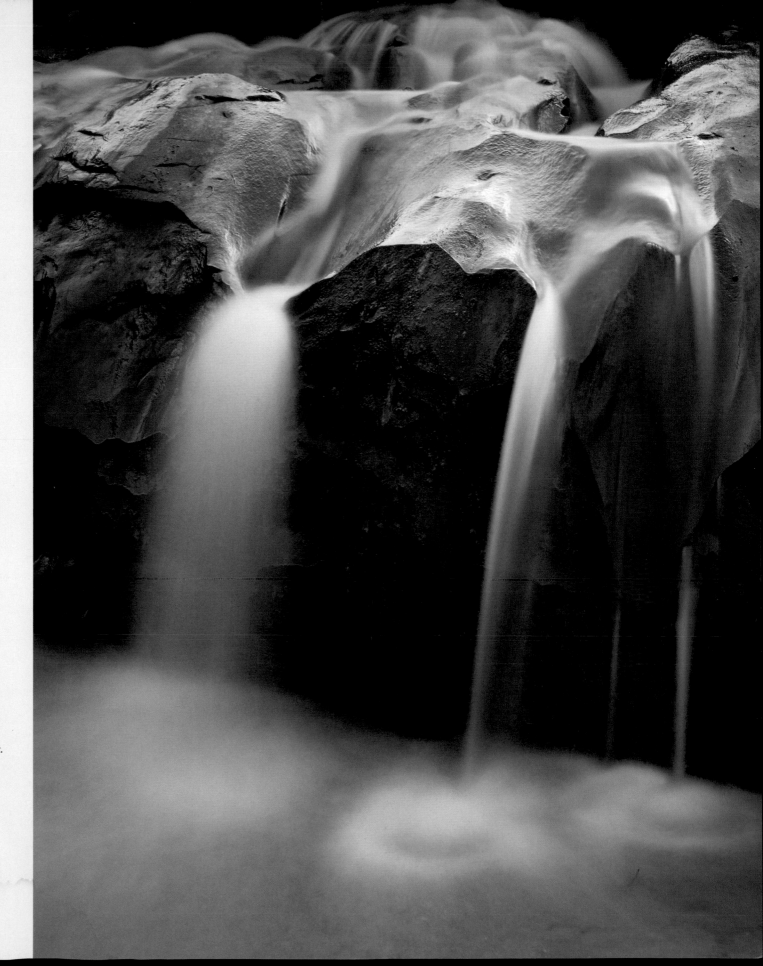

A 10-foot-tall waterfall in Willow Gulch, revealed for the first time in decades. April 2004.

OPPOSITE *The 50-foot-tall Lake Powell "bathtub ring" (center right) stains the wall along Fiftymile Creek. The height of the ring reveals how much water has been lost since the reservoir was last full in 1999.* October 2007.

Glen Canyon Timeline

11 million years ago The Colorado Plateau, a massive upland, begins in Colorado and extends through Glen Canyon as far as Utah. The Colorado and San Juan Rivers and their tributaries carve out the canyons and mesas.

AD 500–1250 Ancestral Puebloan people live in Glen Canyon, farming the region's many fertile drainages. More than three thousand archaeological sites recorded by pre-dam salvage surveys date to this period.

July 1869 John Wesley Powell and his men float wood dories through Glen Canyon on their historic expedition to explore and map the unknown Colorado River drainage. "A curious ensemble of wonderful features—carved walls, royal arches, glens, alcove gulches, mounds and monuments. We decide to call it Glen Canyon," writes Powell in his journal. The trip lasts ninety-nine days, traveling 1,000 miles and negotiating nearly five hundred rapids.

May 1910 Rainbow Bridge National Monument is established. Located in Glen Canyon, Rainbow Bridge is the world's largest natural bridge and one of the most sacred sites of the Navajo Nation.

1922 The Colorado River Compact is signed, evenly dividing Colorado River water rights between the upper-basin states (Wyoming, Colorado, Utah, New Mexico) and lower-basin states (Arizona, Nevada, California). Each basin's annual water allotment is 7.5 million acre feet. Arizona does not ratify the compact until 1944, after challenging it in the U.S. Supreme Court three times. This "Law of the River" remains in effect today.

1937 The National Park Service floats a proposal to create Escalante National Park, which would protect a large portion of Glen Canyon. The proposal is shot down by Utah politicians who argue that a park would harm economic development opportunities.

1938 Norm Nevills runs the first commercial river trip through Glen Canyon, carrying four passengers in a wooden boat. The river-running business grows steadily over the next two decades, with more people floating down Glen Canyon than the Grand Canyon.

1944 A treaty with Mexico is signed, requiring the United States to deliver 1.5 million acre feet of Colorado River water annually to its southern neighbor. Treaty rights and obligations are administered by the International Boundary and Water Commission.

1956 Congress passes the Colorado River Storage Act, authorizing a series of dams on the upper Colorado, including Glen Canyon Dam. The previous year, conservation groups—including the Sierra Club—agreed not to fight Glen Canyon Dam if the U.S. Bureau of Reclamation killed a proposed dam in Dinosaur National Monument.

June 1957 Gaylord Stavely and his wife Joan Nevills, daughter of Norm, are the last party to float the full 200-mile length of Glen Canyon.

1958 First blasting to create Glen Canyon Dam.

January 21, 1963 Floodgates on the 710-foot-high Glen Canyon Dam close and the reservoir, named for Powell, begins to fill. In the same year the Sierra Club publishes *The Place No One Knew*, in which then executive director David Brower laments his failure to save Glen Canyon.

1965	The Glen Canyon Dam and hydroelectric plant are completed, comprising more than 5.3 million cubic yards of concrete. At the dedication ceremony, First Lady Ladybird Johnson says: "As I look around at this incredibly beautiful and creative work, it occurs to me that this is a new kind of writing on the wall. A kind that says proudly and beautifully, 'man was here.'"
February 1967	Congress authorizes construction of the $3.5 billion Central Arizona Project (CAP). The 330-mile-long pipeline carrying Colorado River water will enable Phoenix to grow from a city of 500,000 people to a megalopolis of more than 3 million.
1970	Ken Sleight and Friends of the Earth unsuccessfully sue the U.S. Department of Interior when Lake Powell backs up across the boundary of Rainbow Bridge National Monument.
1972	Congress establishes the 1.2-million-acre Glen Canyon National Recreation Area.
1975	Edward Abbey publishes *The Monkey Wrench Gang*, in which characters plot the destruction of Glen Canyon Dam.
1980	Nearly two decades after the floodgates close, Lake Powell reaches full pool at an elevation of 3,700 feet above sea level and includes nearly 2,000 miles of shoreline.
1981	Founding members of Earth First! unfurl a 300-foot-long banner that looks like a giant crack from the top of Glen Canyon Dam. "Surely no man-made structure in modern American history has been hated so much, by so many, for so long, with such good reason," proclaims Edward Abbey at the symbolic "cracking of the dam," which kicked off a decade of environmental monkey-wrenching.
1992	Glen Canyon National Recreation Area receives a record 3.5 million visitors.
1996	Richard Ingebretsen founds the Glen Canyon Institute, aimed at decommissioning the dam.
1999	Drought affecting the upper and lower Colorado River basins begins in earnest.
2000	The Glen Canyon Action Network is founded with a mission to mobilize people in support of reestablishing a free-flowing Colorado River through Glen and Grand Canyons. The organization's name is changed to Living Rivers in 2001.
2004	Glen Canyon National Recreation Area receives 1.8 million visitors, the fewest in twenty years.
April 2005	After six years of drought, Lake Powell is 67 percent empty, the lowest the reservoir has been since it filled. Cathedral in the Desert and the Anasazi ruins of Fort Moqui emerge intact. Two out of five marinas close.
January 2006	Despite the previous wet winter, the U.S. Bureau of Reclamation projects that Lake Powell will be half empty.
December 2007	The seven upper- and lower-basin states sign an agreement to address the impacts of drought and to determine how water shortages will be shared.
May 2008	Slightly above average winter snowpack in the Rockies raises Lake Powell to approximately 64 percent of capacity, the biggest increase in six years. A dry spring and summer, along with water demands, are expected to draw the reservoir down to nearly half capacity by the end of the year. Governor Arnold Schwarzenegger declares California (the biggest user of Colorado River water) in an official state of drought. Gas at Lake Powell marinas is $5 a gallon.

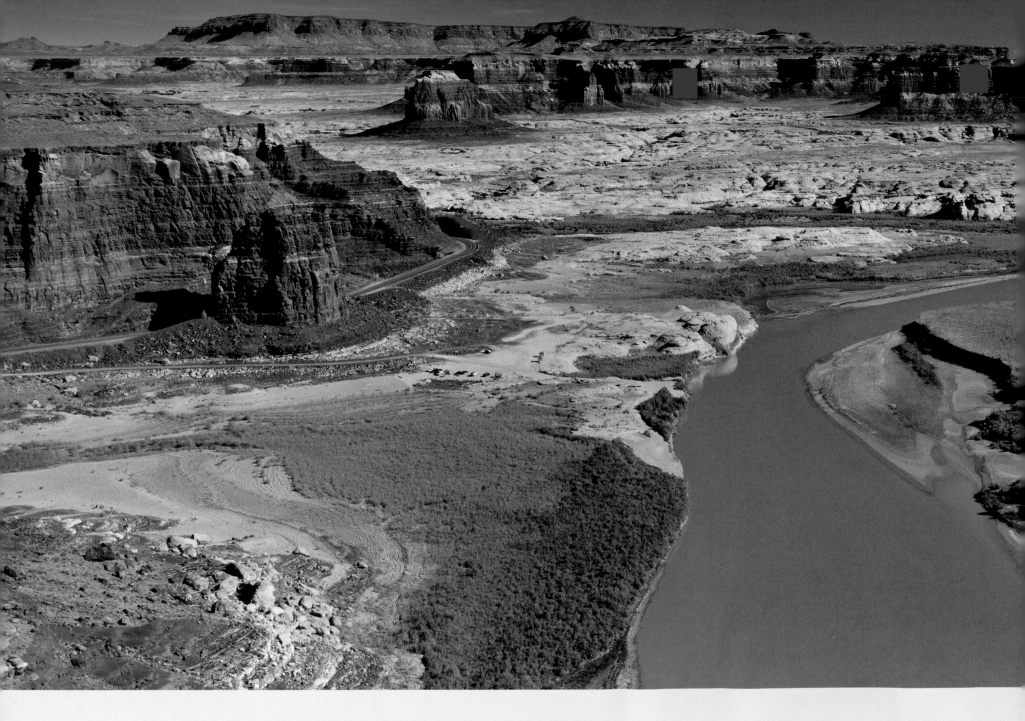

*Upstream view of the now free-flowing Colorado River,
from Hite Overlook across from the abandoned Hite
Marina. The flat and green areas were inundated by
Lake Powell to a depth of nearly 100 feet when the
reservoir was last full in 1999. October 2007.*

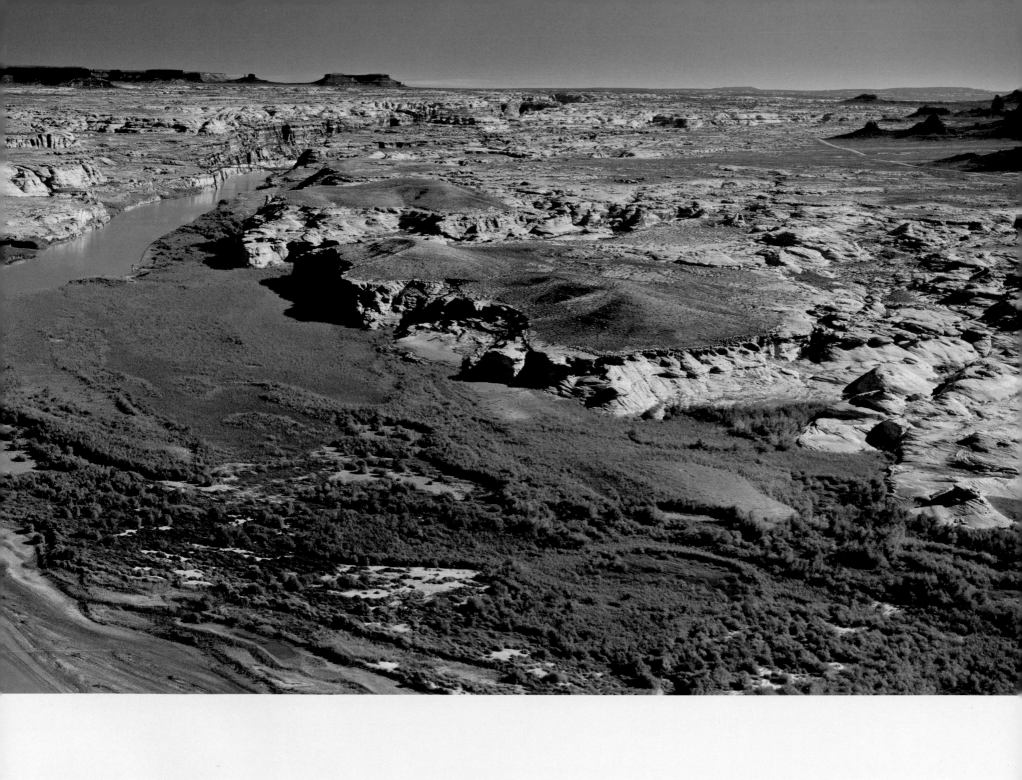

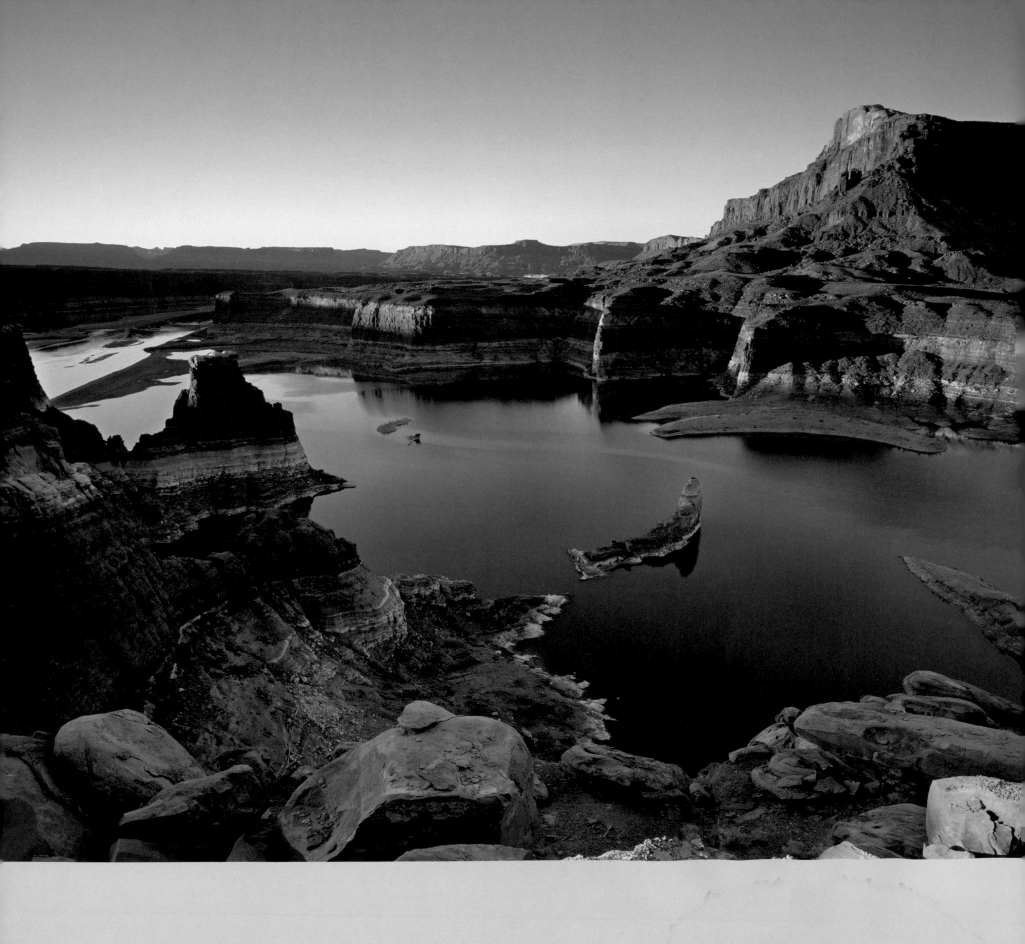

[CHAPTER ONE]

WHY GLEN CANYON MATTERS

APRIL 2000—WE LAUNCHED JUST AFTER SUNRISE, when the winds were still asleep and paddling across the big bays would be easier. The pointed nose of my sea kayak split the lake's quiet silver surface like scissors cutting into fabric. With every half-hearted stroke, I let the boat glide for as long as possible so I could soak up the reflected scenery—the orange rock, the blue sky, the turquoise water that gently lapped against canyon walls and unfurled like octopus tentacles up each narrow, twisting slickrock drainage. An inland sea of clear, odorless, motionless water stretching to the horizon defied the high-desert landscape through which I traveled. On this placid morning, I found Lake Powell both hypnotically beautiful and bizarre.

A sudden screeching noise from the bottom of the boat jolted me out of my trance and reminded me where I really was. On the most superficial level, I was paddling the Escalante Arm of Lake Powell with my family on a two-week kayaking trip, exploring remote reaches of the massive reservoir. But as I peered into the sunlit waters, glimpses of Glen Canyon, long buried beneath the man-made Lake Powell, haunted me. The tops of dead cottonwood trees that once thrived in a spectacularly rich riparian wilderness scratched my kayak like long, bony fingers. I was in a graveyard.

Once an arm of Lake Powell, this body of water occupies the mouth of North Wash. The main body of Lake Powell has receded down the primary canyon of the now free-flowing Colorado River at far left. October 2007.

Skeletons of reservoir-drowned cotton-wood trees reemerge from the stagnant waters of Lake Powell in Smith Fork Canyon. October 2007.

Entombed for more than forty years beneath Lake Powell, Glen Canyon once encompassed 170 miles of the Colorado River's main channel and nearly two hundred side canyons. The vast drainage straddling the Arizona–Utah border was the ecological heart of the Southwest's river systems, where the Green, San Juan, Dirty Devil, and Escalante Rivers all converged. Unlike the turbulent waters of the Grand Canyon downstream and Cataract Canyon upstream, Glen Canyon's calm main channel and shaded side canyons provided a unique nursery where fish, plant, and mammal species that could not survive elsewhere in the region were able to reproduce and thrive. The drainage also harbored more Native American archaeological sites than almost anywhere else in the Southwest and was home to numerous sacred Navajo and Hopi sites, all flooded without the informed consent of tribal religious leaders. Among Anglo explorers, ranging from John Wesley Powell to Edward

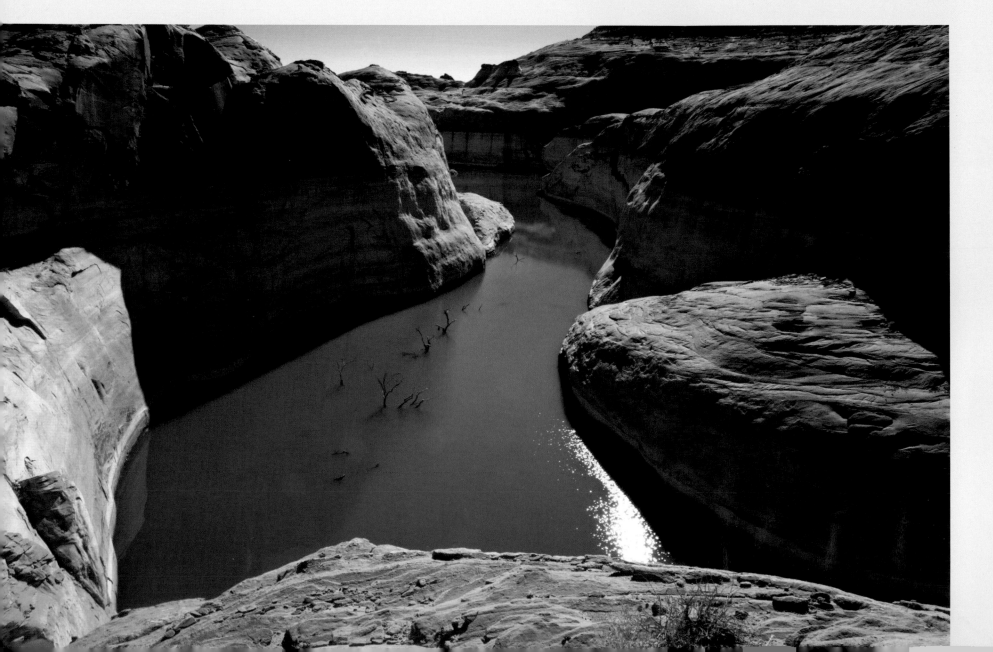

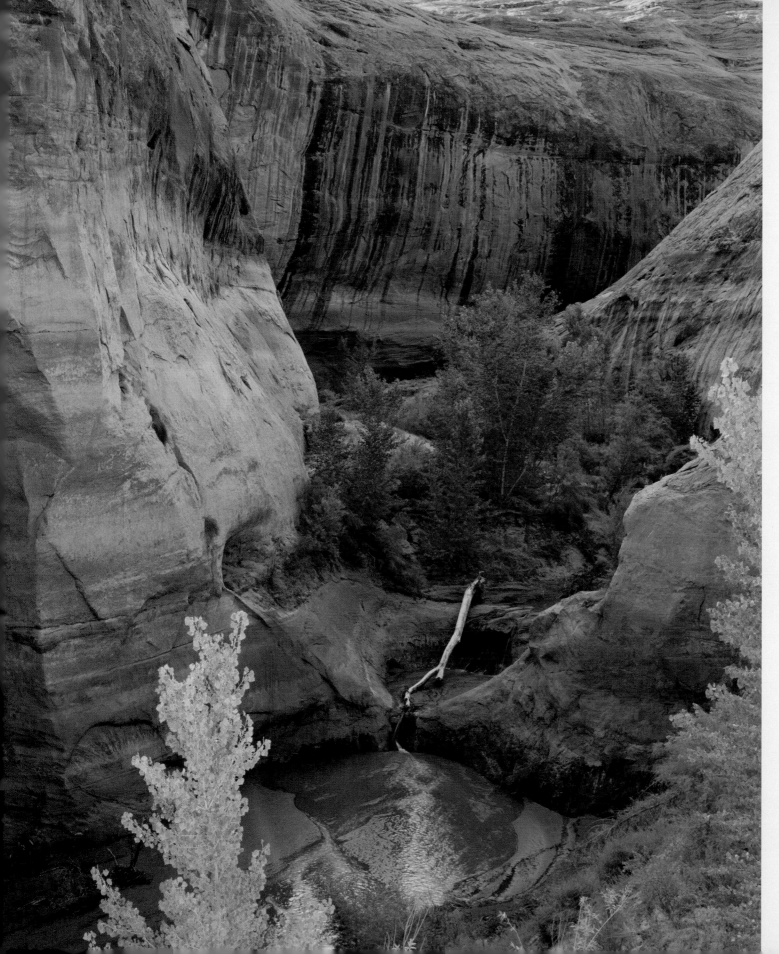

A newly emerged double waterfall in Davis Gulch, once 75 feet below the surface of Lake Powell. One year prior to this photograph, the falls were buried beneath a thick layer of reservoir sediment. Lake Powell's 75-foot-tall "bathtub ring" reveals the water's depth when the reservoir was last full. October 2007.

Abbey, Glen Canyon was often described as the most beautiful place in the Southwest, a pristine paradise that surpassed the Grand Canyon. For all these reasons, the flooding of Glen Canyon has been viewed by many wilderness activists as the worst environmental crime of the twentieth century.

Photographs of spectacular Glen Canyon scenery chronicled in the Sierra Club book *The Place No One Knew*—published in 1963, the year the gates of Glen Canyon Dam slammed shut—documented what would soon be buried by the West's insatiable thirst for economic development. "Glen Canyon died in 1963 and I was partly responsible for its needless death," admonished Sierra Club executive director David Brower in the book's introduction. "So were you. Neither you nor I, nor anyone else, knew it well enough to insist that at all costs it should endure. When we began to find out it was too late."

The loss of Glen Canyon soon came to represent much more than an inundated 300-square-mile drainage in a remote corner of the Southwest. The perpetrator of the crime, the 710-foot-high wall of concrete along with the azure blue "lake" it created, became a symbol for environmentalists of all that was wrong with the modern American West. Edward Abbey succinctly summed up the opposition during a 1981 speech atop Glen Canyon Dam, when the founding members of Earth First! unfurled a plastic crack down the concrete monolith: "Surely," he proclaimed, "no man-made structure in modern American history has been hated so much, by so many, for so long with such good reason."

As other environmental fights have ebbed and flowed, the loss of Glen Canyon remains a cause célèbre—a battle cry—like no other. In *A Story That Stands Like a Dam*, Russell Martin aptly describes the destruction of Glen Canyon as a powerful flashpoint in United States environmental history.

"After three hundred years or so, we had finally conquered the continent. No doubt it was inevitable that our ongoing efforts to develop the wild regions that remained at some point would encounter the passionate opposition of those who were convinced we had done enough, that some of our best country simply should be left alone. That encounter, more specifically and dramatically than anywhere else, took place at Glen Canyon…By 1963, when a Sierra Club book called it 'the place no one knew,' Glen Canyon had become somehow hallowed, the most potent symbol of environmental destruction in the nation, a symbol it long has remained."

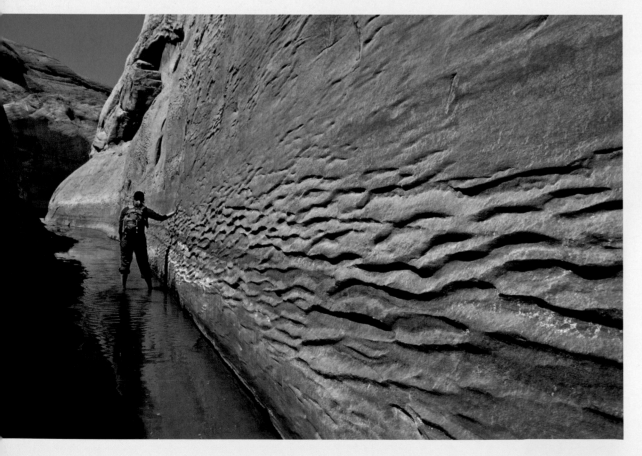

Recently exposed narrows in Wetherill Canyon, once 100 feet below the surface of Lake Powell. April 2006.

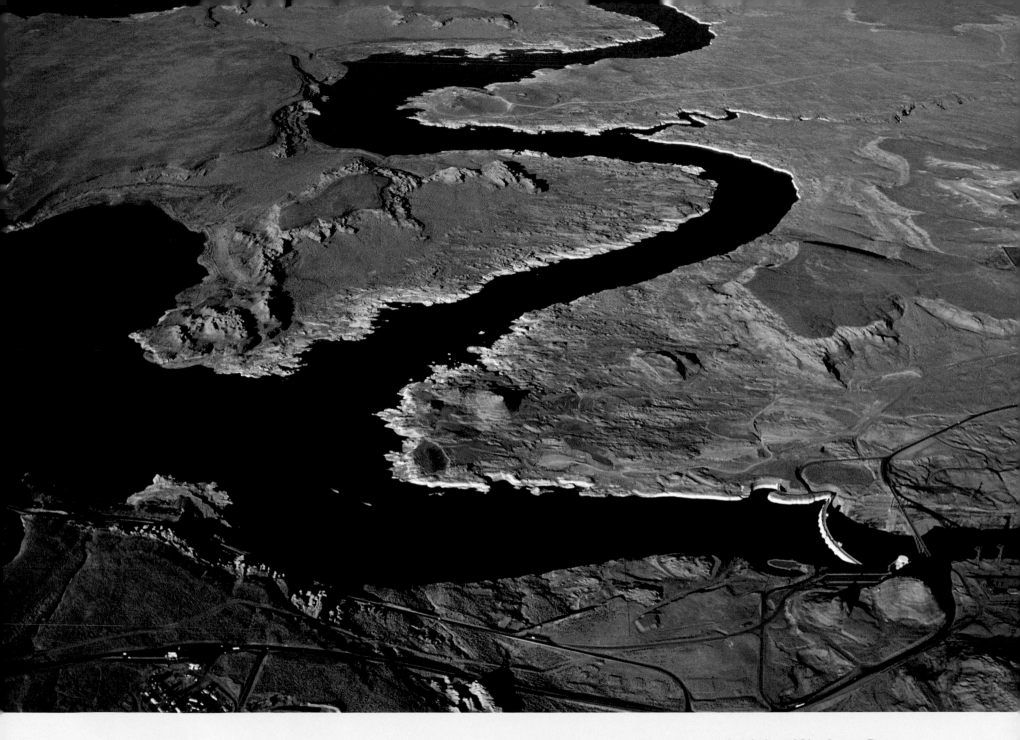

Aerial view of Glen Canyon Dam (lower right corner) and Lake Powell on the Arizona-Utah border, with the water level of the reservoir approximately 25 feet below its full-pool elevation. April 1993.

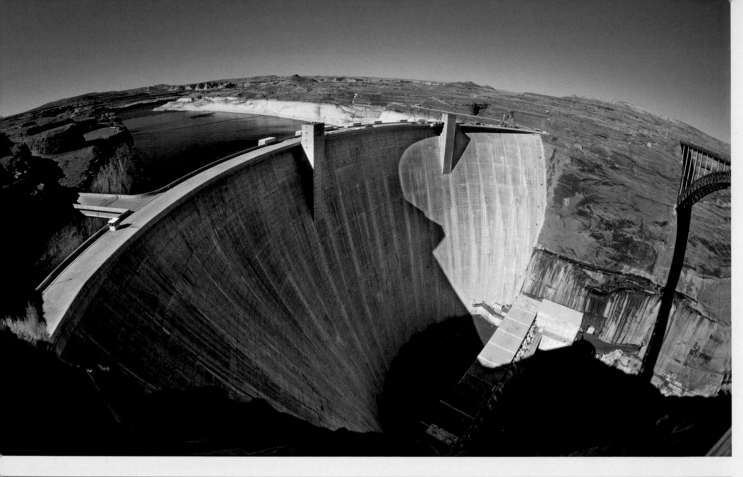

Glen Canyon Dam viewed from the Carl Hayden Visitor Center over Glen Canyon, with the water level of Lake Powell 110 feet below its full-pool elevation. April 2006.

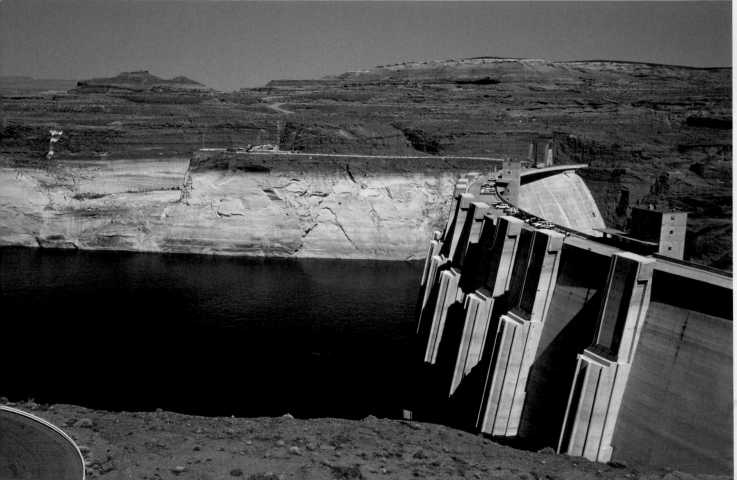

Upstream face of Glen Canyon Dam, with the water level of Lake Powell 145 feet below its full-pool elevation. At this level, the reservoir has lost nearly 70 percent of its total water volume. April 2005.

However, Glen Canyon Dam and Lake Powell have also become symbols of a very different perspective toward nature and what makes for a good life in the modern American West. What environmentalists like Brower and Abbey loathed was, and continues to be, dearly loved by others. "I'm proud as a peacock about how the lake has turned out," said Floyd Dominy, age ninety-four, during a 2003 interview for *Backpacker* magazine (published April 2004). As commissioner of the U.S. Bureau of Reclamation from 1959 to 1969, Dominy championed Glen Canyon and many other big dams on the Colorado River. "I can't even find the words to describe the beauties of Lake Powell. I consider Glen Canyon Dam my crowning glory, my biggest accomplishment in life."

Environmental campaigns aimed at restoring Glen Canyon are viewed by Lake Powell related businesses and many old-guard western politicians as nothing less than outrageous. In 1996, after the national Sierra Club made decommissioning Glen Canyon Dam one of its program goals, Congress held hearings in an attempt (at least by western state delegations) to point out the proposal's absurdity. "While you're at it," Utah representative Chris Cannon advised Sierra Club leaders during the hearing, "return Mount Rushmore to its pristine state, remove the Statue of Liberty and reclaim Liberty Island…and remove the Golden Gate from San Francisco Bay."

The fifty-year debate over the dam has not been simply a disagreement about a place, but about a way of life. "If it weren't for the water impounded in Colorado River reservoirs, including Powell, life would not be possible in the American West," insists former Utah representative Jim Hansen, who garnered millions of dollars in irrigation and water-storage projects for his state during his tenure. In defense of life as we know it, members of the Utah congressional delegation attached a rider to the U.S. Department of Interior appropriation bill in 2005 prohibiting the agency from using federal funds to "study or implement any plan to drain Lake Powell." Similar measures have appeared in every Interior spending bill since 2000.

Growing up in the 1960s and 1970s when Lake Powell was filling, I reasoned that the destruction of Glen Canyon was collateral damage for nothing less than the comfortable Southwest lifestyle I enjoy, plus a man-made lake—the second largest in the United States—that is scenic in its own right and admittedly fun to float. Yet the tradeoff always seemed bittersweet at best. I wished I could have explored the spectacular twisting slot canyons, paddled the lazy river, and seen the intact Anasazi ruins for myself, but I was born too late. "Whatever meaning people give Glen Canyon, whatever reading one may give the texts on Glen Canyon, there is this humbling inescapable fact: Something great is gone," summed up Jared Farmer in his 1999 book, *Glen Canyon Dammed*. "Not some idea of nature, but the reality of maidenhair fern unfurling in the quiet of a glen. Something independently real and irreplaceable—a place if not a wilderness—lies submerged beneath the wakes of passing boats."

As I stared down into the drowned, long-dead remnants of Glen Canyon during my April 2000 kayaking trip, the painful reality of loss hit me. I thought there was no turning back the clock, no second chance. What I didn't realize at the time was that my boat was brushing against the tops of dead cottonwood trees because the lake level was dropping due to drought. And it would keep dropping as the drought relentlessly continued.

JUNE 2003—I have returned to the Escalante Arm of Lake Powell eager to see what the drought has wrought. Where I had paddled my kayak across a 100-foot-deep reservoir three years earlier, I am now hiking in an ankle-deep, silt-laden, wonderfully flowing river that is pulsing with life. I fill my water bottle from seeps bubbling out of the canyon walls still weeping with lake water. I watch hummingbirds dart about newly established gardens of maidenhair ferns. I walk barefoot alongside mountain lion tracks pressed in river sand and marvel at cottonwood saplings already 4 feet tall growing out of dead snags. And I cry at the overwhelming realization that at least part of Glen Canyon is still alive.

In January 2000, Lake Powell was at 95 percent of capacity with about 24 million acre feet of stored water (1 acre foot represents about 326,000 gallons) and nearly 2,000 miles of shoreline. By April 2005, after six years of significantly below-average precipitation in the upper Colorado River basin, the lake level had dropped a record 140 feet to only 30 percent of capacity. As the reservoir retreated, Glen Canyon returned from the grave. This dramatic and unexpected emergence prompted a media frenzy in the spring of 2005 when Cathedral in the Desert, the poster child of the paradise lost as well as other archaeological and natural sites, emerged intact.

For approximately three weeks—before the snow-melt from the wet winter of 2005 raised the lake 30 feet—hordes of tourists, including many journalists and photographers, walked on the floor of the fabled 1-acre alcove. Cathedral's 50-foot waterfall had returned and maidenhair fern had started taking root. An April 8, 2005, *New York Times* headline proclaimed: "Glen Canyon is on its way back—viewable in much of its former glory." And a photo-laden feature in the April 2006 issue of *National Geographic* that documented Glen Canyon's resurrection beckoned: "A Dry Red Season: Drought drains Lake Powell uncovering the glory of Glen Canyon."

These and other stories were peppered with the recollections of aging baby boomers—including David Brower's two children—who had visited pre-dam Glen Canyon in their youth and had made the journey back to mecca. "A stout man with a salt-and-pepper beard emerged and gazed at the waterfall, removing his glasses to wipe away tears," wrote Tom Price for the *New York Times*. "He turned out to be Richard Norgaard, who first came here in 1962 as an 18-year-old river guide." Norgaard told the *Times*, "This is a hell of a chance for this canyon again…But I'm upset that it was lost in the first place, and that in two months it will be lost again."

The winter of 2005 brought slightly above-average precipitation, which raised Lake Powell to about 50 percent of capacity and swallowed the alcove floor of Cathedral in the Desert. However, because of increasing municipal water demands, continued below-average precipitation in recent years, and a warming Southwest climate, the lake has remained half empty or less since 2005 and there is no scenario—beyond flooding of biblical proportions—in which it would be full again anytime soon. Nearly a decade of drought has shrunk the massive reservoir from 250 square miles to its current diminished state of fewer than 130 square miles. As the reservoir has shriveled, hundreds of miles of twisting side canyons have emerged and a flowing river channel has replaced the northernmost section of the lake where a shuttered, landlocked Hite Marina sits like a ghost town.

Several regional environmental organizations, including the Glen Canyon Institute (GCI) and Living

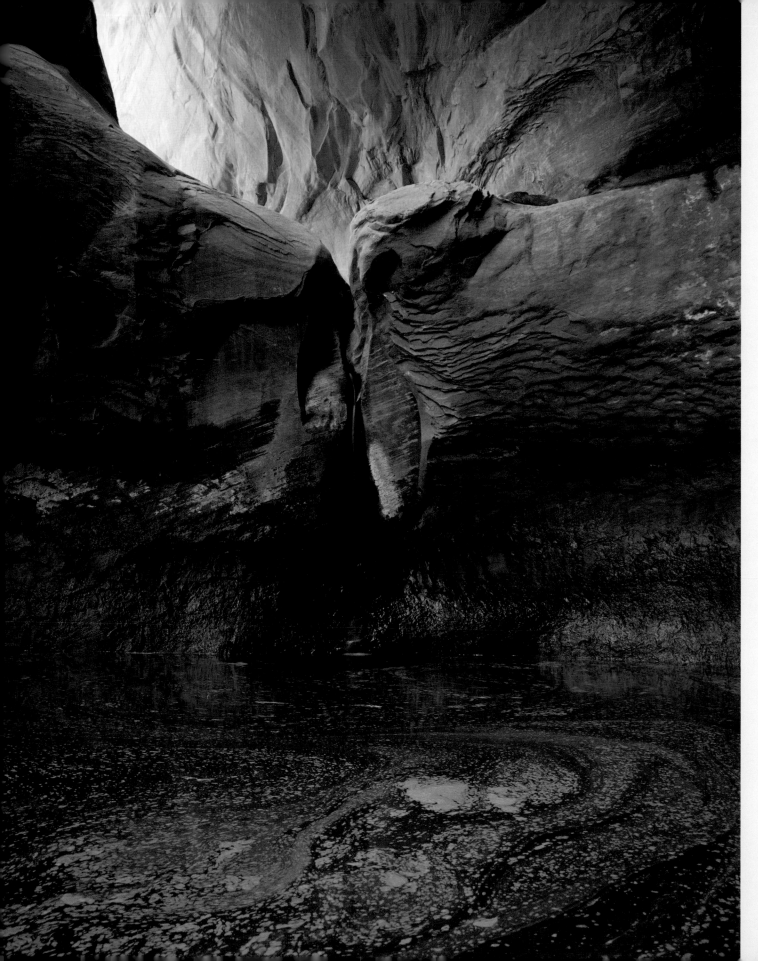

A newly restored waterfall in the sandstone chamber known as Cathedral in the Desert, Escalante Canyons.
April 2005.

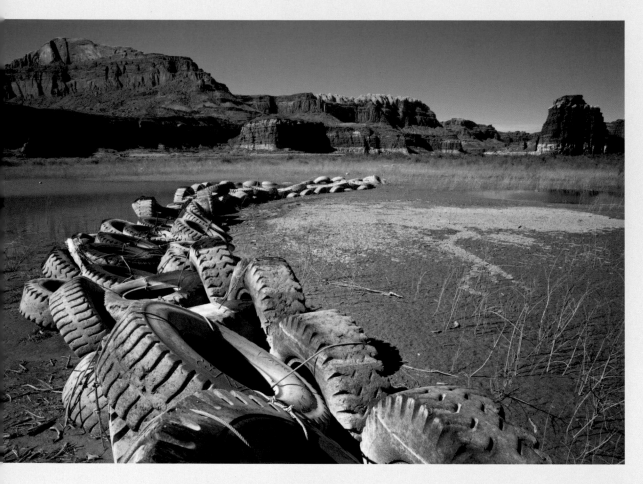

Old chained-up tires once used as breakwater barriers around Hite Marina now rest on mudflats, at a location once 95 feet below the surface of the reservoir. October 2007.

OPPOSITE *Author Annette McGivney, along with her son Austin and Mike Frick, explores a newly reclaimed section of Smith Fork Canyon.* June 2005.

Rivers, are fighting to gain protection for the resurrected sections of Glen Canyon—perhaps as a national park—in order to stave off future inundation. They argue that western water policy must be changed to ensure a lower Lake Powell regardless of rainfall, urging that laws such as the Endangered Species Act, the Wilderness Act, and the National Environmental Policy Act that arose in part from the damming of Glen Canyon should be tapped to protect the reemerging canyon.

"We are now focusing on the beauty of the place and getting people to witness it instead of talking about decommissioning the dam," said Glen Canyon Institute president Richard Ingebretsen in May 2005, when the

group launched its Glen Canyon National Park campaign. GCI maintains that it would be far more efficient, and better for the restored landscape of Glen Canyon, to keep Lake Powell's water downstream in Lake Mead (also expected to stay half empty for the next decade) or underground where it wouldn't evaporate. The group believes a national park designation would help promote this kind of water policy and restore Glen Canyon by government mandate rather than by accident.

But there are others—mostly western politicians, water managers, southwestern developers, and Lake Powell recreationists—who are fighting to save their beloved reservoir. They would prefer to look the other way and wait for the lake to fill; they insist that whatever has been exposed by drought is "dead," that there is nothing left to save.

I found myself on the front lines of this debate beginning in 2003 as I researched and wrote a series of articles for *Backpacker* about Glen Canyon's emergence. I interviewed numerous individuals on all sides of western water policy issues and also hiked in dozens of newly emerged side canyons, exploring places that had been buried under 100 feet of water for thirty-five years. These were not the ruined, stinky silt flats filled with boat debris I had expected, but were landscapes in a spectacular state of ecological recovery. Ironically, the lake that had once wrought destruction has been a significant factor in this emerging splendor—as the reservoir subsides, lake water continues to seep from the porous sandstone walls for months, jump-starting the growth of native vegetation and hastening the return of birds, insects, and animals. Flash floods from heavy rains also help flush out tall sediment banks that had accumulated in side canyons.

Although media attention to Glen Canyon's surprise emergence has died down since 2005, the ecological

recovery has not. With every hike in recent years, I am always overwhelmed by the beauty of the place and the gravity of the current opportunity to act—or not. Here it is. The place everyone knew as "the place no one knew," made famous because it was doomed. The place lost to 1950s environmental complacency and the trigger that led future activists to swear that such a devastating mistake would never happen again. Here it is, the tragically forsaken but miraculously resurrected Glen Canyon, standing dripping wet on our doorstep. What are we going to do?

For anyone who has mourned the loss of Glen Canyon or southwestern wilderness in general, the partial restoration of this mythic place is a gift. It is also a challenge. Our dilemma is whether or not we, as a society, prefer Glen Canyon and what it symbolizes over Lake Powell and all that it symbolizes. A national decision to protect a restored Glen Canyon involves embracing not only a place, but also a new way of living in the American West that puts environmental sustainability above the drive for short-term economic growth.

"The lake is lower now than anybody ever imagined," notes Dan Beard, former commissioner of the Bureau of Reclamation under President Clinton and now a board member of the Glen Canyon Institute. "It provides a new reality about what is possible. It's time for the federal government to consider operating the dam in a different way so that we can protect what's been uncovered." Amazingly, Americans are being given a second chance not only to experience Glen Canyon, but to save it.

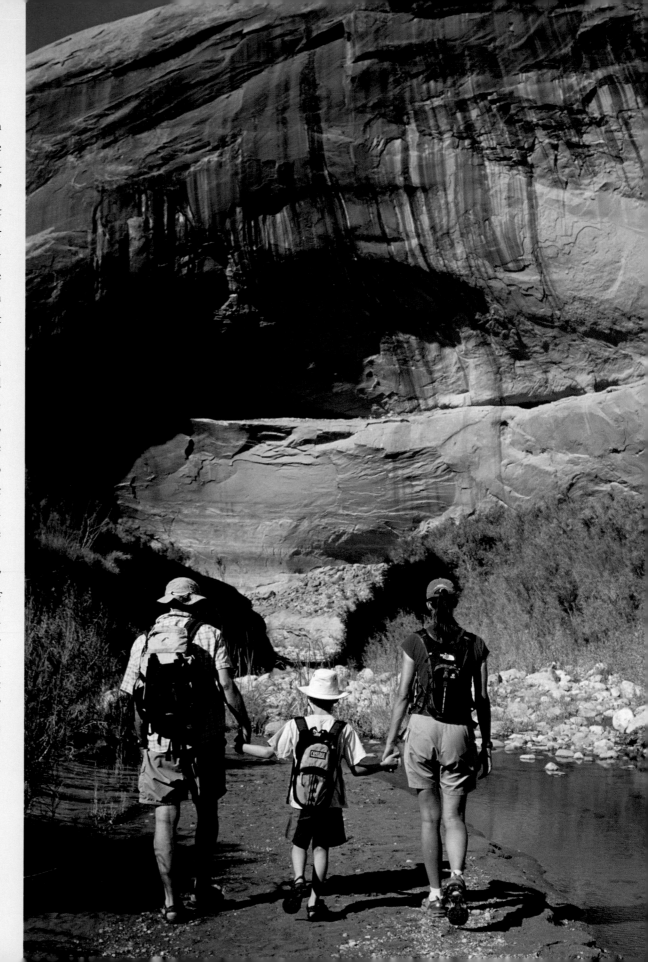

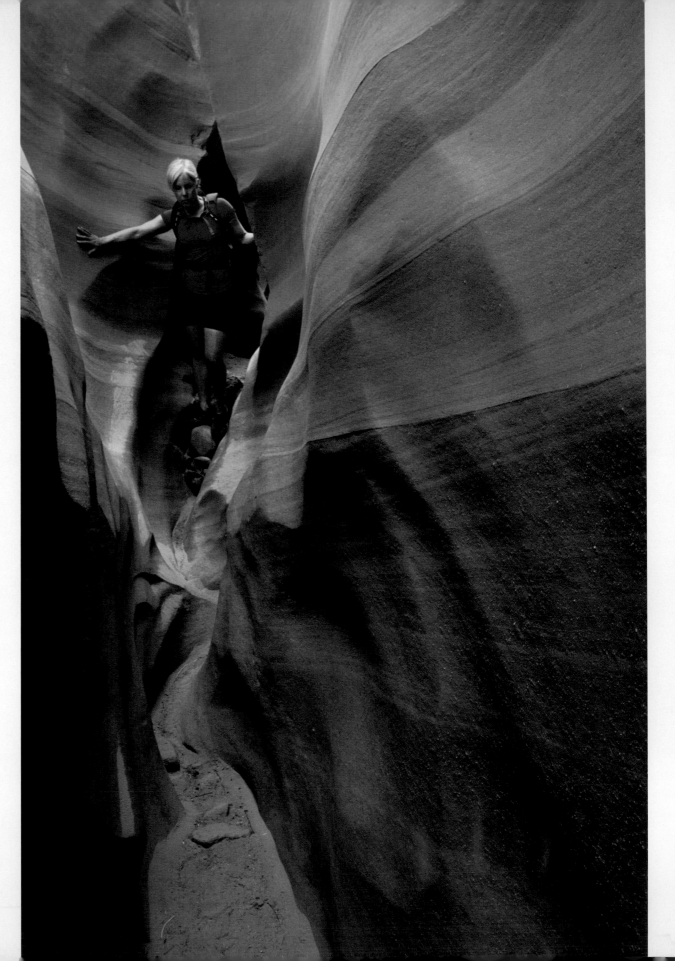

Recently smothered beneath 30 feet of reservoir sediment, these narrows in Labyrinth Canyon have been restored to their prereservoir condition.
April 2006.

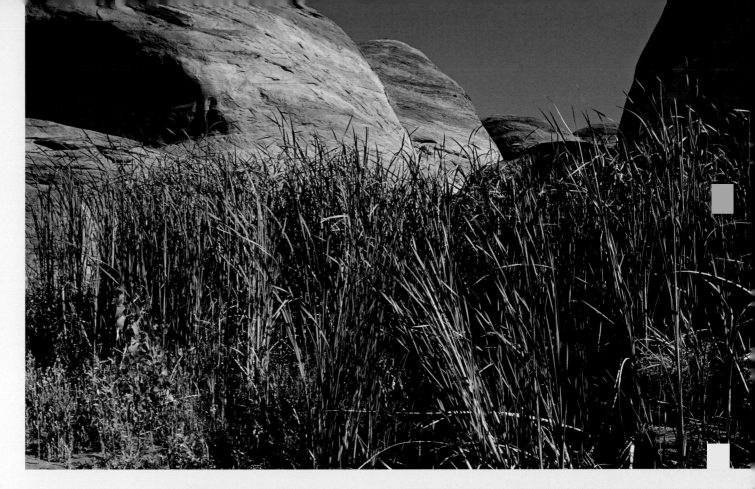

A profusion of cattails reclaim the streambed in Smith Fork Canyon, at a location last inundated by Lake Powell three years prior. June 2005.

Looking up a tributary canyon of Smith Fork Canyon, with the Smith Fork stream in the foreground. Compared to the image taken two years earlier, the thick growth of cattails has been washed away as flash floods scoured the sediment banks the plants once occupied. October 2007.

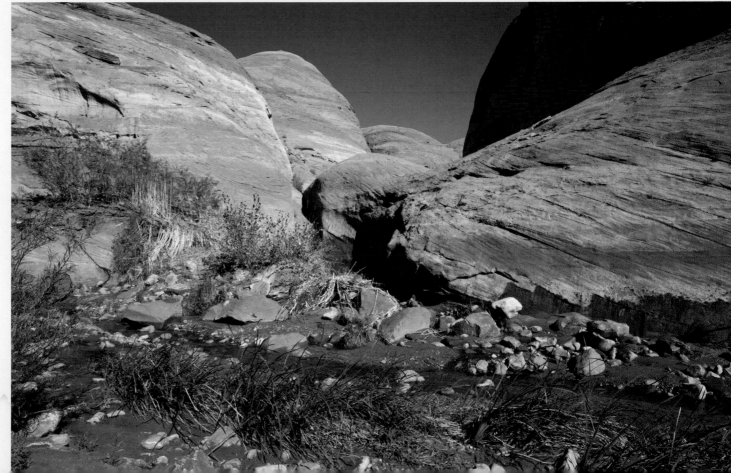

On the Rebound

Glen Canyon's many side drainages—the Colorado River tributaries—are recovering first and fast.

Although there is little going on in the way of official, government-sponsored biological inventories of Glen Canyon National Recreation Area, the anecdotal evidence of ecological recovery is everywhere. *Backpacker* magazine editors exploring sections of canyon along the outer reaches of Lake Powell have witnessed the landscape transform in just three years from clogged, barren silt banks to pristine slickrock streambeds bustling with native plants and wildlife. Dave Wegner, science director for the Glen Canyon Institute, estimated in 2005 that the many stretches of side-canyon habitat where the reservoir has been consistently absent for five years are at least halfway recovered to their pre-dam environment.

Here's how it's happening:

As the reservoir drops, gradually creeping down the sandstone walls, the forces of photosynthesis kick in. Sunlight shines on long-dormant seeds and spores tucked in cracks and on ledges, and these sprout after being underwater for possibly decades.

Within days, algae and mosses come to life. And over a period of weeks, ferns, reeds, and sedges grow in places where water seeps from the canyon walls. Hanging gardens of ferns appear around resurrected springs.

As the vegetation grows, aquatic and terrestrial insects and amphibians begin to repopulate their former habitats. Dragonflies and damselflies dart above the water, and tiny canyon tree frogs and red-spotted toads cling to damp sandstone walls.

New food sources attract a variety of native neotropical birds, including southwestern willow and vermillion flycatchers, Bell's vireos, and Bewick's and canyon wrens.

Once the lake recedes from the canyon floor, a Glen Canyon tributary's natural streamflow cuts through sediment left by the lake. In optimum conditions, flash floods wash the sediment completely away and return the canyon to a scoured slickrock bottom. Aquatic life,

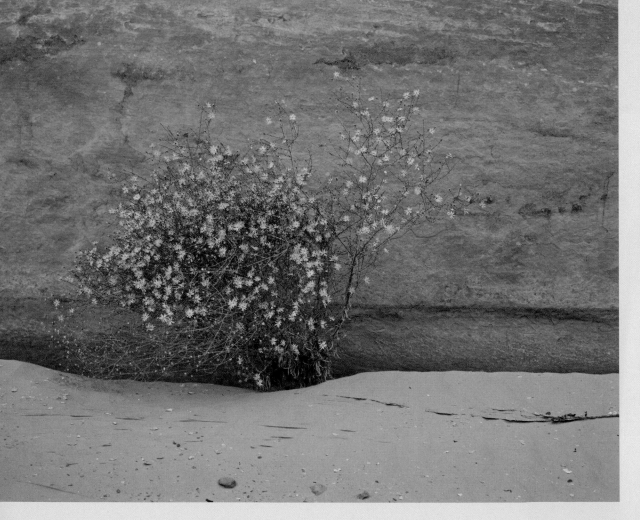

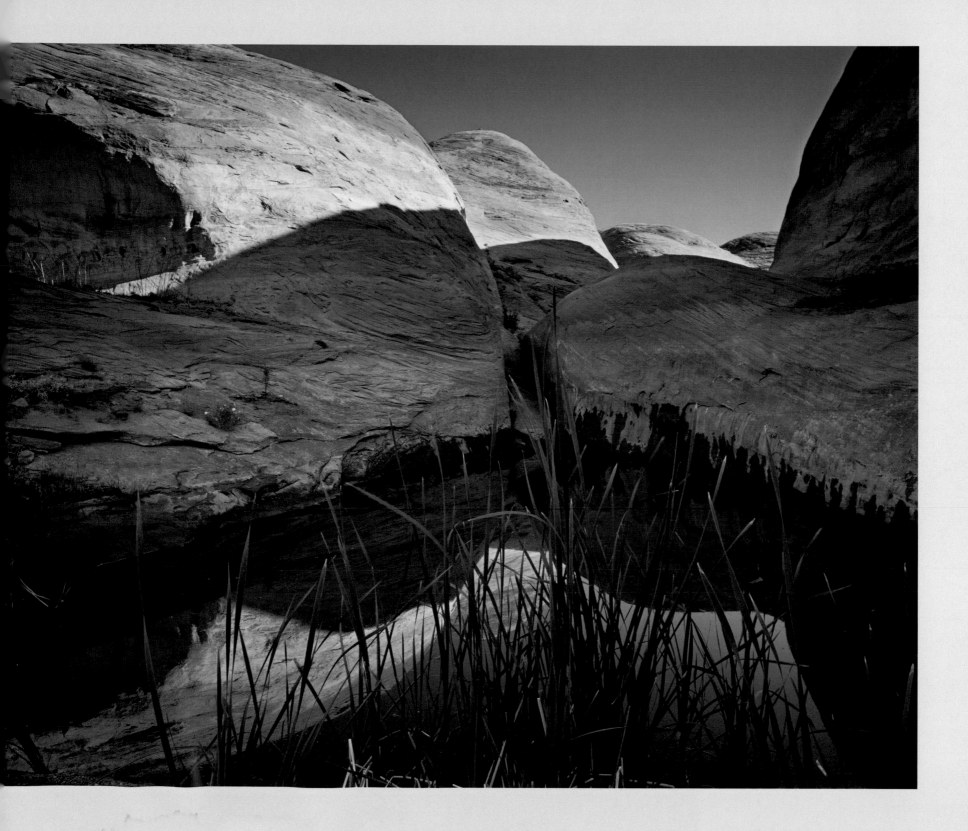

PAGE 32 *Utah daisies take root in the windblown sand along Davis Gulch in Escalante Canyon, where Lake Powell once flooded the area with 90 feet of water.* October 2007.

PAGE 33 *Restored pool and reeds in Smith Fork Canyon. The reservoir's fading "bathtub ring" can barely be seen, almost at the top of the dome just left of center.* April 2004.

Cattails and algae reclaim the streambed in Slickrock Canyon, at a location flooded by Lake Powell three and a half years prior. October 2005.

including a profusion of crayfish, swims downstream.

Within two months of streambed emergence, the native ecology of a tributary can be well on its way to recovery. Willow and cottonwood seeds blow down-canyon and find purchase on moist, sandy soils along the streambank. These cottonwoods can grow 4 to 5 feet per year.

Newly emerged slickrock pools nurture a micro-wetland habitat populated by cattails, reeds, monkey-flowers, and grasses. Willow-eating beavers venture down canyon and build ponds.

With the steady progression in vegetation, native reptiles and mammals return and a sustainable food chain is restored. If the tributary's habitat is not stressed by inundation from the reservoir or extended drought, historical megafauna, including deer, mountain lions, and bighorn sheep, will migrate back into the canyon, marking the final phase of recovery.

But to note: Fluctuating lake levels that rise even as little as 5 feet can set the ecological recovery clock back to zero.

Goodbye Lake Powell, Hello Glen Canyon

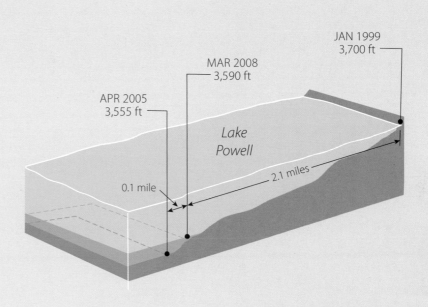

1963	Glen Canyon/Colorado River pre-dam surface elevation is 3,150 feet.
1980	Lake Powell reaches full-pool elevation at 3,700 feet nearly two decades after completion of Glen Canyon Dam.
January 1999	Last date that the reservoir was at capacity.
April 2005	Reservoir drops to historic low elevation of 3,555 feet.
March 2008	Reservoir is at 3,590-foot elevation. Based on legally mandated water delivery requirements and anticipated weather patterns, the Glen Canyon Institute maintains that Lake Powell will be at least 60 percent empty, at 3,580 feet, 60 percent of the time for years to come.

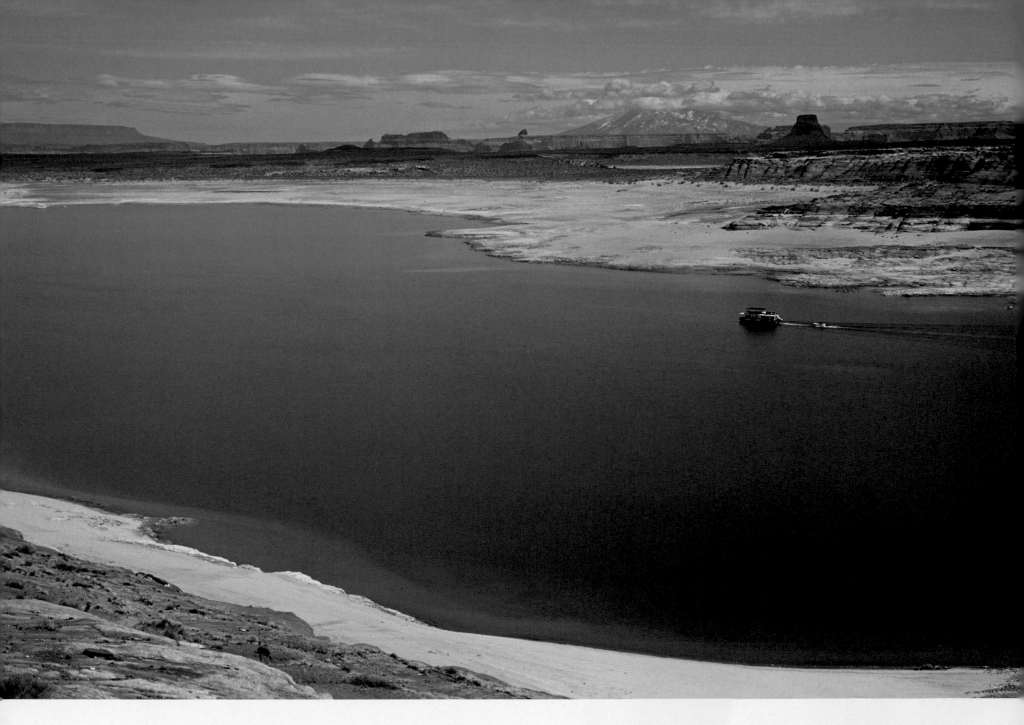

*Wahweap Bay with the water level of
Lake Powell 95 feet below its full-pool
elevation. At this level, the reservoir
has lost nearly 50 percent of its total
water volume.* April 2003.

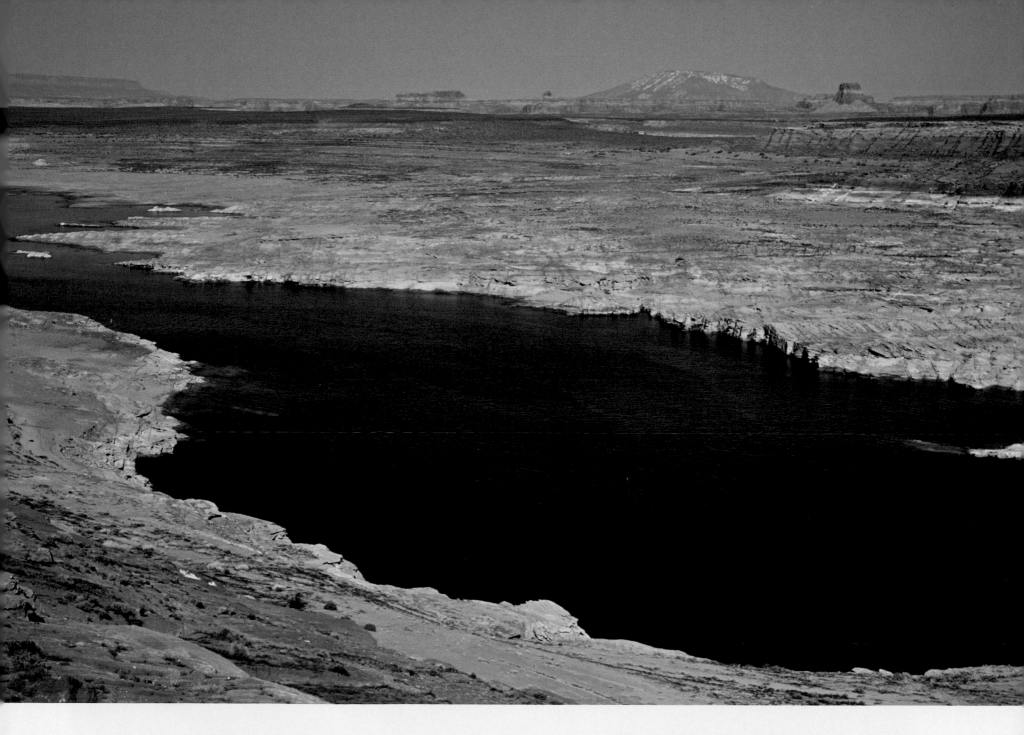

Compared to the image taken two years earlier, the water level in Wahweap Bay has dropped another 50 feet. At this level, the reservoir has lost nearly 70 percent of its total water volume. At full pool, the water would fill the entire frame, with only the mesas on the far right and the distant horizon rising above the water. April 2005.

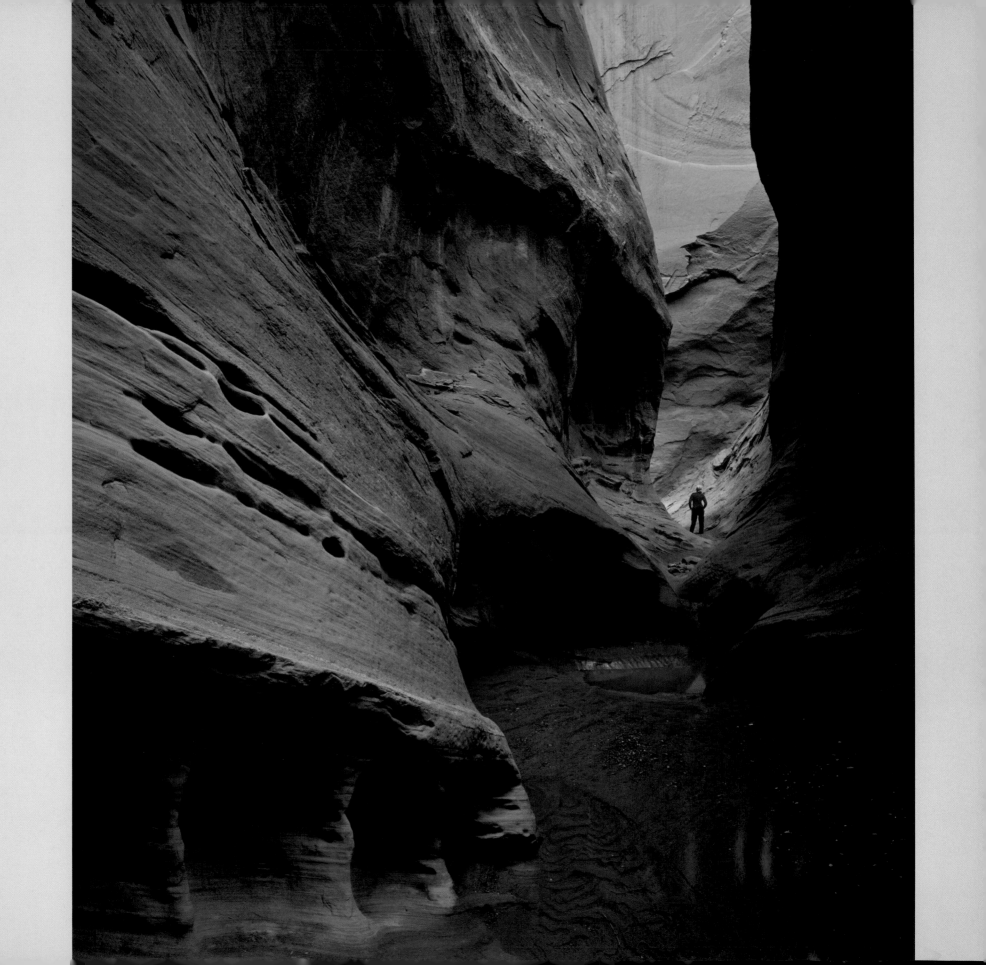

[CHAPTER TWO]

THE POWER OF PLACE

JUNE 2005—THIS CANYON, IT SQUEEZES ME. The fluted walls, now 3 feet apart and 400 feet tall, press in. Close and then closer. I pad my sandals over the white cobblestone floor, exhilarated and intimidated by the intimacy with towering slickrock. Today, my hiking partners and I are exploring Twilight Canyon, a place that five years ago was smothered under more than 100 feet of lake water and 30 feet of sediment. Tomorrow and the next day we'll visit other recovered slots—all stubbornly alive and miraculously scenic.

Glen Canyon encompasses more than one hundred side canyons, and dozens harbor labyrinthine narrows like this one, some still unnamed and uncharted. Each slot has a different personality, a different vibe, depending on how the light plays off the walls and how the walls play off each other. In Twilight, the light is yellow and descends in heavenly shafts; it swirls and dances and turns the tan walls orange and our pink skin violet. We stumble with our mouths open and our heads back. With churchlike reverence, we are silent as we look impossibly upward to where the canyon is bisected by a narrow sliver of sky.

Recently scoured-out narrows in Cascade Canyon. After the reservoir receded, flash floods washed out the 25-foot-deep layer of sediment deposited here. April 2005.

Lake Powell's 145-foot-tall "bathtub ring" dwarfs a small pontoon boat used to access and photograph newly revealed sections of Glen Canyon. April 2005.

There is something irresistible about these slots that lures us up narrowing passages. I imagine myself as an ant in a sidewalk crack, hungry for what lies ahead. We see absolutely no sign of the lake except for bright-colored paint streaking the walls where jet skiers once became inconveniently wedged. My body learns to do new things to get around obstacles—a deep pool or giant chockstone—to keep going. I stem and crawl and wade and climb.

Like moths attracted to a porch light, we venture up a side drainage. It's deeper, narrower, and darker than Twilight's main canyon. Lake water weeps out of the porous sandstone walls as if a sponge is being squeezed. The bonanza of moisture feeds frogs, bugs, birds, Day-Glo green algae, and numerous hanging gardens of ferns. I pause in a hip-deep, copper-colored pool, press my palms against the damp slick-rock, and listen for a moment to the echoes of frogs and gurgling water. Here, in the womb of the Earth, I am blissfully at peace.

If any American river could be described as bipolar, it is the Colorado. Before its 1,400-mile course was plugged by dams, the Colorado was a waterway characterized by extreme mood swings, with high variability from month to month, year to year, and mile to mile in terms of flow, temperature, and turbidity. *Cadillac Desert* author Marc Reisner likened it to "a forty-pound wolverine that can drive a bear off its dinner…unrivaled for sheer orneriness."

But the Colorado and its major tributaries (the Green, Yampa, Dolores, Gunnison, San Juan, Little Colorado, Virgin, and Gila Rivers) are the lifeblood of the American West, serving as a primary water source for seven states and thirty million people. From headwaters in the snowcapped Rocky Mountains of Wyoming and Colorado, the main stem drops 11,000 vertical feet and drains 108,000 square miles before landing in the Sea of Cortez. Historically, during spring floods, the Colorado River could rage through its steep-walled canyons at 400,000 cubic feet per second (cfs), but by summer could slow to as little as 1,000 cfs and become shallow enough in some sections to walk across. The total flow also varied greatly from one year to the next, ranging from 4.4 to 22 million acre feet in a twelve-month period.

The raging water scoured soft sandstone canyons as the river rolled down the Colorado Plateau, carrying the largest sediment load of any river in the world. On average, 65 million tons of sediment flowed every year through Glen Canyon and then the Grand Canyon, building beaches and supporting fish species uniquely adapted to their erratic, silty environment. Before the dams, there were thirty-two species of fish endemic to the Colorado River and six species endemic just to the section flowing through Glen and Grand Canyons.

Perhaps the one thing that was predictable in the Colorado River basin was drought, especially on the Colorado Plateau. Researchers studying packrat middens and tree rings dating back thousands of years have identified a historical climate pattern. Every several decades there have been "mini droughts" that lasted 3 to 5 years, and every 500 to 700 years there have been "mega droughts" that lasted 30 years on average.

Yet, in this regime of extremes, Glen Canyon nurtured a broad array of life for tens of thousands of years. Flanked by the roiling waters of Cataract Canyon above and the Grand Canyon below, the Colorado's 170 miles through Glen Canyon were tranquil, flowing red and smooth. "Glen Canyon was the ecological vortex for the entire river basin," says John Weisheit, Colorado

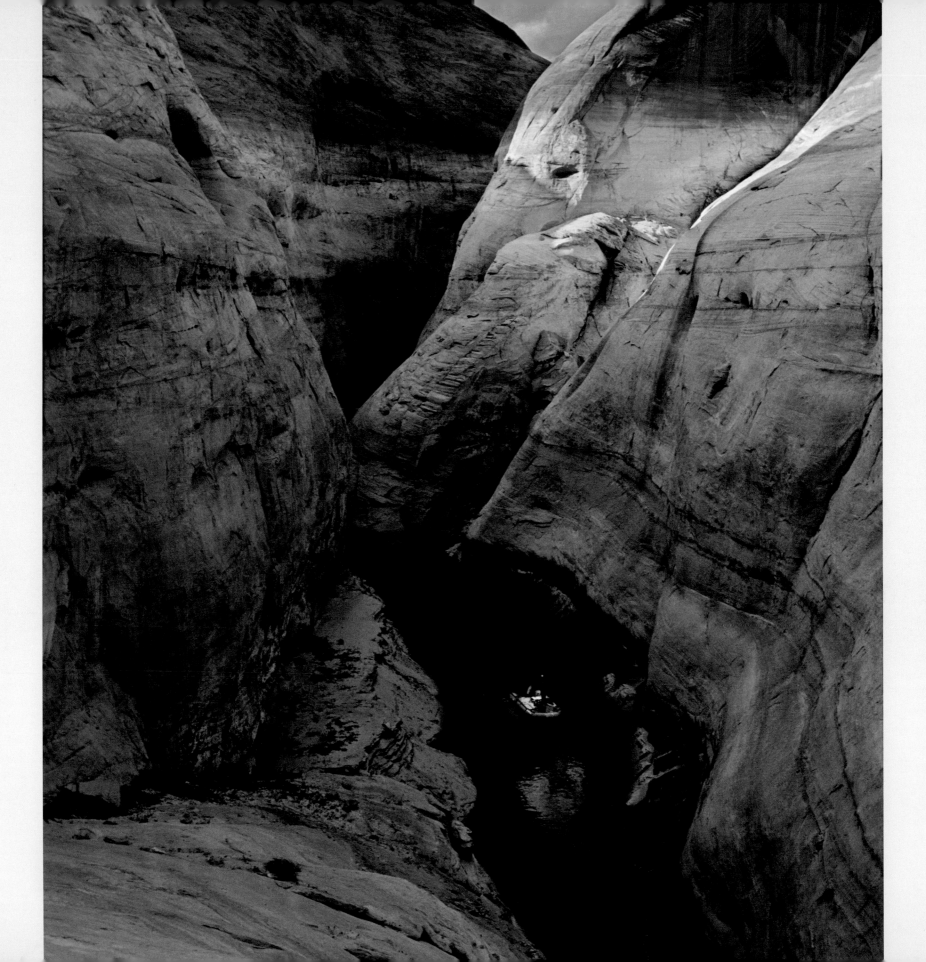

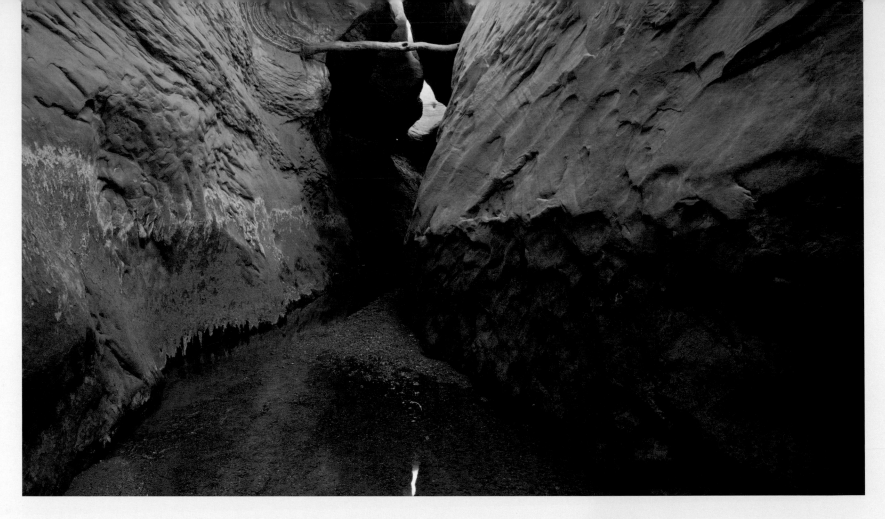

Riverkeeper and director of Living Rivers. "It's where the fish laid their eggs; it served as a nursery for many aquatic species." The fertile soils and perennial waters in the many side canyons also provided a stable environment for humans. During the federally authorized "salvage" surveys conducted by the Museum of Northern Arizona and the University of Utah during the late 1950s, more than three thousand archaeological sites were identi-fied, mostly granaries, dwellings, and rock art dating to between and 500 and AD 1250.

MAKING THE DESERT BLOOM AND THE U.S. ECONOMY BOOM

When John Wesley Powell floated through Glen Canyon on his legendary three-month-long 1869 exploration of the Colorado River, he waxed poetic in his journal about the uncharacteristically peaceful stretch of water that posed no threat to life or limb. "Past these towering monuments, past these mounded billows of orange sand-stone, past these oak-set glens, past these fern-decked alcoves, past these mural curves, we glide hour after hour, stopping now and then, as our attention is arrested by some new wonder," he wrote. "A curious ensemble of wonderful features—carved walls, royal arches, glens, alcove gulches, mounds and monuments. We decide to call it Glen Canyon."

After surviving the rapids of the Grand Canyon downstream, moldy rations, and mutiny, the one-armed major delivered a report to Congress in 1878 on "the arid lands" of the West. His mission from the U.S. government was to chart the country's unknown western territory so that it could be paved and plowed

by hearty pioneers in the name of manifest destiny. But Powell was a scientist who stuck to the facts, and he told Congress what it did not want to hear. The vast expanses of wilderness beyond the hundredth meridian could not support the Jeffersonian ideal of the yeoman farmer, said Powell. This extraordinarily scenic region, which the young United States owned but could not seem to settle, received on average less than 20 inches of rain a year and was plagued by cycles of drought the likes of which the East Coast and Midwest had never seen.

Powell recommended that the government build reservoirs in high elevations along strategic mountain drainages to bring irrigation to farmers and so give them a fighting chance. He advised establishing communities around watersheds, with property boundaries mapped out so that every farmer and/or rancher had access to water. And he admonished that only 3 percent of what he called the Great American Desert—the arid land west of the Rockies—should ever be developed.

Congress balked. Instead of following Powell's advice, the government along with many unfortunate homesteaders chose to believe a prevalent nineteenth-century myth: that "rain follows the plow," even into the desert.

In the last half of the nineteenth century, hordes of hopeful farmers—as well as gold prospectors, trappers, land speculators, and opportunists of all kinds—journeyed west into the Great American Desert. They got their 160 acres as promised by the Homestead Act, tilled the soil, and waited for it to rain. It didn't. The drought of the 1880s wiped out most settlements in the rural, arid West like an eraser cleaning a chalkboard.

In 1902—the year John Wesley Powell died—Congress established the Bureau of Reclamation, finally relenting to Powell's assertion that the interior West would never be developed unless the federal government paid to irrigate it. However, over the next few decades, the guiding philosophy that evolved within the fledgling agency was far more ambitious and environmentally destructive than what Powell had laid out in his plan. An environmentally sustainable system intended to nurture the independent farmer in the Intermountain West grew into a federal behemoth supporting

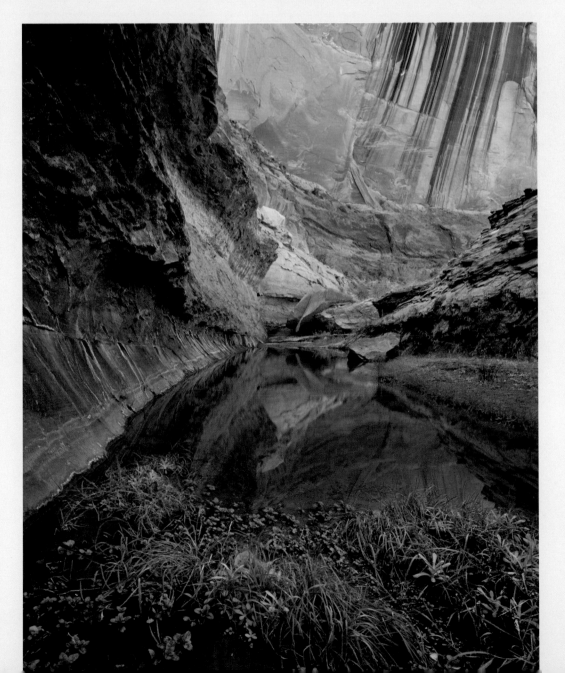

Recently restored streambed in Sevenmile Canyon, once 50 feet below the surface of Lake Powell. Native plants quickly reclaimed the streambed after the reservoir receded. Fading remnants of the reservoir's white "bathtub ring" can be seen on the rocks just above the center of the image. October 2007.

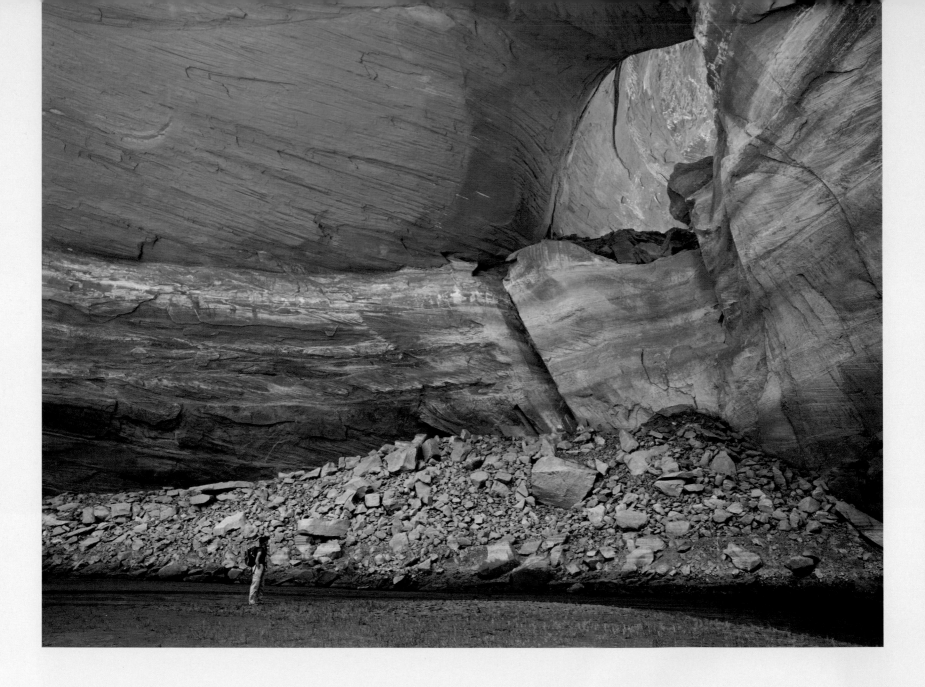

Susie Kay at La Gorce Arch in a newly exposed section of Davis Gulch, Escalante Canyon. She would be 90 feet below the surface of Lake Powell were the reservoir full. May 2003.

industrial farming and urban sprawl in the desert, often hundreds of miles from the Colorado River, even in places that receive just a few inches of rain a year.

Beginning with the construction of Hoover Dam in 1931 (then called Boulder Canyon Dam), the United States embarked on a forty-year building binge, with $21.8 billion spent on 133 major western water projects. The stated goal of the burgeoning Bureau of Reclama-

tion was to impound all of the nation's rivers so that not one drop of water was "wasted" by flowing unclaimed to the sea. Although communities in the rural West still clamored for agricultural irrigation projects, more and more of the agency's focus turned to building big dams—the bigger the better—to generate electricity. And after Hoover Dam, the Bureau could do no wrong in the eyes of the American public.

The 726-foot-high Hoover Dam on the lower Colorado River was at the time the largest structure ever built and helped to pull the United States out of the Great Depression. The giant wall of concrete stood as a visible symbol of a new era, giving Americans hope for a brighter future. In the decades following the dam's completion, an increasing number of giant canals fed by other giant dams transformed Powell's "arid region" into a palm tree-studded oasis. Desert cities exploded, and irrigated industrial agribusiness took the place of the yeoman farmer whose descendants had moved to the air-conditioned suburbs. In post–World War II America, you could almost measure progress by the number of buckets of concrete poured into dams and canals.

Cinderella Story: David Brower Takes on the Empire Builders

The legal groundwork for the West's dam-building binge was laid in 1922 with the historic signing of a compact between Colorado River basin states. As California politicians pushed the federal government to build Hoover Dam, the six other states in the basin worried they would lose their development prospects if California claimed their water rights. Western water law dictates that whoever uses the water first can claim rights to it, even if it's being pumped from hundreds of miles away. The compact negotiated, called the Law of the River, divided Colorado River water evenly between the upper basin (Wyoming, Colorado, New Mexico, Utah) and the lower basin (Arizona, Nevada, California). The average annual flow of the Colorado was determined to be 15 million acre feet; the upper basin got 7.5 and the lower got 7.5. The dividing line between the two basins was arbitrarily drawn at Lees Ferry, Arizona, just above the Grand Canyon. But since the upper basin was largely

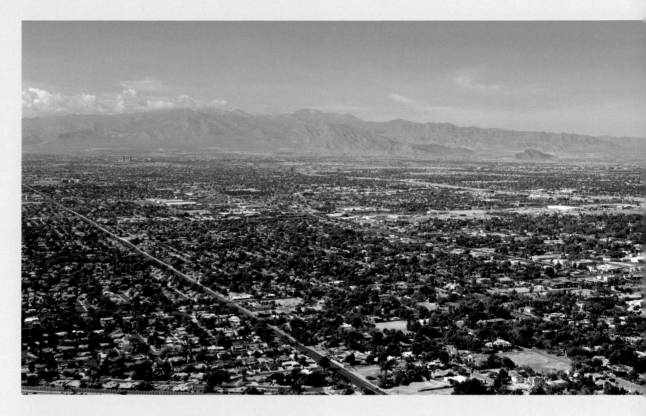

unpopulated and had no reservoirs, most of their share of the river just flowed right into Lake Mead, where it was gobbled up by the fast-growing lower basin.

Ever since Hoover Dam's completion, congressional delegations from upper-basin states had been complaining it was their turn to get big water storage and irrigation projects to spur growth in the sparsely populated Intermountain West. The problem for the federal government was that the projects were becoming prohibitively expensive and there was little chance that farming operations or municipalities using the water would ever pay back the cost.

The Bureau of Reclamation's proposed solution came in 1946 with the introduction of the Colorado River Storage Act and accompanying report titled *The Colorado: A Natural Menace Becomes a National Resource.*

Home to nearly two million people and one of the fastest growing suburbs in the United States, the Las Vegas metropolitan area relies almost completely on Colorado River water from Lake Mead. Photo by Bruce W. Bean. October 2006.

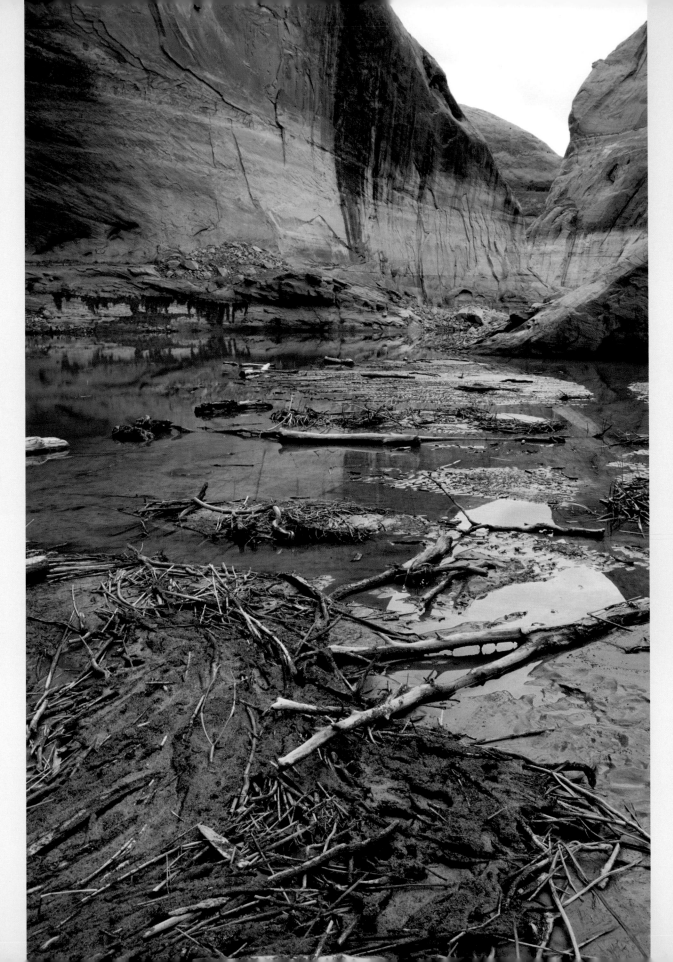

Flood debris and deep layers of muddy sediment clog the "dead zone" and mingle with the stagnant waters of Lake Powell in Willow Gulch, Escalante Canyon. October 2007.

Here the concept of building a series of "cash-register dams" was introduced, the idea being to generate revenue for more dams and irrigation projects through the sale of hydropower. Engineers put bull's-eyes on remote sections of the Colorado River that hadn't been practical locations for irrigation or municipal water development, but that were ideal for hydropower dams because of high flows and sheer, narrow canyons.

The first two targets for these tall dams that would create giant reservoirs in the middle of nowhere were Echo Park in Dinosaur National Monument on the Colorado-Utah border and Glen Canyon, which held no special designation under the U.S. Bureau of Land Management and was so remote that the closest paved road was 100 miles away. Glen Canyon Dam would be located just above Lees Ferry, the dividing line between the upper and lower basins where a station is located that, in accordance with the 1922 compact, measures how much water the upper basin is sending downstream. The proposal would finally enable the upper basin to send only the required amount of water to the lower basin and to bank its extra water behind Glen Canyon Dam rather than give it away to booming California. Increasingly powerful congressional representatives from upper-basin states liked the cash-register idea; they smelled pork. The Bureau of Reclamation saw dollar signs.

David Brower saw something else: a federally funded campaign to destroy national treasures. As the Sierra Club's first paid director, Brower mobilized the growing environmental organization to fight for Echo Park—his favorite place in the Colorado River basin. Brower was an accomplished writer and photographer and sought to generate nationwide public awareness by using every medium available at the time. He produced a homemade movie showing Echo Park's spectacular scenery and river recreation. The film was shown hundreds of times across the country. He recruited longtime Sierra Club member Wallace Stegner, who had just written *Beyond the Hundredth Meridian* about John Wesley Powell and the American West, to edit a large-format picture book about the monument. The book, *This Is Dinosaur: Echo Park Country and Its Magic Rivers,* was the first of its kind, mixing environmental advocacy with large, high-quality photographs to create a relationship between readers and the remote places described. Brower distributed a copy of the book to every member of Congress.

Brower also authored magazine and newspaper articles about Echo Park that inspired a citizen letter-writing campaign. Of the thousands of letters received by the Bureau of Reclamation, opinions ran 80 to 1 against the

Once 90 feet below the surface of Lake Powell, the small stream in Willow Gulch has carved its way down through 30 feet of accumulated sediment. October 2007.

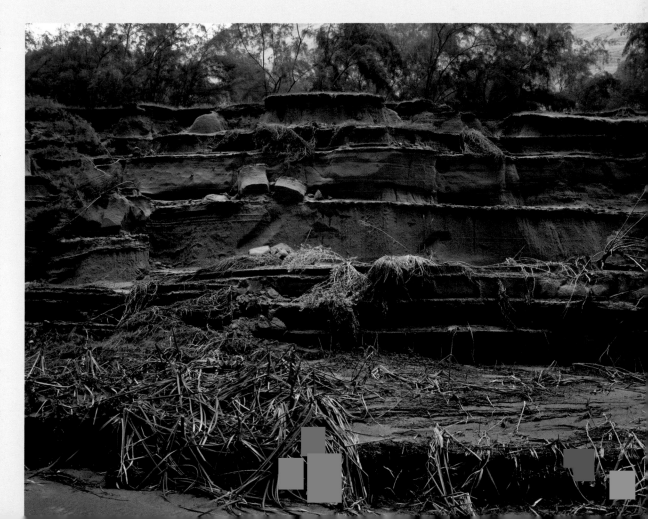

dam. During highly publicized congressional hearings, Brower pointed out a major mathematical error made by the Bureau in calculating evaporation rates, which embarrassed the agency and elevated the environmentalists' position to the point that the Echo Park project was becoming a political liability for anyone who supported it. In 1956, Congress passed the Colorado River Storage Act without the Dinosaur National Monument dam in it, a major victory for environmental activism and the first major defeat for the almighty Bureau. Construction of the 710-foot-high Glen Canyon dam also began that year, sailing quietly under the radar of public attention.

THE "DEATH" OF GLEN CANYON AND BIRTH OF ENVIRONMENTALISM

In the compromise for Echo Park that Brower struck with western politicians and the Bureau of Reclamation, he agreed not to fight the Glen Canyon Dam, slated for a place he had never visited. He even supported making Glen Canyon Dam taller to compensate for water not stored in an Echo Park reservoir. When he did finally float through the doomed section of the Colorado River as the dam was nearing completion, he realized his terrible mistake, and it would become his biggest regret in life. The deal was done; it was too late.

Brower nevertheless used the loss of Glen Canyon to heighten public awareness about the threats that dams posed to wildlands. In 1963, as Lake Powell began to fill, the Sierra Club published *The Place No One Knew,* with spectacular photographs by Eliot Porter and inspiring text from the likes of Henry David Thoreau, Albert Einstein, and Wallace Stegner. The landscape pictured was unlike anything most Americans had ever seen— tight slickrock slot canyons rippling with yellow light, massive amphitheaters, vibrantly green hanging gardens

clinging to orange sandstone, delicate seeps, ancient petroglyphs carved into varnished walls. And with every picture was the constant reminder that it was all in the process of being destroyed.

On the back cover of the book was a pledge written by Brower called "The Idea." It stated: "We shall seek a renewed stirring of love for the earth, we shall urge that what man is capable of doing to the earth is not always what he ought to do, and we shall plead that all Americans, here, now, determine that a wide, spacious, untrammeled freedom shall remain in the midst of the American earth as living testimony that this generation, our own, had love for the next." Perhaps rivaled only by Rachel Carson's *Silent Spring,* published the year before in 1962, for its ability to capture the imagination and the collective conscience of the nation, *The Place No One Knew* filled Americans with guilt and a new level of environmental awareness.

Ken Sleight, who had fallen in love with Glen Canyon in the 1950s and had started a river-running business there, knew the place quite well. What he didn't know was how to fight a powerful federal agency. "We formed a group called Friends of Glen Canyon, but we had no idea what to do next," he says of his efforts that basically involved some futile picketing in the construction boomtown of Page, Arizona. Ironically, after *The Place No One Knew* was published, thousands of people wanted to float through Glen Canyon before it was gone. Sleight's river-running business was booming, but his heart was breaking.

The alcoves, the grottoes, the hanging gardens, the ancient Indian ruins, even the natural arches—all were slowly swallowed by Lake Powell. As the lake was filling, Sleight would stick his hand in the water and press it against the canyon walls to try and say goodbye. In Music

OPPOSITE *Morning sun illuminates the cliffs above drying mud at the foot of Lake Powell's abandoned Hite Marina boat ramp. The reservoir's white "bathtub ring" is visible along the base of the reflected cliff. When the reservoir was last full in 1999, this location was 95 feet below its surface.* October 2007.

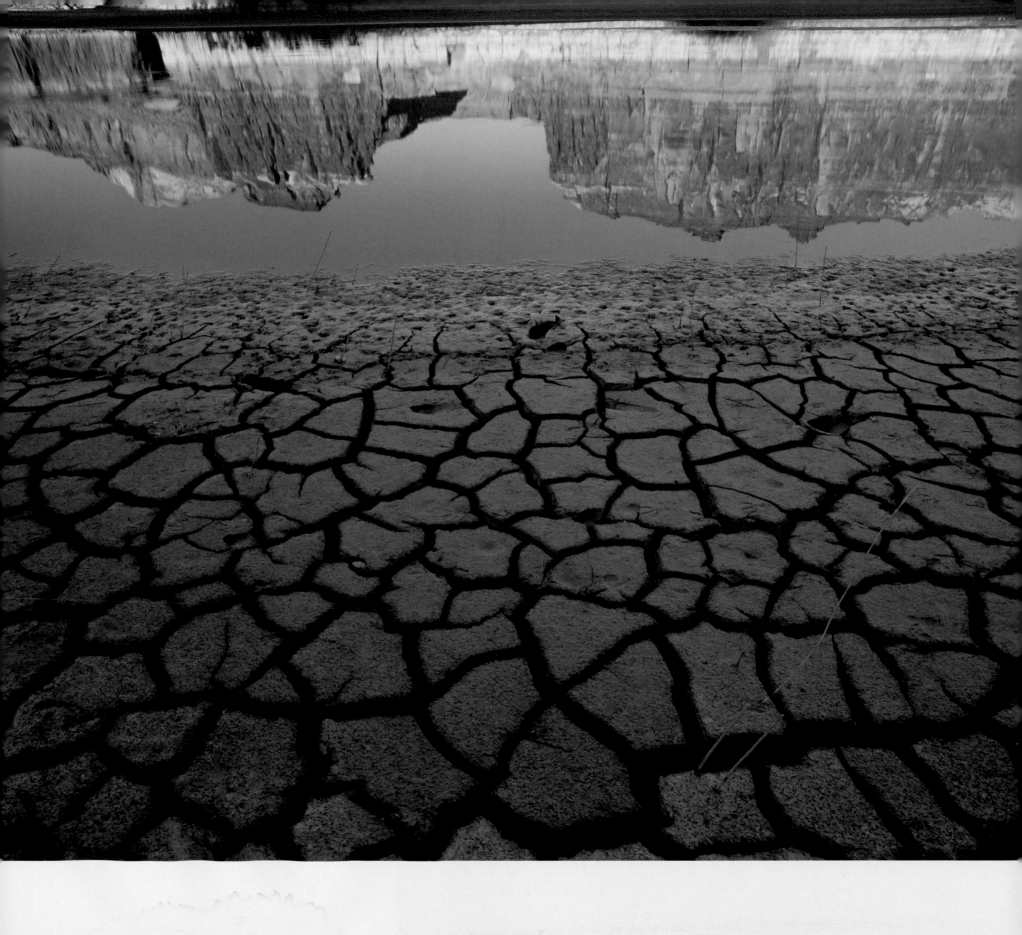

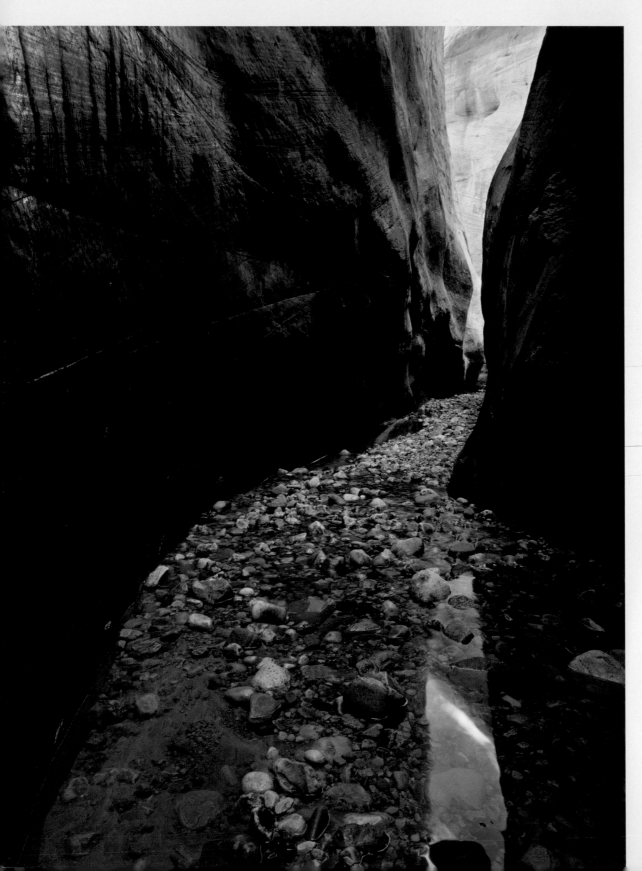

Temple, he recalls reaching over his boat and feeling for the last time the inscription carved by John Wesley Powell in 1869. "This was the most beautiful place in the world, and it was flooded over, desecrated just for money," says Sleight. "I have never been able to get over it. A murder happened and I saw it with my own eyes. It was the worst thing in my life."

After witnessing the drowning of his beloved Glen Canyon, Sleight moved to Canada—but he couldn't stand the mosquitoes. Soon he was back in the desert running trips through the Grand Canyon. It was there in 1970 that he met Edward Abbey, and the two men established a lifelong friendship. They were united, especially by their mutual hatred for Glen Canyon Dam. Consuming many beers over many campfires, they plotted how to create "Dominy Falls"—the giant pile of rubble that would be left by a destroyed dam, named in honor of then Bureau of Reclamation commissioner Floyd Dominy.

The fantasies became literary fodder for Abbey, who used Sleight as the basis for the character Seldom Seen Smith in his 1974 novel, *The Monkey Wrench Gang.* The plot of the fictitious story revolved around dynamiting Glen Canyon Dam and further heightened the dam as a symbol of environmental destruction. Picking up where Brower's polite environmental rhetoric left off, Abbey was angry and rebellious and used the loss of Glen Canyon as a recurring theme in his writing, which inspired legions of environmental activists in the 1970s and 1980s.

THE ERA OF DAM BUILDING ENDS, THE AGE OF SPRAWL BEGINS

Despite widespread public attention to the loss of Glen Canyon in 1963, the Bureau of Reclamation moved forward that same year with plans for two cash-register dams flanking Grand Canyon National Park. One

would be in Marble Canyon, just below Glen Canyon Dam. The other, at Bridge Canyon on the far western end of the Grand Canyon, would flood Havasu Falls, a sacred site of the Havasupai tribe.

The purpose of the two dams was to generate electricity for the proposed $3.5 billion Central Arizona Project (CAP), viewed by Arizona's congressional delegation as the ticket to achieving California-like economic growth because it would supply massive amounts of water to Phoenix and Tucson. And it would enable Arizona to use all of its Colorado River allotment instead of accidentally giving it away to California. The problem was that the CAP water needed to be pumped from Lake Havasu along a 330-mile canal and 1,000 feet uphill, requiring an ongoing and plentiful supply of cheap electricity. The only solution, the Bureau maintained, was the Grand Canyon dams.

Brower and the Sierra Club, along with other environmental organizations, quickly mobilized against the proposal. *The Place No One Knew* was widely distributed to Congress and the public, as was a new Sierra Club large-format photo book about the Grand Canyon. The Bureau was expecting a fight and during congressional hearings offered these defenses: the two reservoirs would not be visible to visitors standing on the rim in Grand Canyon National Park; touring the new reservoirs by motor boat would make the intimidating terrain of the Grand Canyon more accessible and enjoyable to the public; the reservoirs would only encroach a small amount into the existing boundaries of the national park; and, without the dams, there would be no CAP and Arizona citizens would be denied their big chance for economic development.

The Bureau's strategy backfired, indicating that the agency—and perhaps the entire federal government—

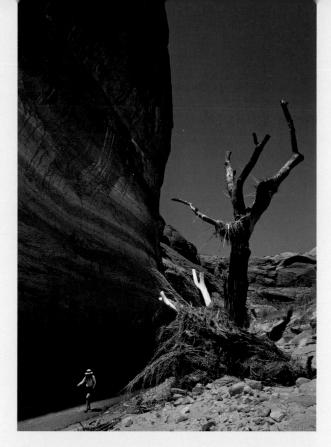

Hiking past the exposed skeleton of a cottonwood tree in West Canyon, previously drowned by the rising waters of Lake Powell. May 2005.

OPPOSITE *Recently scoured-out narrows in Secret Canyon, once 130 feet below the surface of Lake Powell.* April 2005.

was out of touch with the American people. The Sierra Club ran a series of full-page ads in the *New York Times* and other major newspapers protesting the official justification for the Grand Canyon dams. "Should we flood the Sistine Chapel to get closer to the ceiling?" asked one of the ads. The federal government responded by sending the Internal Revenue Service after the Sierra Club, revoking the organization's tax-exempt status, which only helped rally more public support against the dams and tripled the club's membership from 39,000 in 1966 to 135,000 in 1971. The public outrage over the Grand Canyon dams led Congress to kill the proposal in 1967, instead approving the CAP with pumping power provided by the coal-fired Navajo Generating Station near Page, Arizona.

Everyone from President Lyndon Johnson to Bureau of Reclamation commissioner Floyd Dominy to Arizona's congressional delegation blamed the failure of the Grand Canyon dams on "Brower's lies," noted

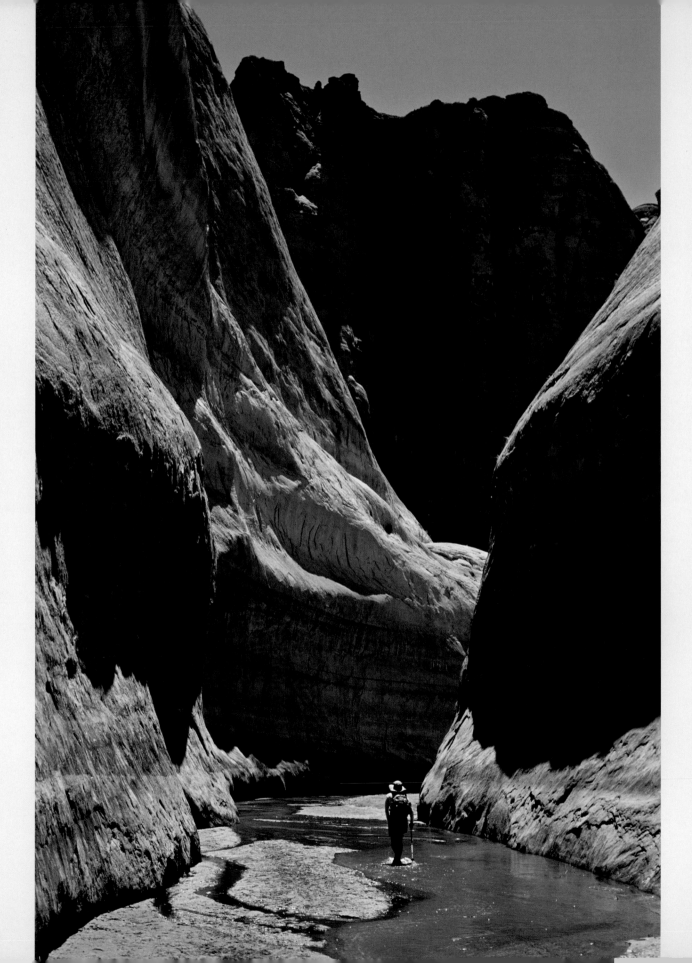

Recently exposed narrows in West Canyon, where another 10 feet of sediment would need to be washed away to reveal the prereservoir streambed. The high-water mark of Lake Powell rises 100 feet above the hiker. May 2005.

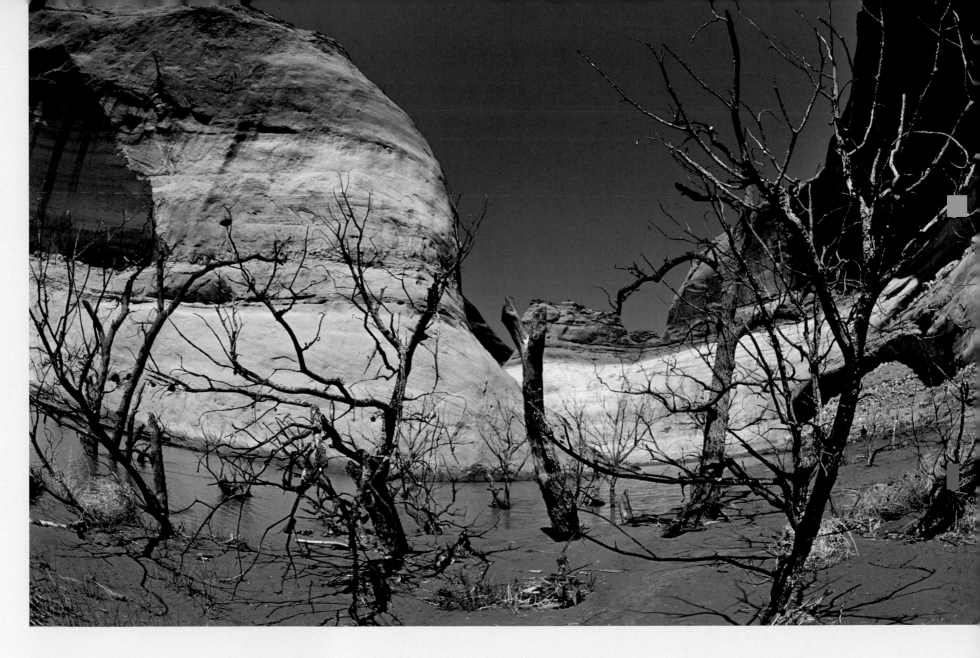

Marc Reisner in *Cadillac Desert*. "They believed that the fate of the dams hinged on a technicality," wrote Reisner. "They couldn't fathom that a sea change in public feeling toward the natural world was taking place, one of those epochal shifts that guarantee that things will never be the same. But it was, and people didn't care whether the dams…drowned a mile or a hundred miles of canyon, or whether they submerged the bottom fifty feet or the entire chasm. They wanted no dams—period."

Within ten years of Glen Canyon Dam's floodgates closing, the nation's landmark environmental laws were passed, including the Wilderness Act, Clean Air Act, Clean Water Act, National Environmental Policy Act, Endangered Species Act, and the Wild and Scenic Rivers Act. A provision was also included in the Colorado River Storage Act that no man-made reservoir could encroach on a national park or monument. The latter served as an assurance that as Lake Powell filled it would not flood Rainbow Bridge National Monument, the world's largest natural bridge and a sacred site of the Navajo Nation.

Skeletons of cottonwood trees along Davis Gulch, which were drowned by the rising waters of Lake Powell, reemerge from the turbid water.
April 2005.

A 30-foot-deep layer of reservoir sediment clings to the wall at upper right along the streambed of Davis Gulch, Escalante Canyon. When Lake Powell was last full in 1999, this streambed was 90 feet below the surface of the reservoir. October 2007.

Even though these laws were passed by popular demand, the federal government—especially congressional representatives from the western states—remained entrenched in a philosophy of expansionism that favored economic development over environmental protection. Glen Canyon Dam was—and continues to be—described by policy makers with glowing boosterism, as if the structure itself rather than the landscape it inundated was a national heritage site. In 1965, at the dedication of Glen Canyon Dam, First Lady Ladybird Johnson proclaimed: "As I look around at this incredibly beautiful and creative work, it occurs to me that this is a new kind of writing on the wall. A kind that says proudly and beautifully, 'man was here.'"

Four decades later, the prodevelopment rhetoric of policy makers remains the same. On October 19, 2006, sixty dignitaries gathered atop Glen Canyon Dam—overlooking a half-empty reservoir—to celebrate the fifty-year anniversary of the authorization of the dam and the Colorado River Storage Act. "[Glen Canyon Dam] was an engineering marvel," enthused Utah lieutenant governor Gary Herbert. "From a Utah perspective, we are an arid state...We know the challenge from our pioneer heritage that dictated [the Bureau of Reclamation] make the desert bloom like a rose. Their vision literally made it blossom."

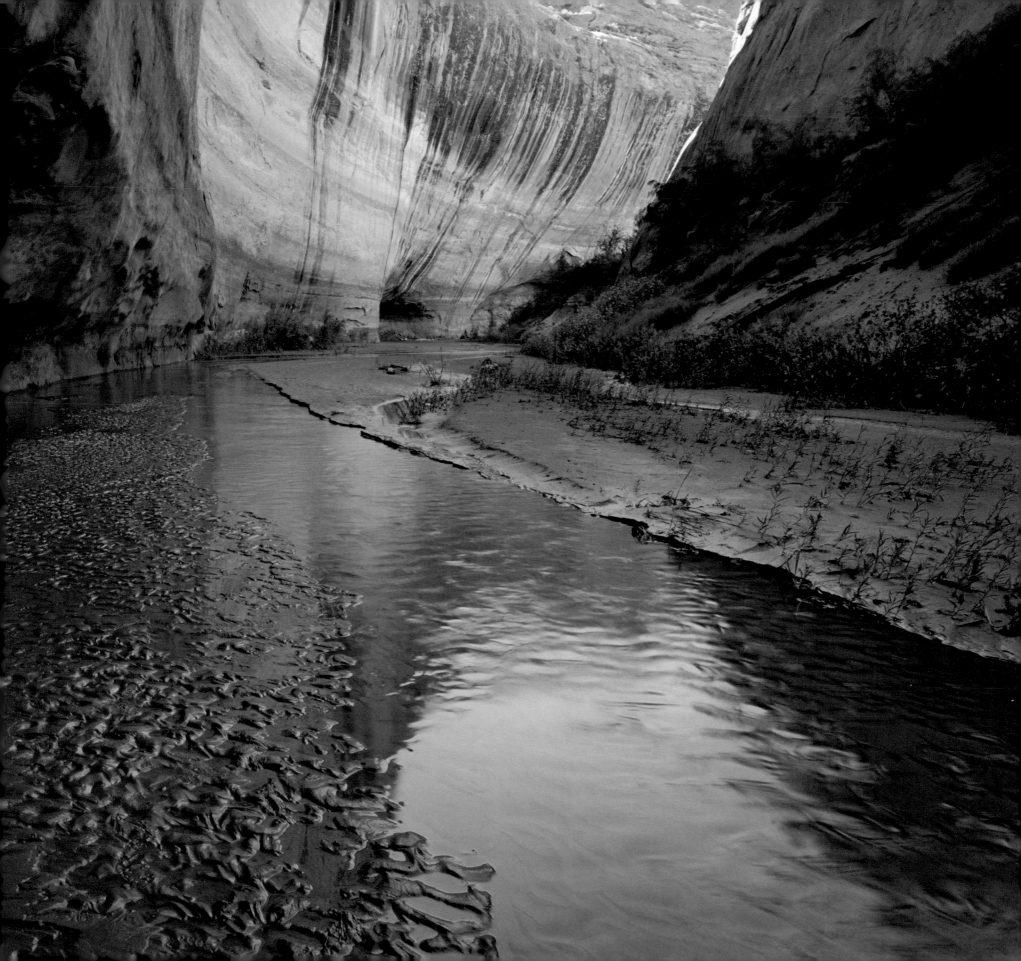

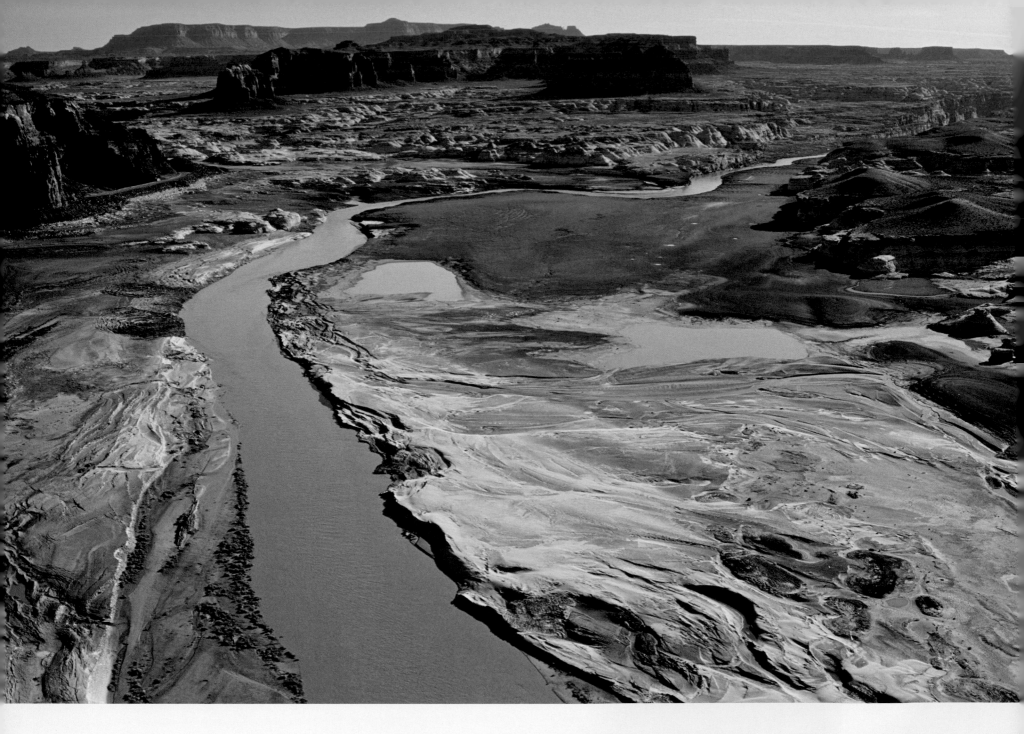

Upstream view of the free-flowing Colorado River from Hite Overlook. When this image was taken, the waters of Lake Powell had receded downriver for the first time in nearly forty years due to several years of drought. The Colorado River flows across the top of a 130-foot-deep layer of sediment that now fills this valley. April 2003.

OPPOSITE *Compared to the same view captured in April 2003, dramatic changes have occurred alongside the Colorado River as seen from Hite Overlook. October 2007.*

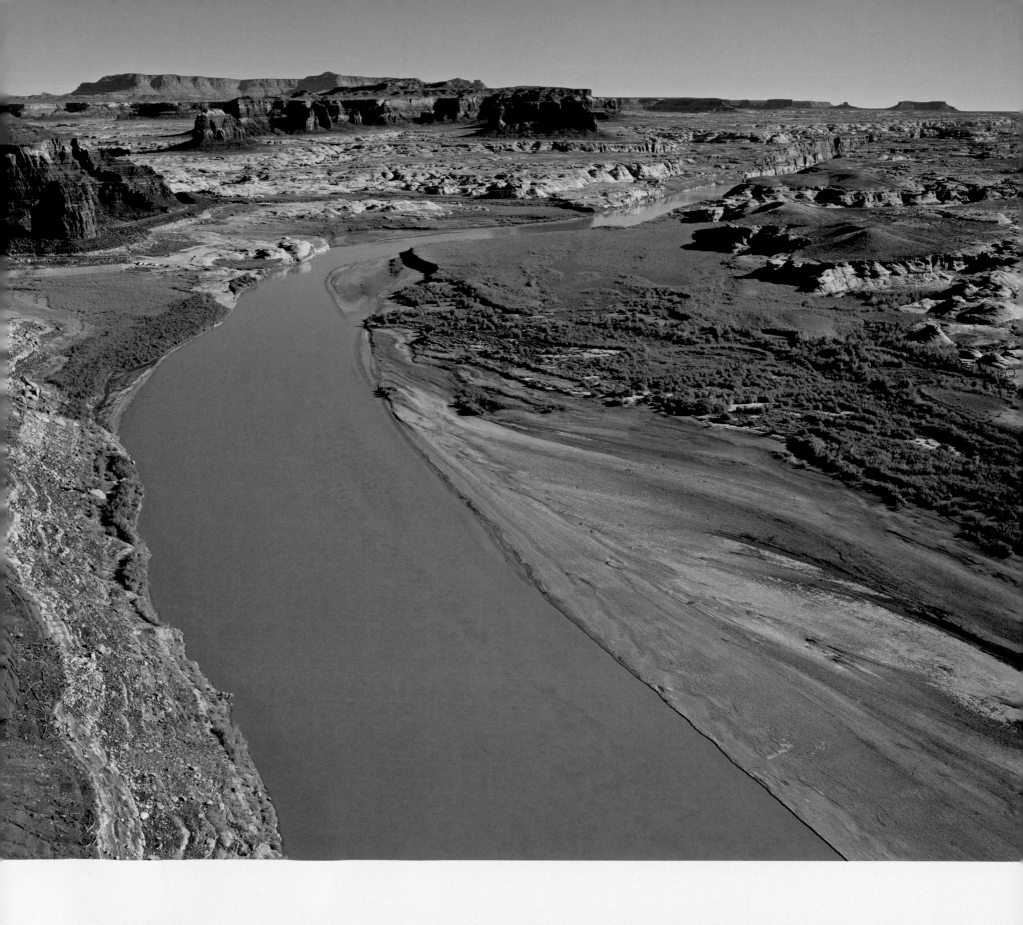

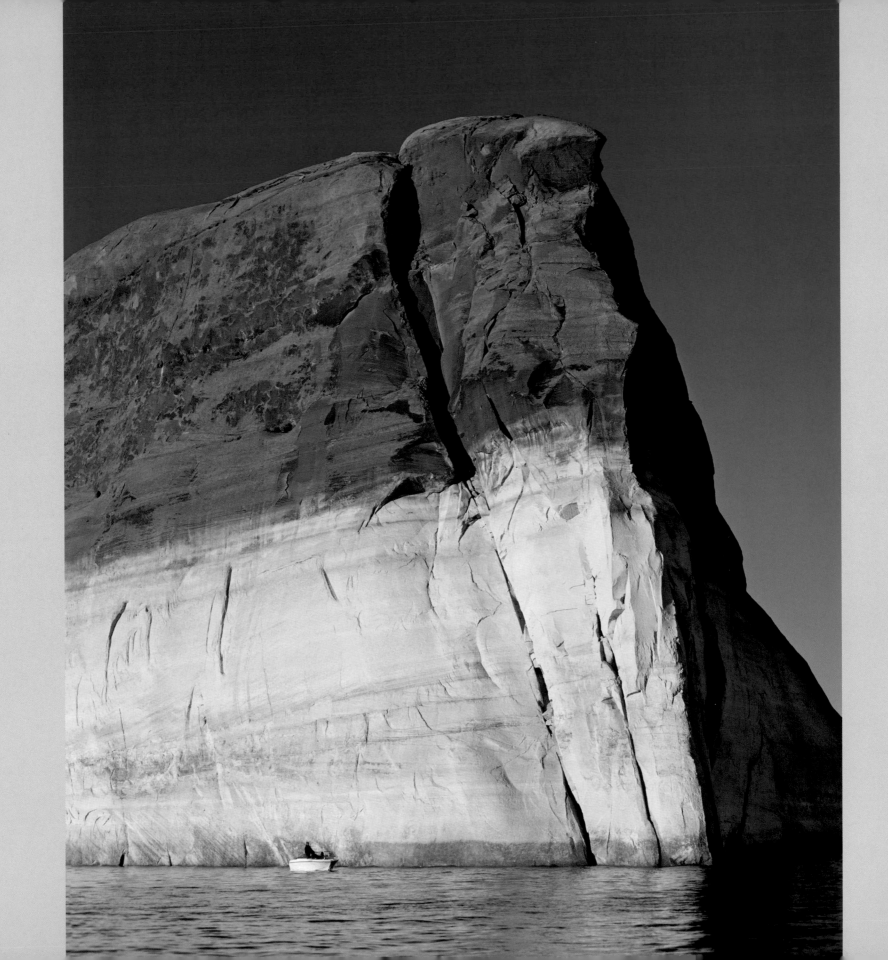

[CHAPTER THREE]

A DIFFERENT BRAND OF FUN

AUGUST 2003—I'M SITTING WITH MY SIX-YEAR-OLD SON Austin on the end of a dock at Wahweap Marina. We're watching the boats come in as an afternoon storm threatens. Blue-black clouds shaped like pirate ships sail across an angry gray sky. The silvery waters of Lake Powell churn in the wind. Waves with whitecaps flip-flop across the bay and splash against the piers below us, filling my nostrils with the pungent smell of lake water. This giant inland sea, with its orange and red sandstone islands jutting from an ocean that mocks the surrounding desert landscape, is uncannily striking.

"Awesome!" exclaims Austin, impressed by a speedboat decorated with metallic blue flames that has pulled up to the dock. Above the flames in a fancy cursive script is the boat's name: "Suck My Wake." Three sunburned, intoxicated men with a garbage bag full of cans stumble out.

Fortunately, Austin quickly turns his attention to the other side of the dock where a houseboat is getting ready to embark. Kindly grandparents smile at us as their two adult sons rush around the deck undoing the moorings. Don and Sharon Peckham, who live in Colorado, have all seven of their children and grandchildren, who live in California, on board; spouses and girlfriends bring the party up to fourteen.

Vivid 98-foot-tall white "bathtub ring" above the waters of Lake Powell at the mouth of Lake Canyon. May 2003.

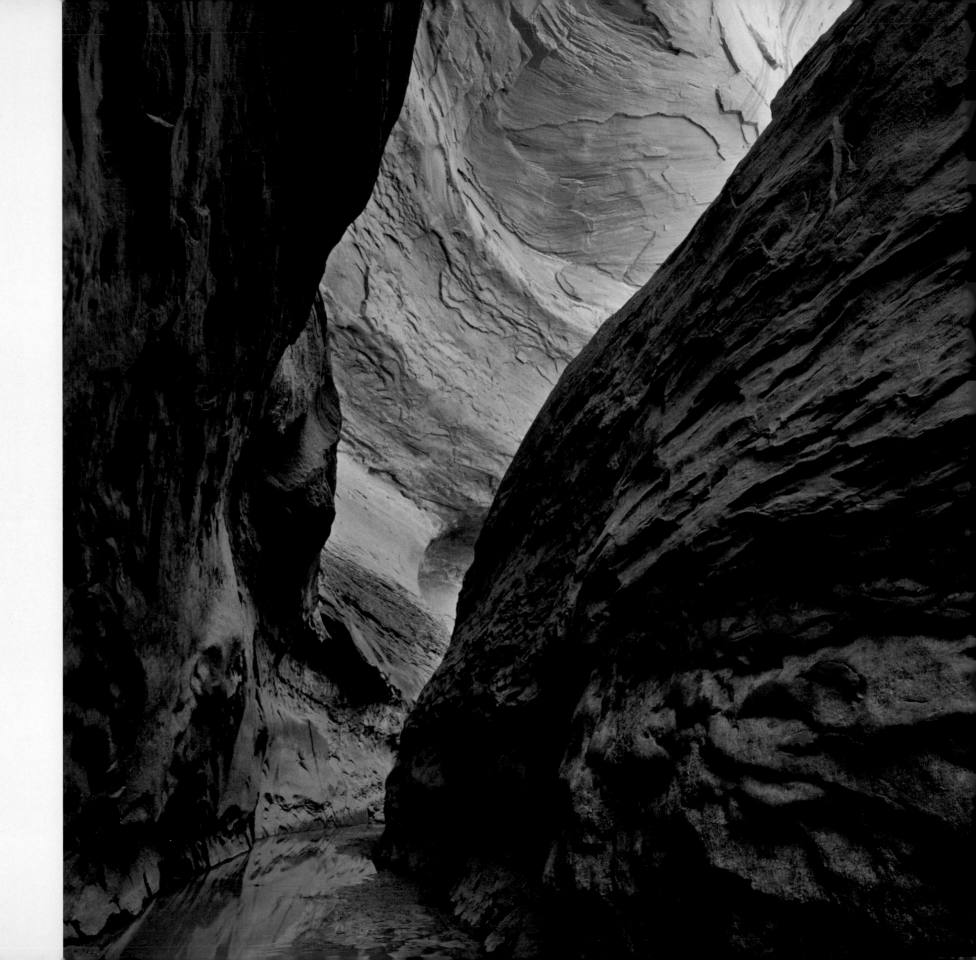

"We come to the lake for one week every summer," says Sharon. "It's the only time when the whole family is together." The Peckhams first visited Lake Powell in 1974. They started the family reunion tradition ten years ago when they used part of their retirement money to buy a time-share in a houseboat—money well spent from a grandparents' perspective. "The kids love it," says Sharon. "They can fish and ski." She beams as her sons push the boat away from the dock for a week of uninterrupted family time. "And we get a family picture," adds her husband, his voice drowned out by the humming boat engines. The family waves as the 36-foot-long craft putters out into the choppy waters of Wahweap Bay.

When Glen Canyon Dam was officially christened in 1965 and Lake Powell declared open to the public, the idea of motorized recreation on a giant man-made lake was a foreign concept to most Americans. In post–World War II America, Boy Scouts went backpacking, hunters went camping, and families went on road trips to national parks in their Rambler station wagons. But zipping around on water skis in a remote desert? That was a new one.

To get Americans warmed up to this new form of recreation, Floyd Dominy took a page from David Brower's playbook. In 1965, the Bureau of Reclamation produced a film (scripted by Dominy) and an accompanying book, both titled *Lake Powell: Jewel of the Colorado*, that promoted the federal government's vision.

"Sired by the muddy Colorado in magnificent canyon country, a great blue lake has been born in the West," wrote Dominy. "Do you like fun sports? Yes. This is sun country. Water skiing, swimming, scuba diving—

Once 50 feet below the surface of Lake Powell, Fiftymile Creek is now restored to prereservoir conditions. October 2007.

all in clean blue water that looks like deep blue sky…If you're tired in mind and soul, in need of restful serenity, I don't know of a better place." To encourage people to visit Lake Powell, the Bureau built five marinas, along with boat ramps, stores, and campgrounds. The lake was stocked with the standard variety of sport fish, and native species were soon extirpated.

Glen Canyon became one of twenty-one national recreation areas established by Congress in 1972. Although the Bureau of Reclamation would continue to manage the dam, the National Park Service would manage the 1.2-million-acre Glen Canyon National Recreation Area (NRA). The Park Service directive for managing Glen Canyon, as with all national recreation areas, was (and still is) to accommodate and promote fun in the form of boating, camping, fishing, and water sports on the country's new reservoirs. Waterskiing on man-made lakes in the desert was just one of many new technology-driven pleasures realized by an increasingly prosperous nation.

"Recreation wasn't the primary purpose of the dam," said Dominy in a 2003 interview published in *Backpacker* in April 2004, "but I've argued since that the recreational benefits alone justify building it."

In 1973, the number of visitors to Glen Canyon NRA climbed above 1 million. By the late 1980s, more than 3 million visitors a year were zipping around on the vast turquoise waters of Lake Powell. And in 1992, the national recreation area received a record 3.5 million visitors, nearly as many as Grand Canyon National Park.

The popularity of Lake Powell in the 1980s and 1990s created an economic boom in what used to be the poorest corner of the Southwest. "There was nothing here. It was godforsaken country," recalled Joan Nevills-Stavely in the April 2004 issue of *Backpacker*.

She grew up on the banks of the Colorado, and her father, Norm Nevills, supported his family by running river trips through Glen Canyon in the late 1940s and early 1950s. He and his wife died in a plane crash in 1955 before the dam had become a reality. "I took over Daddy's business, so when I first heard they were going to dam Glen Canyon I was totally against it. We made our living on the river," said Nevills-Stavely. "But we had to adapt to survive."

Nevills-Stavely, who went on to work for the Page Chamber of Commerce for twenty-eight years, likens the loss of Glen Canyon to the death of a family member. She has gone through the various stages of grief over many years and has moved on. "I'm glad the lake happened. I feel good about it now," she said. "Lake Powell is a beautiful sight, but it is also a great business opportunity for this part of the country—especially for the Navajo. Before the dam all they had was sheep herding."

FAMILY FUN ON AMERICA'S FAVORITE FAKE LAKE

Founded in 1956 to house dam construction workers and their families, Page, Arizona, now has about seven thousand residents. Luxury hotels, golf courses, fast-food restaurants, gas stations, grocery stores, and even a Super Wal-Mart line the manicured streets. According to a study by Michigan State University economics professor Daniel Stynes, the 2.3 million visitors to Glen Canyon NRA in 2001 spent $132 million that supported 3,200 local jobs. Stynes found the economic development engine of Lake Powell to be comparable to that of Grand Canyon National Park, which supported 3,800 jobs in 2001 but with 4 million visitors—nearly double that of Lake Powell.

In this respect, you could still call Glen Canyon

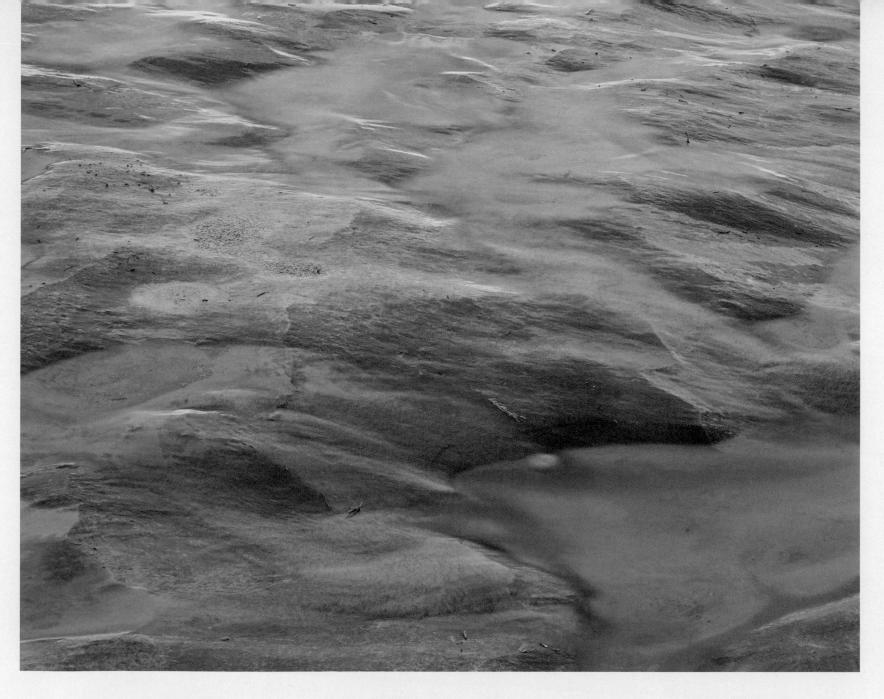

A brightly sunlit canyon wall reflects in water flowing along Fiftymile Creek's sculpted streambed of Navajo sandstone. Now restored to its pre-reservoir condition, this streambed was once submerged beneath Lake Powell and 15 feet of sediment. October 2007.

Smith Fork flows into the stagnant waters of Lake Powell (center right), with the water level of the reservoir 102 feet below its full-pool elevation. The reservoir's white "bathtub ring" can be seen high on the wall at center left and on the wall at right. October 2007.

OPPOSITE *A large concrete anchor for a boat dock rests on the bottom of Lake Powell's dry bed, at the foot of the abandoned Hite Marina boat ramp.* October 2007.

a cash-register dam. Motorized recreation on the reservoir has been a huge moneymaker, especially for Glen Canyon NRA's concessionaire Aramark, which manages all marinas, boat rentals, stores, gas stations, lodging, and tours at Lake Powell. Aramark is a Fortune 500 company with multimillion dollar annual profits. It operates concessions at many national parks and other recreation destinations across the country. The company's registered trademark for Lake Powell is "America's Natural Playground."

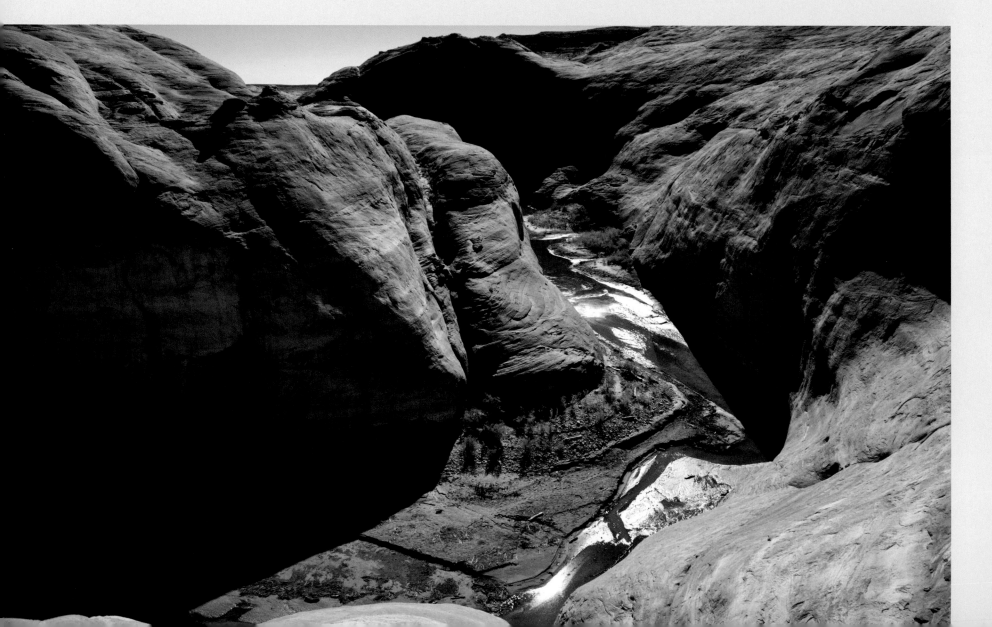

An article in the July 1998 issue of *Family Fun* magazine enthused that Lake Powell is "made to order" for houseboating and family vacations. "In 1963, when Glen Canyon was flooded to create Lake Powell, one magical landscape was lost but another was created: a water-lover's playground that now draws fun-seekers by the thousands," wrote Gregory Lauzon, who added that "houseboating has grown up with Lake Powell—and with the burgeoning family vacation industry." In the mid-1970s, he noted, there were fewer than a dozen houseboats on the reservoir, but in the summer of 1998 there were four hundred. "On today's houseboats, families can get away from it all without, well, getting away from it all," he continued—pretty much summing up the thrust of Aramark's marketing strategy for Lake Powell.

Proponents of Lake Powell insist that the dam has "improved" upon nature and that the reservoir offers a better recreational experience than pre-dam Glen Canyon. "The Glen Canyon area and its one hundred or more side canyons do not need to be restored because they were never lost or destroyed by the waters of Lake Powell," Page resident Stan Jones (aka Mister Lake Powell) told Congress during hearings in 1997. "Every canyon is still there and in its full splendor. Yes, there may be 100 or 200 feet of water on their floors, but the water actually enhances these canyons. Now they have a reflective base and are completely accessible. The water access into Glen Canyon can make the trip short, full of additional splendor and very calming. In a week or two of concerted boating effort, a person could see nearly all hundred of these canyons. Without the water access, I doubt you could see them all in a lifetime."

There's no denying that, unlike the old Glen Canyon that was generally inaccessible to the very young, the elderly, and otherwise physically challenged,

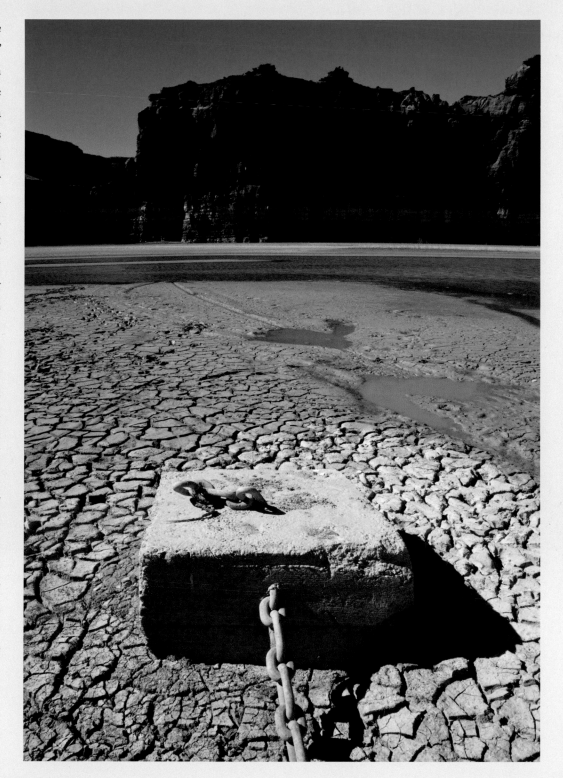

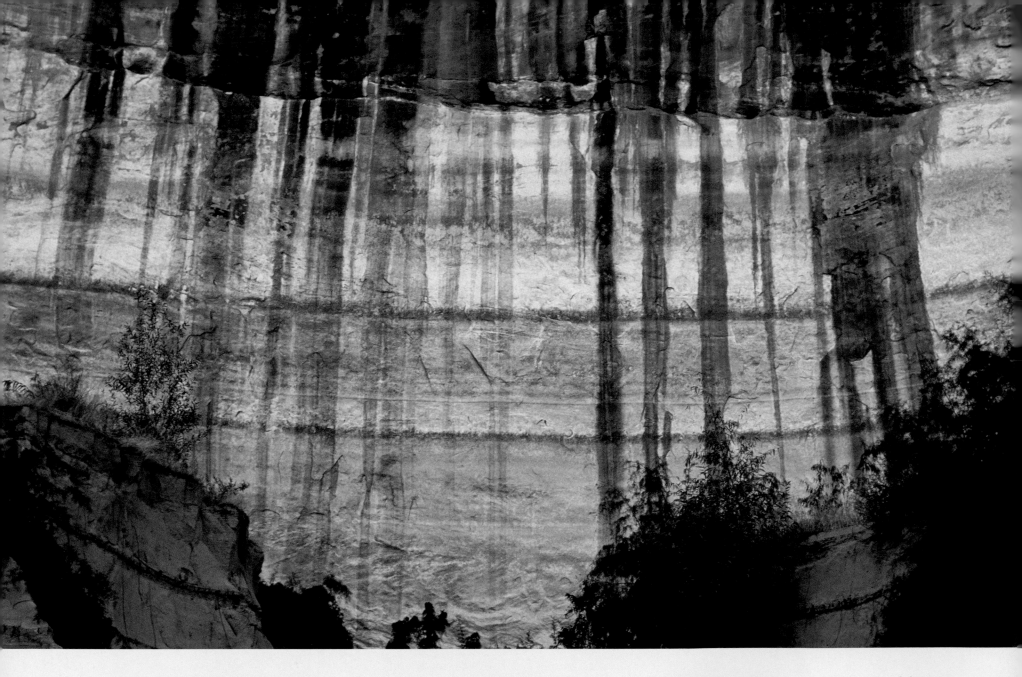

A 75-foot-tall white "bathtub ring" stains the bottom of this cliff along Lake Canyon. Dripping water from above, laden with red hematite and other minerals, is quickly recoating the white mineral deposits with a more usual red patina. Crumbling sediment banks laid down when Lake Powell flooded this canyon are at the bottom left and right of the image. April 2006.

OPPOSITE *The musician Paul Winter plays his soprano saxophone in Clear Creek Canyon, just upstream of Cathedral in the Desert, during an intimate one-man concert to celebrate the reemergence of this renowned sandstone chamber for the first time since it was first flooded by Lake Powell in the late 1960s.* May 2003.

everybody can go boating on Lake Powell—if they can afford it. A time-share in a standard houseboat starts at around $20,000 a year. Owning the houseboat outright, or any kind of motor boat big enough to negotiate the wind-whipped waters of Lake Powell, is a major investment that includes paying for boat storage, maintenance, and a vehicle that can haul it. Renting a houseboat for three days costs around several thousand dollars; a motorboat is $330 a day. Then there's the cost of gas—which

in July 2008 was more than $5.00 a gallon at Aramark marinas. And that can add up to $1,200 per week, since motorboats only get about 3 miles to the gallon and houseboats get even less.

POWELL'S ECONOMIC PROMISE DECREASES WITH LAKE LEVEL

Compared to Lake Powell's recreation heyday in the 1980s and 1990s, it seems the Jewel of the Colorado is losing its luster. Drought-driven reduction of the lake by more than 100 feet, the closure of two out of five marinas in 2003 and 2004, and high gas prices have all steered tourists away. Since 2001, Page-area business—including hotel stays—has dropped by 40 percent. Visits to Glen Canyon NRA have plummeted from a high of 3.5 million in 1992 to 1.8 million in 2006.

Meanwhile, visitation at nearby national parks has climbed slightly during the same time period. In 1992, Grand Canyon National Park saw 4.2 million visitors, and 4.4 million in 2006. Zion National Park had 2.3 million visitors in 1992 and 2.5 million in 2006.

According to Park Service analyst Butch Street, who manages the agency's Public Use Statistics Office in Denver, there are "many different factors" behind the visitation decline in Glen Canyon NRA compared to nearby parks, but he believes the economy is one of the main reasons. "The person going to Lake Powell is an entirely different user from the person going to Grand Canyon and Zion," he says. "Glen Canyon NRA has traditionally attracted visitors who like to spend their disposable income on expensive toys like Jet Skis. Higher gas prices and less disposable income makes visitation go down, plus there's a negative perception about boating conditions because of the drought." These factors may also partially explain why visits to Lake Mead National

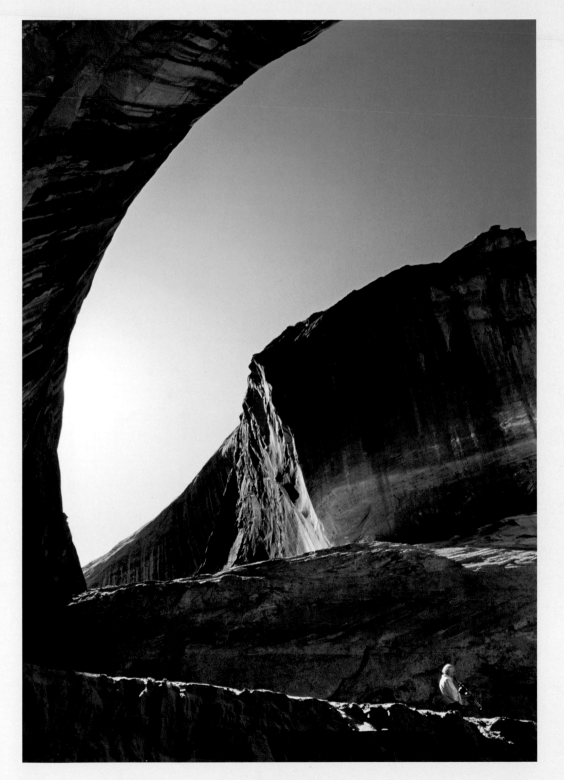

Recreation Area have dropped as well, from 9 million in 1992 to 7.7 million in 2006.

In addition to economic factors, visitation to Lakes Powell and Mead may also be down because of America's changing tastes in recreation. While public-lands hiking and camping has grown in the last decade, motorized boating has dropped significantly. Boat registrations in western states have also decreased in recent years. Glen Canyon Institute's Richard Ingebretsen points to the stable visitation rates at nearby Grand Canyon and Zion National Parks as reason for converting Glen Canyon to a national park. He says recent trends prove that tourists today are more interested in visiting the Southwest's crown jewels than in houseboating on a reservoir.

In fact, the pall cast on Lake Powell's recreation potential is an opportunity that environmental groups such as Living Rivers and the Glen Canyon Institute

who have steadily questioned the reservoir's very existence. From a windowless office next to the pizza place at Wahweap Marina, Steve Ward hammers out press releases countering claims from "drain it" advocates that land on his desk like Molotov cocktails. Ward is Aramark's public relations director for the company's Lake Powell enterprise. But he is no PR desk jockey from Phoenix or Los Angeles. He grew up in Page in the 1950s and 1960s and watched the town transform from a bunch of trailers to lakefront condos and resorts. He also saw Glen Canyon disappear. "Glen Canyon was all about beauty and solitude and communing with nature," said Ward in the April 2004 issue of *Backpacker*. "You can do that now on the lake. And you can still enjoy Glen Canyon—but it's the top part."

Ward has spent the better part of his adult years in a motorboat exploring, fishing, and photographing Lake Powell's many side canyons. He loves the man-made reservoir almost as much as Floyd Dominy does. "I can take you to spots on the lake that look just like those pictured in *The Place No One Knew*," he bragged. "Sure, Cathedral in the Desert had a special, spiritual feeling. The last time I was there was very sad. I was in high school and it had ten inches of water in it. But there are an amazing number of places on the lake that have that same kind of spiritual feeling."

Like Joan Nevills-Stavely, Ward also says that Glen Canyon Dam is justified if only because it has brought economic prosperity to the historically poverty-stricken Native Americans living in the Southwest. Today, Lake Powell–related businesses at the reservoir and in nearby Page are easily the largest employers for the 256,000-member Navajo Nation. As with all tourism-industry jobs, these are mainly minimum-wage positions waiting tables, cleaning hotel rooms, and ringing up cash

Paul Winter plays his soprano saxophone in Clear Creek Canyon, just upstream of Cathedral in the Desert. May 2003.

registers, but they are the only jobs for 200 miles in any direction.

Charlotte Spencer, a young Navajo woman who has worked for the Glen Canyon NRA concessionaire Aramark for five years, says she is thankful for the lake. She is in charge of the canteen on a Mississippi-style paddleboat that operates tours from Wahweap Lodge to Rainbow Bridge. "I took the job right out of high school and fell in love with it," she says. "I grew up on the reservation but have no idea what it was like before the lake was here." If Lake Powell didn't exist, Spencer says she and all her friends would likely leave the reservation for Phoenix or some other city where they could find work.

In the summer of 2004, as Lake Powell continued to drop, the first phase of Antelope Point Marina, located on the Navajo reservation, opened for business. The $80 million project is managed by two wealthy Phoenix businessmen who leased lakefront property from the tribe. The marina is often held up by the Park Service and Page-area businesses as a shining example of how Lake Powell is helping Native Americans in the area, even though the ongoing drought has led many to question the tribal government's investment in the project. The marina's managers contend that Antelope Point is drought-proof because the entire facility—including a restaurant and store—is located on a 27,000-square-foot floating platform that can move with lake levels. No matter how low Lake Powell gets, they say, the marina will be able to stay open and the people working there will still have jobs.

Given all the benefits he sees from Lake Powell, Steve Ward believes the idea of restoring Glen Canyon is preposterous, a scam of elitist yuppie environmentalists who don't care about the future of a little town like Page or about impoverished Native Americans. He

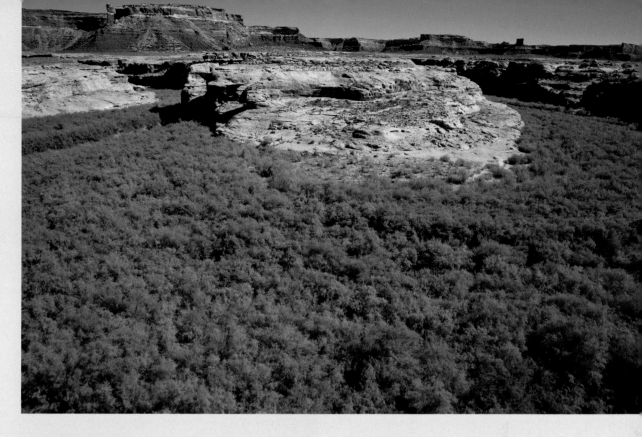

sees the controversy as a showdown between people like himself who enjoy the modern, motorized amenities of lake recreation versus people who cling to David Brower's romantic paradise lost and prefer to trudge on foot through the sizzling desert.

"The old Glen Canyon—Cathedral in the Desert, Music Temple, the cottonwood glens on the canyon bottom—that's not there anymore," he insisted in May 2003, just as the drought was kicking in. "And it won't be ever again. People who look at those beautiful, historic photos need to know that even if the lake dries up, Glen Canyon has been forever changed by the silt and the water. It will never look the way it used to."

Nonnative tamarisk carpets the top of a deep layer of sediment that fills the Dirty Devil River canyon, several miles above the river's confluence with the Colorado. When this image was taken, Lake Powell had receded approximately 11 miles downriver. October 2007.

View down a recently dewatered section of Davis Gulch with a deep layer of sediment smothering the canyon floor. May 2003.

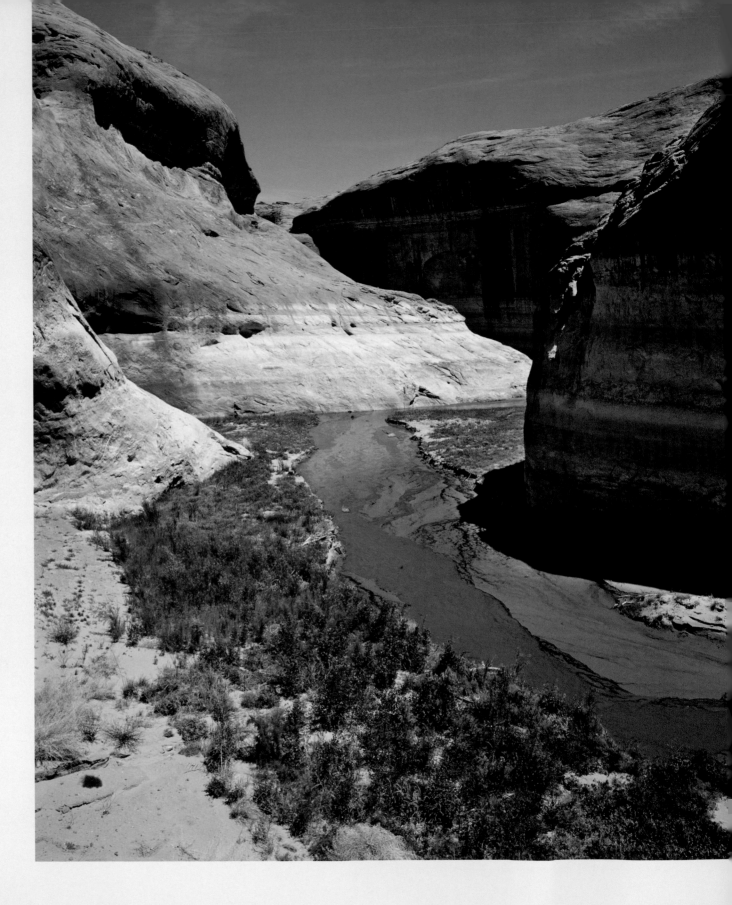

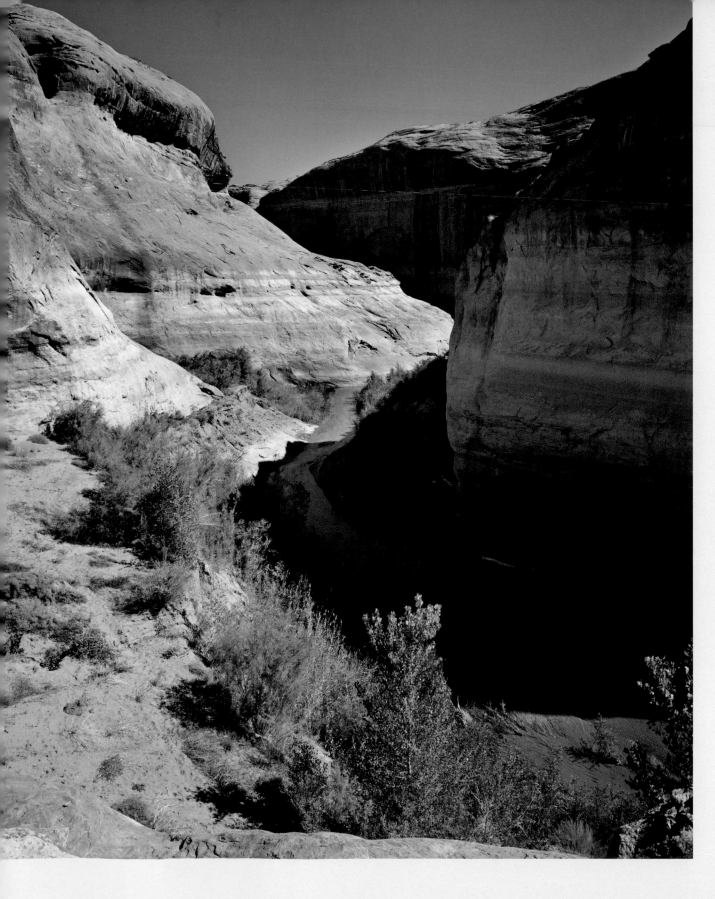

Compared to the image taken in May 2003, it is evident that a large amount of sediment has been washed out of this section of the canyon. The stream has yet to cut down to the level of its prereservoir bed. October 2007.

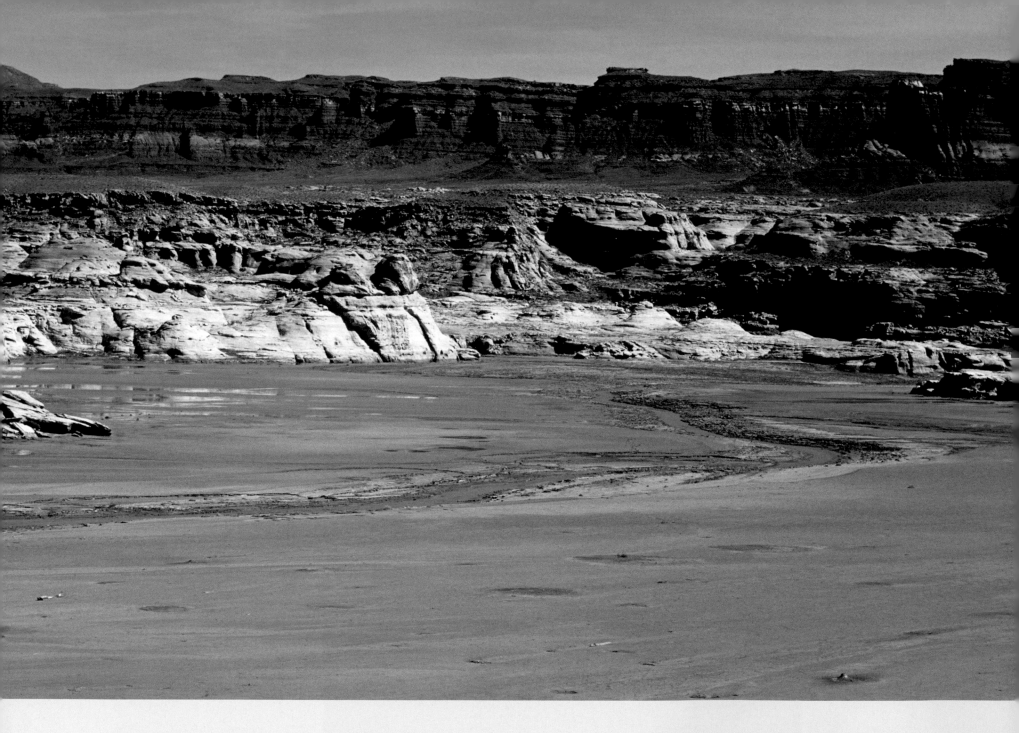

*Downstream view of the Dirty Devil River above its
confluence with the Colorado River. After several years
of drought, the water level of Lake Powell dropped 95
feet to reveal this valley filled with a layer of sediment
130 feet deep. The river now flows on top of this layer.*
April 2003.

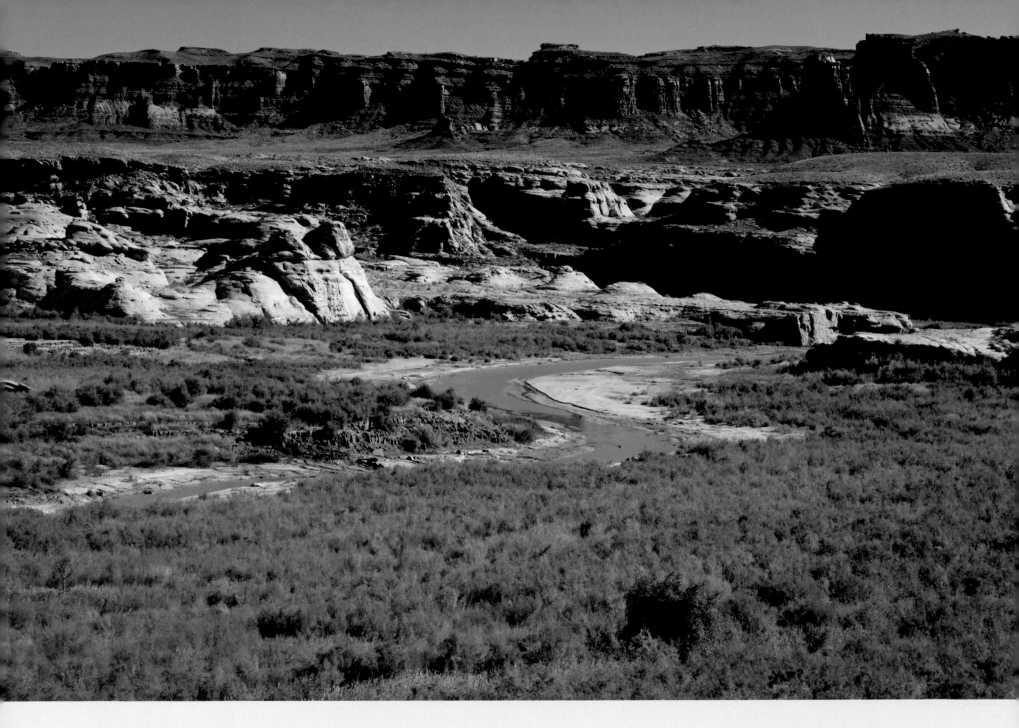

Comparing this image to the one taken in April 2003 shows how the river valley has changed dramatically now that the reservoir has receded. October 2007.

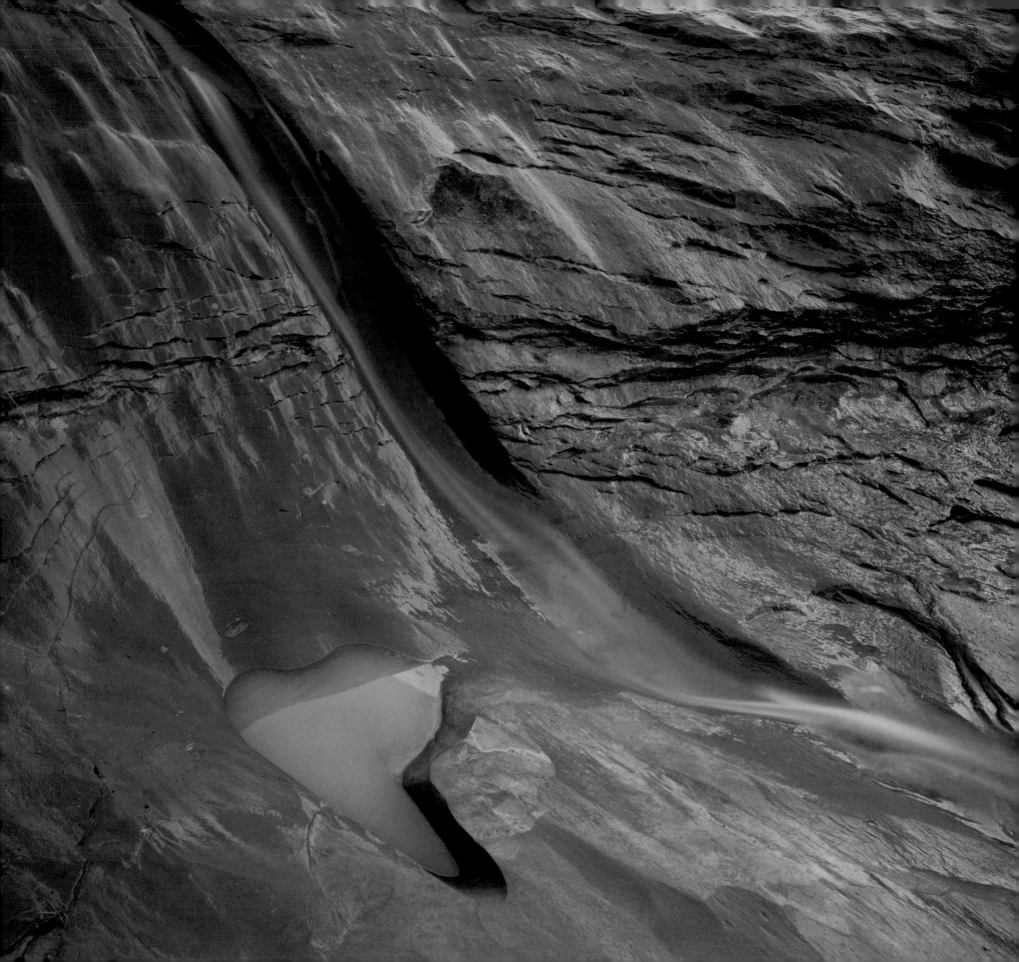

[CHAPTER FOUR]

THE POWER OF POLITICS

MAY 2003—AS RENTED MOTORBOATS SCRAPE against the narrowing canyon walls, spewing blue exhaust into Lake Powell's dead end, a dozen journalists leap from the bows into Cathedral in the Desert. Although the bottom of one of Glen Canyon's most revered places is 60 feet underwater, the mezzanine level of the Cathedral has recently been resuscitated by the drought. It is the first time in thirty-five years that people have been able to glimpse the massive 1-acre alcove.

We scramble up a ledge and relax on an expanse of powdery orange sand. The once-buried Clear Creek has returned as a flowing stream, meandering through the sand on the far side of the alcove before it drops off the ledge. A 6-foot waterfall has emerged from the depths of the lake where a 50-foot waterfall once cascaded. Overhead, the towering sandstone walls lean toward each other, separated just barely by a sinuous strip of blue sky. Everyone and everything radiates with orange light, as if illuminated by a campfire.

"Witness Glen Canyon restoring," says Richard Ingebretsen, breaking the group's churchlike silence. "What you are seeing is a resurrection. It is a miracle." Ingebretsen has brought a group of reporters here to counter claims that Glen Canyon is dead, forever buried beneath a potential Superfund site of sediment.

A brightly sunlit canyon wall reflects in a small, recently restored waterfall along Fiftymile Creek, once buried beneath 30 feet of Lake Powell sediment. October 2007.

We walk toward the mouth of Clear Creek, where water gurgles from algae-covered rocks. "You can see the plant life is already coming back," he points out. "The silt quickly flushes out and the algae, the ferns, the frogs return."

From the top of the Cathedral, near the faint white line of the high-water mark, a canyon wren sings. "What a blessing," says Ingebretsen looking up toward the sweet sound, his face glowing in the Cathedral's reflected light.

Richard Ingebretsen is an emergency-room physician and a University of Utah physics professor in Salt Lake City. But his true life's work, his all-consuming passion, is getting rid of Lake Powell. The clean-shaven, baby-faced Ingebretsen hardly fits the profile of an ecoterrorist monkey-wrencher—what some of his dam-supporting opponents have called him. Ingebretsen has an M.D., and a Ph.D., works fifteen hours a day, and is a devout Mormon descended from Brigham Young. His near-religious crusade against the dam began at age eleven when his Boy Scout troop visited Glen Canyon as the reservoir was just starting to fill.

"We hiked up in Forbidding Canyon and around Rainbow Bridge. We played in the pools. It was so beautiful," he recalls. "And everywhere we went, the Scout leaders would say 'You better enjoy this now because in a year it will all be gone.' That hurt. It really stuck with me."

As an adult, hurt turned to anger when Ingebretsen focused his obsessive tendencies on researching the reasons for Lake Powell's creation. There were no good ones as far as he was concerned, so he founded the Glen Canyon Institute in 1995 with the goal of restoring and protecting Glen Canyon. In 2007, the Salt Lake City–based nonprofit had about three thousand members and a budget of $300,000.

"Glen Canyon Dam serves no legitimate purpose," insists Ingebretsen. "It was built for political reasons and it remains today for political reasons."

Former Arizona senator Barry Goldwater, one of the staunchest supporters of Colorado River irrigation projects in the 1950s and 1960s, publicly admitted as much just before his death in 1998. In the PBS documentary *Cadillac Desert: The American Nile,* he said that he regretted his vote in support of Glen Canyon Dam. "If I had it to do all over again, I'd vote against it. Water supply is important, but not that important." Stewart Udall, who as Secretary of the Interior oversaw the Bureau of Reclamation when the dam was built, has expressed similar regret. "It was wrong," he told PBS.

A POSTWAR MODERN MARVEL BECOMES A TWENTY-FIRST-CENTURY BOONDOGGLE

Glen Canyon Dam was the Bureau of Reclamation's last big dam and marked the end of the agency's empire-building phase. Over the last forty years, the Bureau's civil engineers and developers have been replaced by hydrologists and statisticians who methodically manage the West's impounded waters with the assumption that it's all they have to work with. Creating a reservoir on the scale of Lake Powell today would be politically—and probably legally—impossible. There are six dams along the Colorado River's 1,400-mile course as well as numerous other diversions and dams on major tributaries. Like a railroad moving freight, the upper- and lower-basin states develop annual and monthly operating plans that determine exactly how much water on the highly regulated Colorado will move downstream.

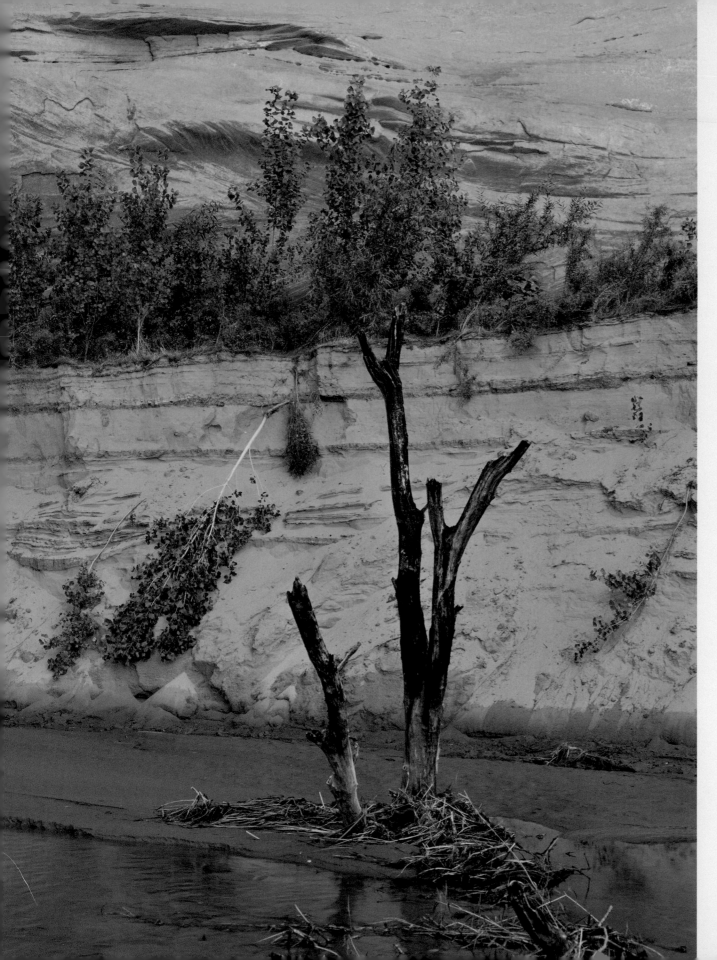

The skeleton of a cottonwood tree, drowned by the waters of Lake Powell more than thirty years ago, reemerges from a layer of sediment in Davis Gulch. Young cottonwoods grow on the bank above. October 2007.

Aerial view of Wetherill Canyon on Lake Powell, with the water level 100 feet below its full-pool elevation of 3,700 feet above sea level. At this level, the reservoir's volume is 50 percent of capacity. June 2003.

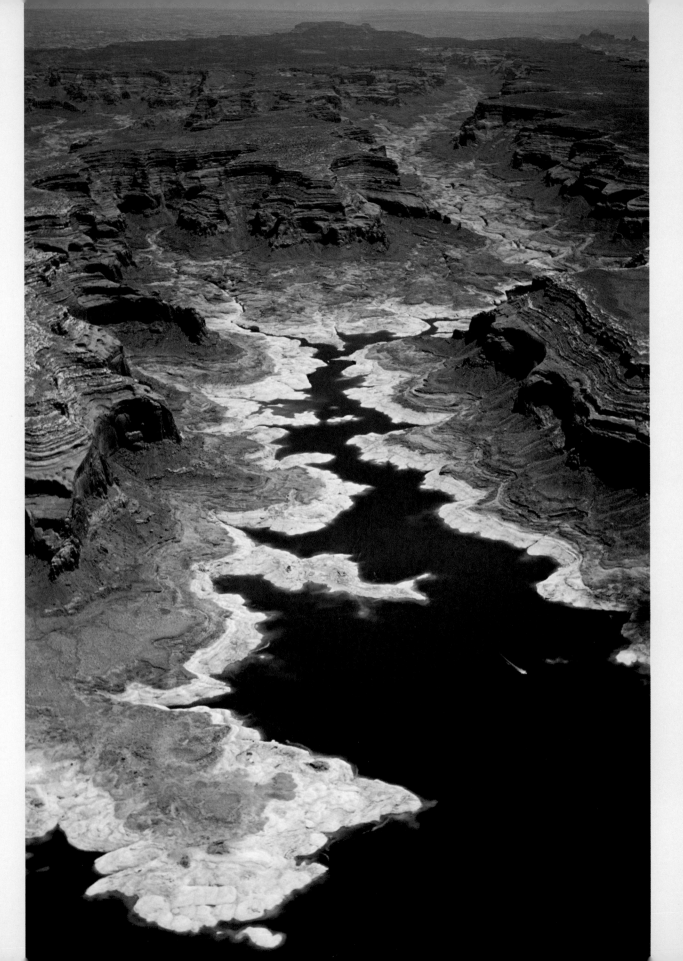

The water is released in conveyer-belt fashion, with Denver and Salt Lake City drawing their allotment from the Colorado's mountain drainages well above Lake Powell. The thirsty desert meccas of Phoenix, Las Vegas, San Diego, and Los Angeles—along with southern California's massive agricultural irrigation districts—draw their legal allotment from Lake Mead and the reservoirs downstream from Lake Mead. Despite the common misconception that Lake Powell is a lifeline to desert metropolitan areas, no water is drawn directly from the reservoir except for the relatively small amount that goes to the community of Page and the cooling towers at the nearby coal-fired Navajo Generating Station. As such, Lake Powell exists primarily as a holding tank—an insurance policy—to make sure the upper basin has the water it legally owes the lower basin, allowing Colorado, Utah, New Mexico, and Wyoming to draw freely from water resources upstream.

But there are some kinks in this well-oiled water delivery machine. First of all, the river is seriously overallocated. When the states negotiated the Colorado River compact in 1922, the data used to determine the river's average annual flow was based on the wettest period in the last five hundred years (in the early 1900s). What was believed at the time to be a conservative estimate of 15 million acre feet of total annual flow per year is in reality closer to 13 million acre feet in most years. And according to a 1944 treaty, an extra 1.5 million acre feet per year must be delivered to Mexico, which is also in the Colorado River basin but was not included in the 1922 compact. That leaves an annual average deficit of 3.5 million acre feet.

Currently, the lower basin (with 70 representatives in Congress) is sucking up 110 percent of its annual Colorado River allocation of 7.5 million acre feet, while

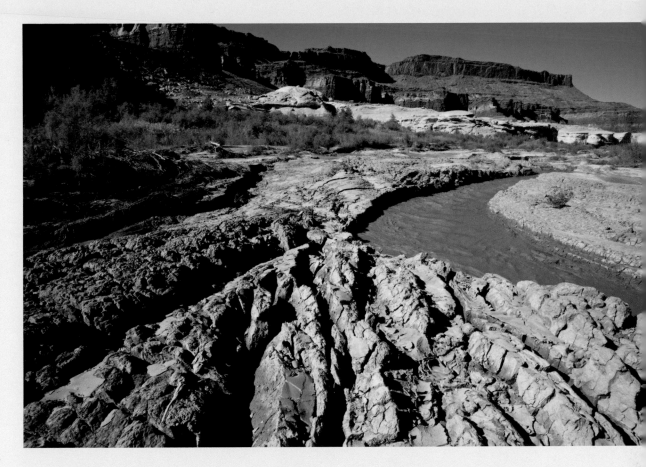

the upper basin (with 22 congressional members) is using only slightly more than half of its share. The deficit between what is supposed to be and what is has been shouldered completely by the upper-basin states, which, given their lack of political might compared to the lower basin, will probably continue to be the case. But upper-basin politicians insist—and threaten—that their states will soon need their full allotment because of growing populations and development.

Beyond overallocation, major flaws with the water "banking" system of Lake Powell and other Colorado River reservoirs include high evaporation rates and sediment buildup. Lake Powell, with its vast surface area, triple-digit summer temperatures, howling winds, and

The turbid waters of the aptly named Dirty Devil River cut through a thick layer of sediment one-half mile above the river's confluence with the Colorado River. October 2007.

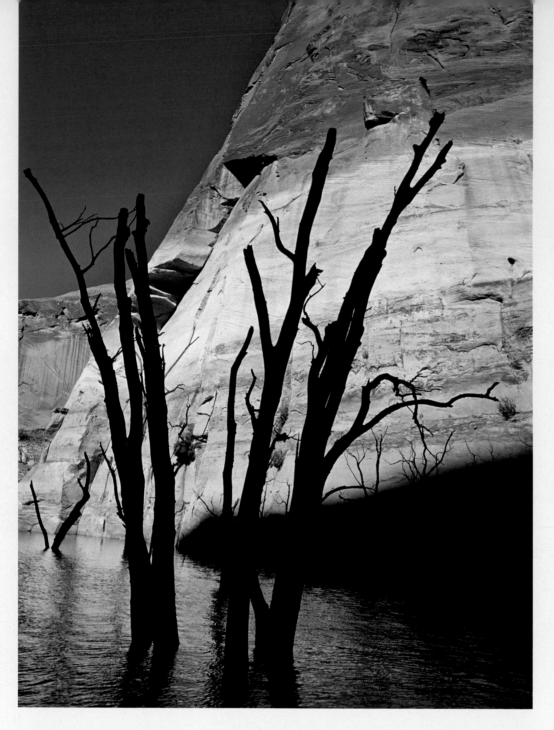

less water lost to evaporation—about 400,000 acre feet in 2007—but the amount is still significant.

Meanwhile, the storage capacity of Lake Powell is constantly shrinking as the Colorado River's silty waters drop one dump truck full of sediment every two minutes in the reservoir. On average, 65 million tons of sediment settle in the upper reaches of the lake per year, diminishing the reservoir's capacity by at least 50,000 acre feet annually. Both the Bureau of Reclamation and environmental groups agree that Lake Powell will eventually fill with sediment, rendering Glen Canyon Dam obsolete, but there's a difference of opinion on when this will happen. According to the Bureau's Tom Ryan, the agency estimates the lake will fill to the brim with sand in 700 years, although power and water storage would be significantly diminished before that. "We consider the useful life of Powell to still be hundreds of years," he says.

However, Living Rivers and the Glen Canyon Institute estimate that Lake Powell has only about 50 years left before silt buildup begins to interfere with the dam's mechanical operations and 150 years before the lake is rendered the biggest mud pit in the United States. The groups argue that it's critical to start sending the sediment through the dam now with river releases, rather than wait until there's no water for transport and the only way to remove the potentially toxic silt is by dredging.

According to Ryan, sediment buildup and evaporative loss is just the cost of doing business. "It is a relatively small price to pay when you consider the benefits to water supply and hydropower that Lake Powell and Glen Canyon Dam provide," he says. For many upper-basin politicians and economic development proponents, Lake Powell's inefficiencies as well as the fact that no major cities or irrigators draw directly from the reservoir

The skeletons of Lake Powell— drowned cottonwood trees reemerge from their watery grave in Forgotten Canyon, beneath the reservoir's 98-foot-tall "bathtub ring." October 2005.

porous sandstone, loses 750,000 to 1 million acre feet per year to evaporation and seepage (water sucked into the rock) when the lake is full. That's enough water to meet the annual supply of Los Angeles and more than the whole state of Nevada uses. With Lake Powell less than half full, the decreased surface area has resulted in

A grounded buoy in Forgotten Canyon at a location that was once 80 feet below the surface of Lake Powell. October 2005.

A discarded boat battery lies on the recently exposed floor of West Canyon. Just above the center of the image, a hiker is dwarfed by the sediment bank that clings to the left wall. May 2005.

are beside the point. Their justification for Glen Canyon Dam is simple: it serves as a literal barrier to the more powerful and populous lower basin seizing the unused water of the upper-basin states. The water in Lake Powell is the upper basin's ace in the hole. Or at least it was before climate change kicked in.

PORK-BARREL POLITICS AND A CHANGING CLIMATE

An August 2004 report by University of Washington hydrologist Niklas Christensen found that the effects of climate change will likely cause the Colorado River to produce far less water within the next ten to twenty years, perhaps 30 percent less, than the amount currently used by basin states. In addition to promoting and exacerbating drought, Christensen said that increased temperatures from climate change may cause accelerated spring melting of the Rockies' snowpack, with increased evaporation into the atmosphere and reduced flow into rivers and, subsequently, reservoirs.

It is possible that this scenario was responsible for reducing what was expected to be an average and even above-average runoff in the upper Colorado River basin in the winters of 2006 and 2008 to a below-average amount, and average amount, respectively, by the end of each snowmelt season. "Inflow projections to Lake

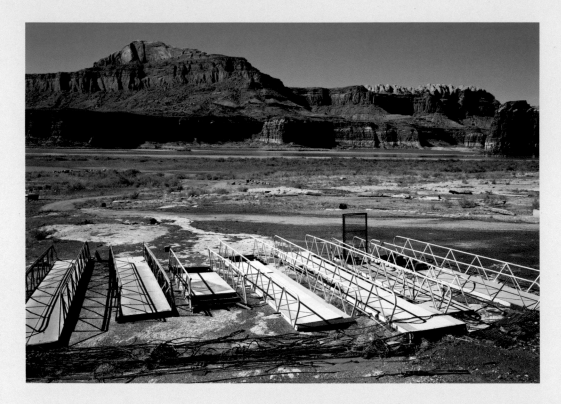

Gangplanks near the abandoned Hite Marina boat ramp litter the old shoreline of Lake Powell. October 2007.

Powell have been reduced in response to warm and dry spring conditions in the Colorado River basin," reported the Bureau of Reclamation's Tom Ryan in June 2006 on the Bureau's Upper Colorado Region website. Based on existing snowpack in April of that year, inflow had been projected to be 97 percent of average, but this had been revised downward to 74 percent because "snowmelt runoff had occurred earlier than normal."

According to a study of the Colorado River water delivery system commissioned by the Glen Canyon Institute, Lake Powell will never return to predrought levels. Although the reservoir once functioned as a savings account banking unused water, current demands from growing Sunbelt cities have turned it into a fluid checking account where resources are spent as quickly as they are earned. "Our numbers show that if upper-basin demand is static, Lake Powell will be half empty

half of the time," says GCI's Richard Ingebretsen. "If there is development in the upper basin that increases demand, even at a conservative level, Powell will be 75 percent empty at least half of the time." Ingebretsen says these predictions are actually modest because they do not fully account for the real but unknown future effects of climate change on western water supplies.

A variety of recent scientific studies evaluating the impacts of climate change in the Southwest and across the globe have concurred with GCI's predictions. In April 2007, the United Nations Intergovernmental Panel on Climate Change identified the American Southwest as a region where the current drought will likely worsen as a changing atmosphere causes temperatures to rise by as much as 5 degrees Fahrenheit over the next century and precipitation to significantly decrease. Climate models from the National Oceanographic and Atmospheric Administration as well as those from academic study groups all show that both Lake Powell and Lake Mead will remain less than half full indefinitely. In February 2008, researchers from San Diego's Scripps Institution of Oceanography released findings showing a 50 percent chance that climate change combined with demand will cause both Lakes Powell and Mead to dry up by 2021.

Although Bureau of Reclamation engineers also admit that climate change is real and affecting water supplies, they refuse to believe that current demand combined with global warming will bankrupt the savings account of Lake Powell. "I am not in the camp that Lake Powell is going to stay low forever; it will fill back up eventually," says the Bureau's Ryan, who develops computer models that predict short-term and long-term precipitation and resultant water supply in Lake Powell and upstream reservoirs. He says his models—all based on historical data and not future

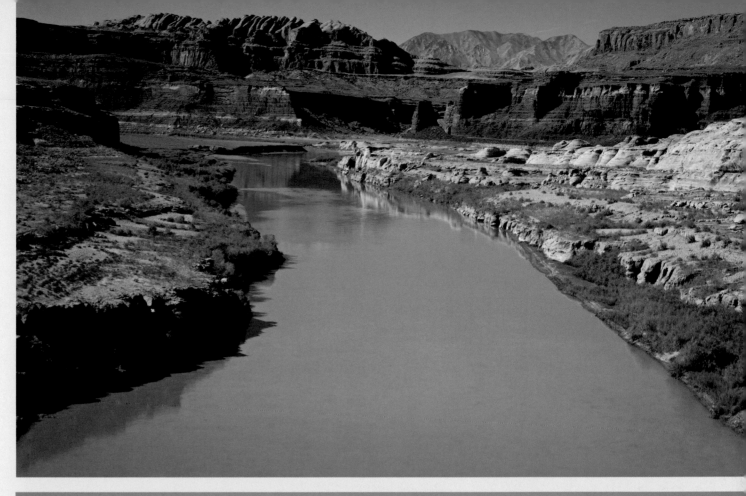

Downstream view of the now free-flowing Colorado River seen from the US 95 bridge near Hite. When Lake Powell flooded this canyon, the Colorado deposited sediment here to a depth of 130 feet. The river now flows on top of this sediment, 130 feet above its prereservoir bed. As soon as the waters of Lake Powell receded, new vegetation quickly covered the crumbling sediment banks on both sides of the river. April 2003.

Downstream view of the Colorado River seen from the US 95 bridge near Hite. Comparing this image to the one taken in April 2003 clearly shows the dramatic change that has occurred. When Lake Powell was last full in 1999, its surface was approximately 95 feet above the river here and the reservoir extended 35 miles upriver. October 2007.

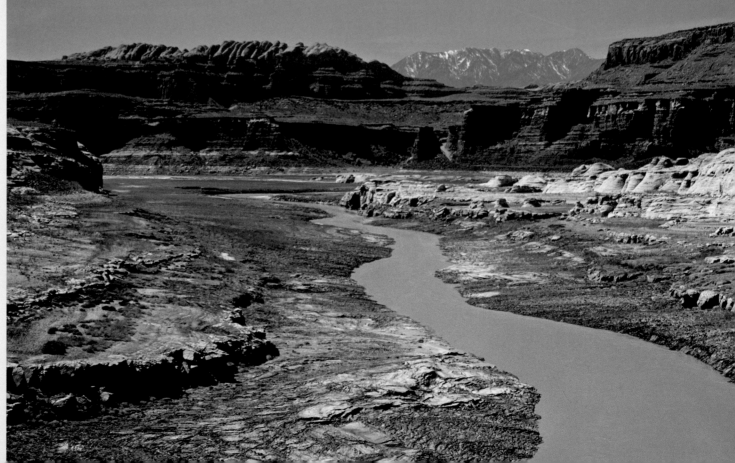

This majestic bridge spans the now free-flowing Colorado River upstream of the abandoned Hite Marina. October 2007.

climate predictions—show Lake Powell remaining at slightly less than 50 percent of capacity for the next several years, but climbing up to 60 or 70 percent of capacity over the next fifteen to twenty years. And while environmental groups point to the effects of drought and climate change as reason to question the viability of giant reservoirs in the desert, the Bureau of Reclamation holds the opposite view—that Lake Powell has been and will continue to be critical in helping the West survive drought. "Without Lake Powell to supplement the flow right now, the upper-basin states would need

to curtail use to meet their obligations to the lower basin," says Ryan.

But don't get the idea that Denver taps will run dry without Lake Powell. "When the Bureau talks about curtailing use, it's not municipal use—that's a scare tactic," says University of Utah political-science professor Daniel McCool, who has been researching western water policy for twenty-five years and has written several books on the subject. "No cities are going to run out of water, even in drought." For starters, McCool says, the upper basin only uses 4.2 million acre feet of its 7.5-million-acre-foot

allotment. Of the water being used, about 90 percent goes to agricultural irrigation rather than to municipal uses. The lower basin uses 110 percent of its allotment, and 80 percent of that is sucked up by agriculture. The vast majority of the farming operations are water-intensive crops like alfalfa, hay, and cotton that are grown not to satisfy market demand but to take advantage of a tangled web of subsidies and tax breaks. The trail of pork goes back a century to the days when the federal government literally had to pay people—especially farmers—to settle in the West. If the upper basin is required by the Bureau to "curtail use," the users affected would be those growing water-intensive, low-profit crops, not city residents.

"Dams are a functional symbol of society for many people," observes McCool. "It means progress, stability, economic growth, it stands for everything that side of apple pie. People will defend them no matter how stupid." He points to Utah as an example of how water is being distributed to satisfy political rather than social needs. Mining, ranching, and agricultural interests comprise less than 3 percent of Utah's economy but use 85 percent of the state's water.

Even in the populated lower basin, a similar policy is perpetuated by politicians and agribusiness lobbyists. The Imperial Valley in southern California, which receives less than 5 inches of rain a year and relies completely on canals piping in Colorado River water, is the single biggest user of water in the entire Colorado River system. Roughly four hundred farms in the Imperial Irrigation District—mostly large industrial agriculture operations—use more than 2.8 million acre feet (nearly 1 trillion gallons) per year. That represents 70 percent of California's share of the river and the same amount as Arizona's entire allotment. And much of the Imperial water is used to flood-irrigate alfalfa rather than to grow produce that winds up in grocery stores.

"It's like a house of cards," says McCool of the original vision—or lack of it—behind Glen Canyon Dam. "If we construct an allocation regime that is so absurd it requires a dam, then we can say the dam is necessary. There are hay fields in Colorado that are kept alive by federally subsidized water, subsidized pricing, subsidized loans, and subsidized energy. That's the only way you can grow hay at 7,000 feet—somebody else pays the bill."

McCool and a growing number of environmental groups argue that many government-subsidized water projects in the West do not benefit local economies as politicians claim, but merely serve the interests of agribusiness—the primary recipients of tax-subsidized

A profusion of new plants reclaim the streambed in Sevenmile Canyon, at a location flooded by Lake Powell four years prior. October 2005.

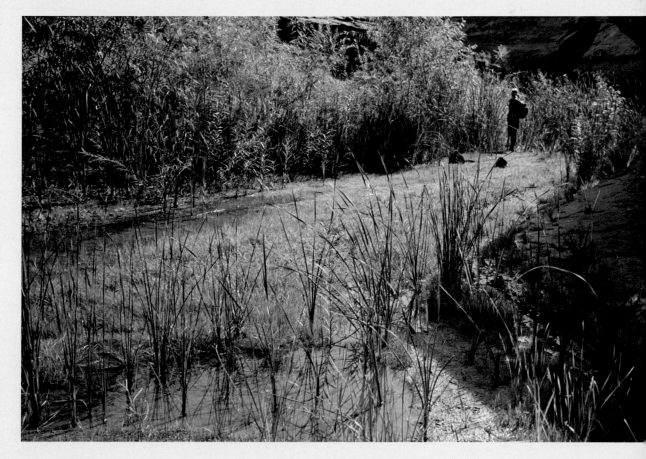

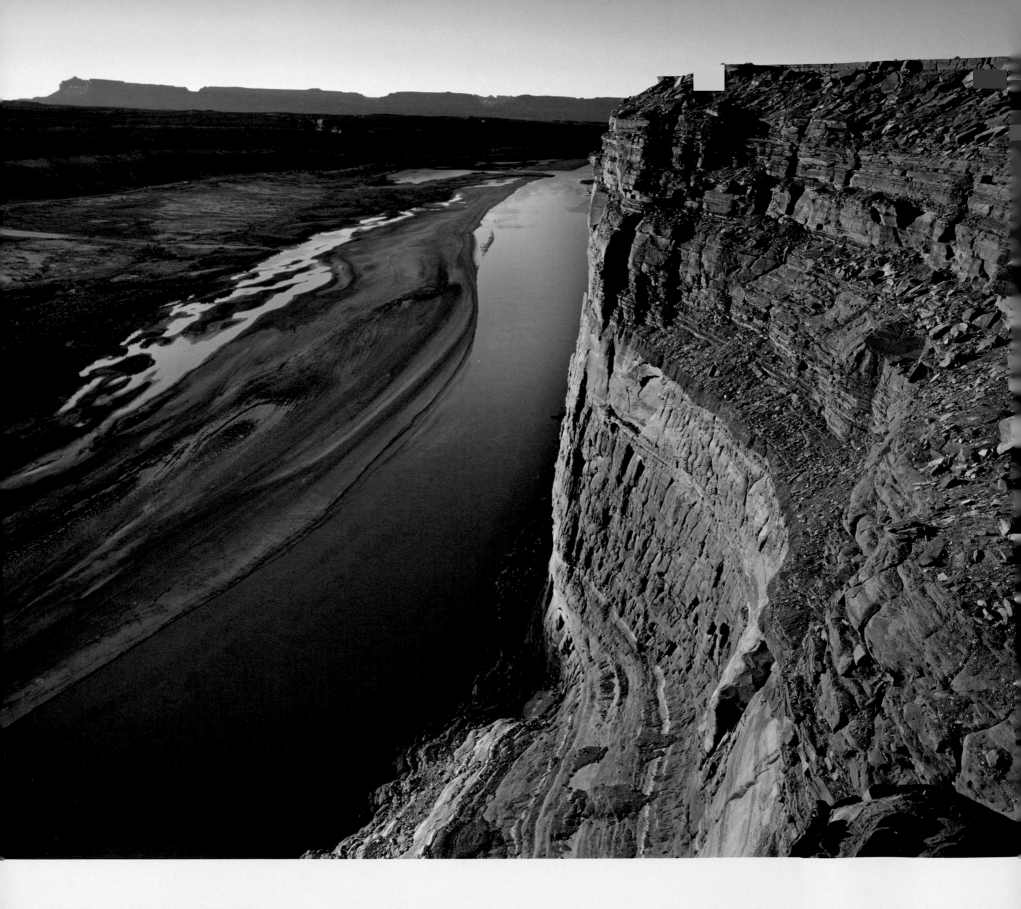

irrigation water from the Colorado River—and the congressional representatives those companies help get elected. Even though agriculture comprises a small and ever-decreasing part of the western economy, the industry is one of the largest contributors to political campaigns. In California, where there are more than 9 million acres of irrigated farmland, the agribusiness lobby is an especially powerful player in securing government pork. According to the Center for Responsive Politics, agribusiness donated $33 million to congressional candidates for the 2006 election, 70 percent of which went to Republicans.

However, these large campaign contributions from agribusiness—and the tax subsidies California farms receive—do not directly translate into economic or social benefits for California voters. According to the U.S. Department of Commerce, the agriculture industry only supported 379,000 jobs in California in 2004 (not including undocumented immigrants). Meanwhile, the leisure and hospitality industry supported 1.4 million jobs and health care supported 1.5 million jobs in the state. In terms of wage and salary contributions to the California economy, the health-care industry is ten times greater than agriculture; even the entertainment industry is nearly three times larger than agriculture. And yet, health-care and entertainment businesses receive very little in terms of federal financial support and tax subsidies compared to the longstanding regime that feeds agribusiness.

Former Utah representative Jim Hansen, who retired in 2003 after forty years in the House of Representatives, sees the situation differently. He is proud of the money he has brought home to his state. As longtime chairman of the House Resources Committee, Hansen oversaw appropriations for the Bureau of Reclamation

and championed numerous water development projects in the West. "The theory is that you start out with a subsidy for the farmer's water in hopes that one day he'll be able to pay it back. Sometimes that happens; sometimes it doesn't," admits Hansen. "But you have to ask, was it the best thing for society even if it did cost the taxpayers quite a bit of money? In most cases I'd say yes because it opened up the West by making water and electricity available."

HYDROPOWER FIZZLES WHILE THE GRAND CANYON SUFFERS

More than fifty years after it was conceived as a money-making scheme, the idea of Glen Canyon being a profitable cash-register dam through hydropower sales seems to have been quietly mothballed. Nearly a decade of drought has significantly taken the ring out of the register because the low lake levels decrease the distance the water falls and the amount of power that can be generated. Dam manager Ken Rice says the drought has reduced hydropower revenues by an average of about 40 percent since the drought began. Glen Canyon Dam still generates enough hydropower to provide electricity to 1.7 million people, but that only comprises 3 percent of the total amount used by the fifteen-state western area power grid, which buys electricity from sources all over the country and then distributes it on demand to cities and towns throughout the West.

One of the dam's primary contributions used to be providing peak power on short notice. The power plant would suddenly crank up when everyone in Phoenix turned down their air-conditioner thermostats on a hot summer afternoon. But the 1992 Grand Canyon Protection Act put a stop to this when it mandated that Glen Canyon Dam be operated to minimize harm to the

OPPOSITE *Downstream view at sunrise of the now free-flowing Colorado River, from Hite Overlook across from the abandoned Hite Marina. When Lake Powell was last full in 1999, its waters filled this entire valley to a depth of 95 feet and extended 35 miles upriver. Hite Marina's concrete boat ramp can be seen at the far left edge of the frame, a quarter of the way down from the top.* October 2007.

OPPOSITE *Recently exposed stream in Smith Fork Canyon, where sediment once filled the canyon up to the top of the shadow line at the base of the sunlit domes. Approximately 10 feet of sediment still covers the preservoir streambed.* October 2007.

Sediment buries the floor of Ticaboo Canyon to a depth of approximately 15 feet, as cottonwood skeletons reemerge from the muck.
October 2007.

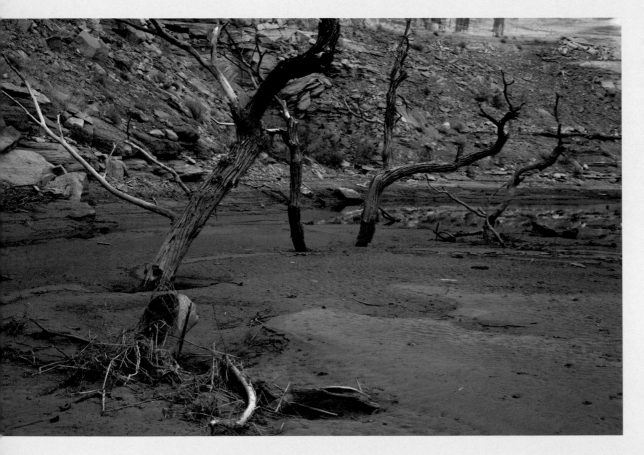

Grand Canyon's river ecosystem. Erratic releases from the dam to meet peak power demand were determined to be one reason behind environmental degradation in the Grand Canyon since the dam was built.

Other downstream effects of Glen Canyon Dam also proved highly destructive: the complete removal of sediment—now trapped behind the dam—from Grand Canyon's waters; the dramatic change in water temperature from warm to ice cold due to flows coming through the bottom of the dam where Lake Powell is deepest; and the cold-water-loving trout stocked at Lees Ferry eating the canyon's native fish.

The drastic habitat changes in the Grand Canyon resulted in the extinction of four fish species and the extirpation of the Southwest river otter and muskrat. Still struggling for survival in the altered environment are four federally listed endangered species: the southwestern willow flycatcher, yellow-billed cuckoo, Kanab ambersnail, and the humpback chub. In December 2007, the Grand Canyon Trust and other environmental groups filed a lawsuit against the Bureau of Reclamation for alleged failure to abide by federal endangered species laws and the Grand Canyon Protection Act in managing Glen Canyon Dam. The suit claims that the federal government in recent years has privileged hydropower operations over protecting Grand Canyon habitat and the needs of endangered species.

Despite federal agencies spending $8 million a year for the past decade on partial attempts to save the humpback chub—including three manufactured canyon floods and the mechanical removal of trout from the river—the chub is on the brink of extinction. "The Grand Canyon is dying," says John Weisheit of Living Rivers, one of the groups participating in the lawsuit. "The humpback chub is an indicator species of the health of the whole Grand Canyon river ecosystem. The only way to truly restore the Grand Canyon is to get rid of the dam." The bottom line for Living Rivers and other Southwest environmental groups is that saving Glen Canyon also saves the Grand Canyon.

WATER POLITICS TRUMPS CONSERVATION

After reservoir levels had been dropping for nearly a decade, political leaders representing thirty million people relying on Colorado River water finally admitted that there could be future water "shortages" if the drought continues. In December 2007, the seven western states sharing the Colorado's water signed a

pact to determine how such shortages would be dealt with, the first official acknowledgment that the current drought requires policy changes.

The agreement primarily focused on ways to keep water levels in Lake Mead above the "tipping point" elevation of 1,050 feet, just above the water intake pipes for Las Vegas. Arizona was given approval to continue drawing its full allotment and to store some of the reserve underground. Nevada was authorized to build a reservoir just north of Mexico to capture excess water before it crosses the U.S. border—which will completely dry up the ecologically sensitive Colorado River delta, home to numerous endangered species. There were no significant policy changes requiring states to cut back on water use before the Lake Mead tipping point is reached.

Even though Secretary of Interior Dirk Kempthorne (who oversees the Bureau of Reclamation) touted the agreement as monumentally progressive, environmental groups said it was just more of the same 1950s-era thinking. Michael Cohen of the California-based Pacific Institute stated in the December 14, 2007, *Los Angeles Times* that the plan made no acknowledgment of the need to live "in an era of limits."

"There is more water on paper than there actually is on the landscape," John Weisheit told the *New York Times* in a December 10, 2007 article. "They are looking at this in a way that will allow more development even though the water is not theoretically there."

Moreover, despite the drought and dropping reservoir levels, the Bureau of Reclamation and Southwest politicians supported proposals in 2007 to build multimillion-dollar pipelines from Lake Powell to the Navajo Nation and the city of Flagstaff. Utah's congressional delegation also sought support in 2007 for a half-billion-dollar taxpayer-funded pipeline that would suck

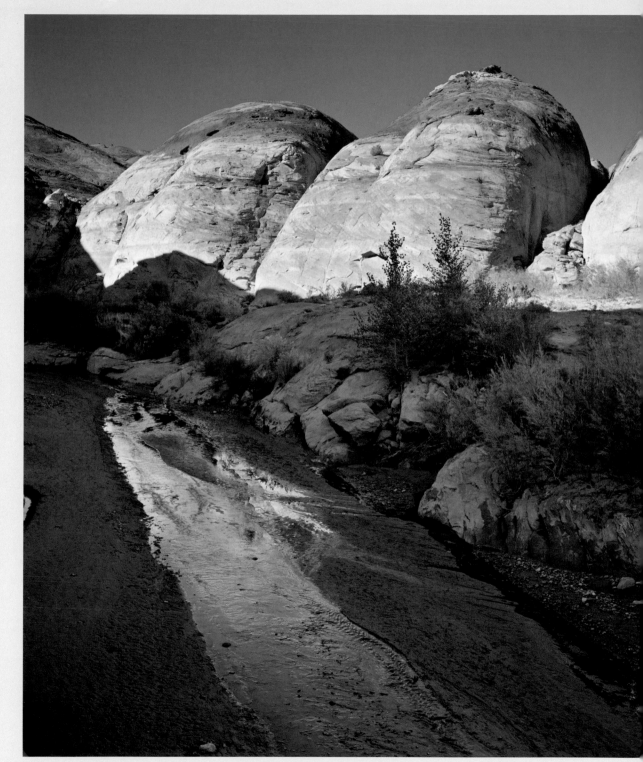

A cluster of purple asters reclaims the streambed in Iceberg Canyon, at a location last inundated by Lake Powell three and a half years prior. October 2005.

water from Lake Powell and pump it 120 miles away to booming St. George, where the per capita consumption of water is already twice the national average. Other expensive pipeline and reservoir projects were in the works in the Colorado River's upper basin in 2007 to bring more water to the suburbs of Denver.

"What really gets me," says former Bureau of Reclamation commissioner and current Glen Canyon Institute board member Dan Beard, "is when we look at solving water-resource problems, we put our dunce cap on. When

engineers address a problem, they can get very creative. It didn't take long to figure out a way to put a man on the moon and bring him back. We've taken the computer from being a huge machine in a room and in two decades put it into your pocket. But we are still addressing water problems the same way the Romans did. There are a lot of different ways to do this, and yet people are afraid to use modern approaches. The lack of innovation is due to politics. Water is all about politics."

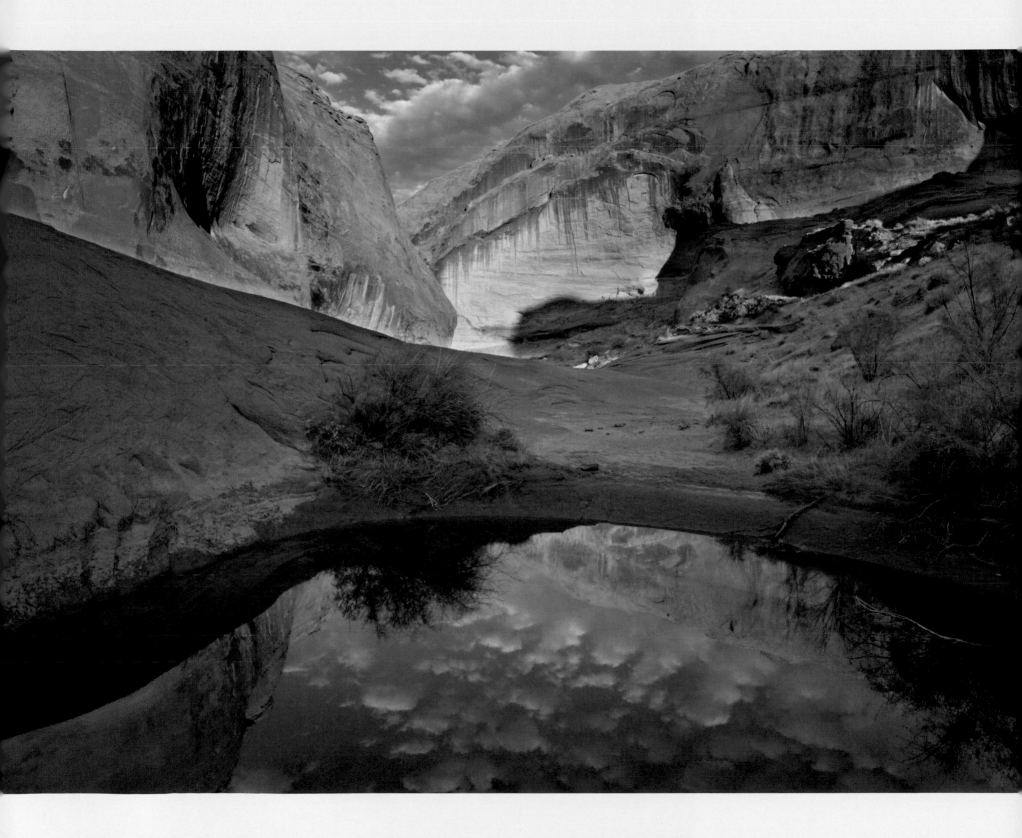

PREVIOUS *Willow Gulch. When Lake Powell was last full in 1999, this pothole was flooded to a depth of 10 feet above the level seen here.* October 2007.

A burst of new plant life grows in the streambed in Sevenmile Canyon, at a location flooded by Lake Powell four years prior. October 2005.

OPPOSITE *Willows and cattails reclaim the streambank in Willow Gulch. Three years before this image was taken, this area was a devastation zone of crumbling sediment banks, windblown tumbleweeds, and other debris left behind as Lake Powell receded.* October 2007.

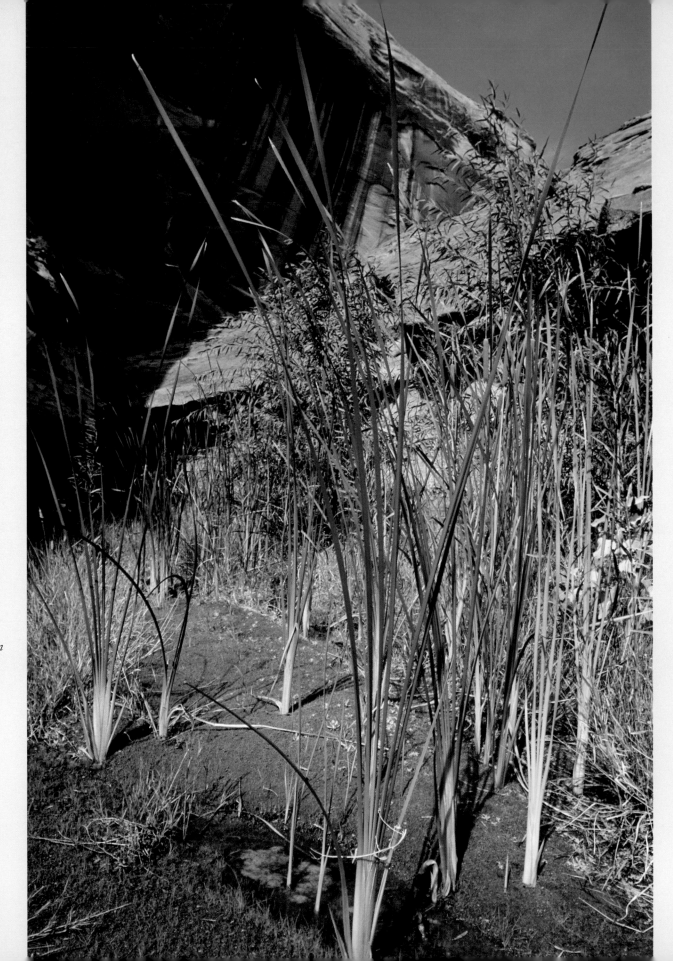

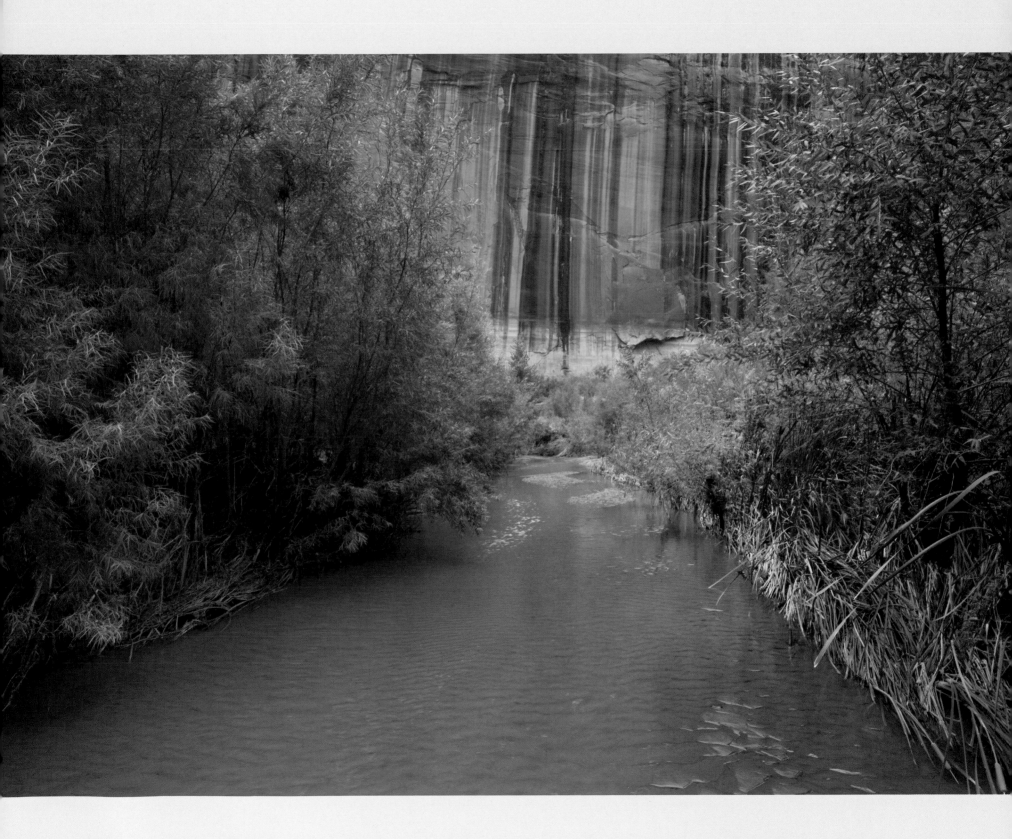

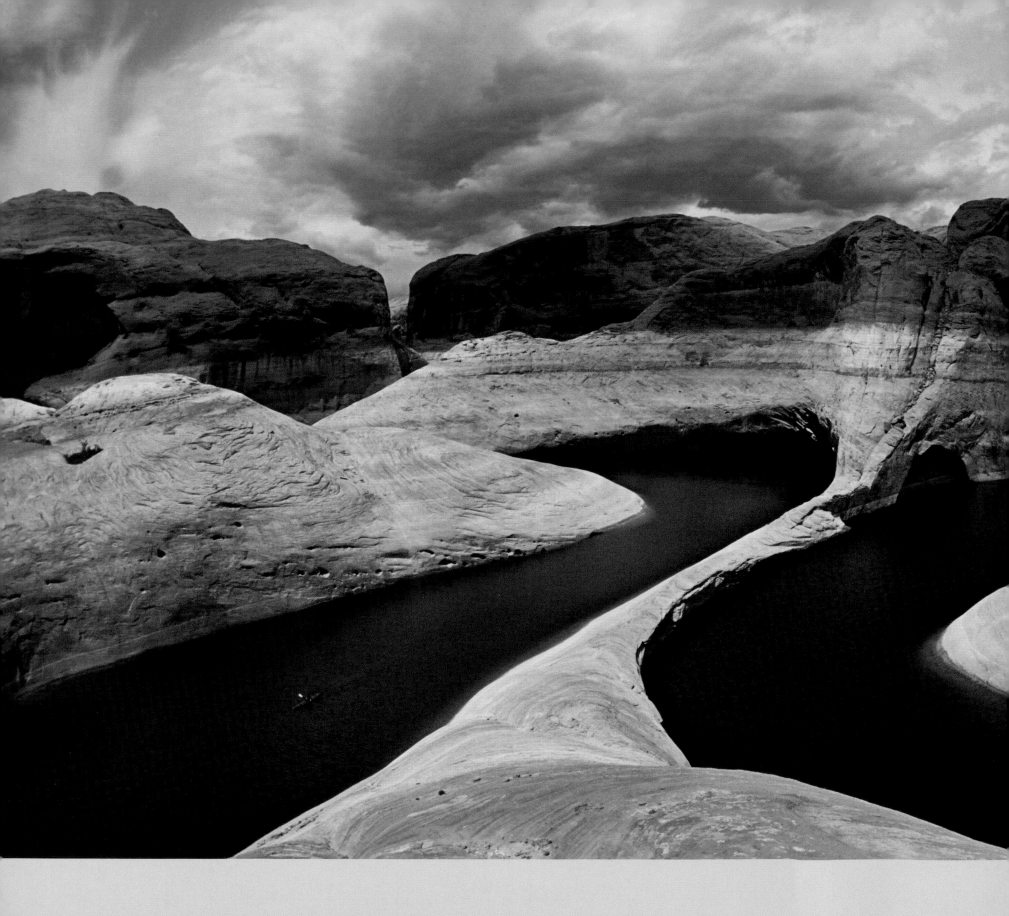

[CHAPTER FIVE]

TWO WORLDS APART

JULY 2005—"THERE IS A WAY UP!" shouts Neil Weintraub, a friend and Flagstaff archaeologist. From the bottom of willow-choked Moqui Canyon, we spied a set of Anasazi granaries tucked on a narrow ledge some 350 feet up the sheer, ivory-colored sandstone wall. I assumed there was no way we could reach them, but Neil knew better. After a serious scramble, we find one granary in perfect condition with wood slats still in the roof and the fingerprints of its builder pressed in the mud mortar. The sandstone bricks are intact, forming a 4-foot-high three-walled shelter flush against the canyon wall. Neil guesses the structure is about one thousand years old.

"I can see why they lived here," he says, looking down at the now-thriving riparian ecosystem that was buried beneath Lake Powell just a few years ago. There are fertile alluvial silt banks for growing crops, plenty of willow for making baskets, a perennial stream, and high, shady alcoves for housing and food storage. The side canyons of Glen Canyon were a major dwelling site for Ancestral Puebloans; Moqui was one of the most popular areas in the drainage for this ancient culture, with 150 ruins and rock-art sites located in just 12 miles of canyon. Venturing downstream in search of more sites, we push through willow thickets and splash in a creek that didn't exist a few years ago when the reservoir was full.

Kayaker (lower left) in Reflection Canyon, beneath the towering 140-foot-tall "bathtub ring" of Lake Powell. April 2005.

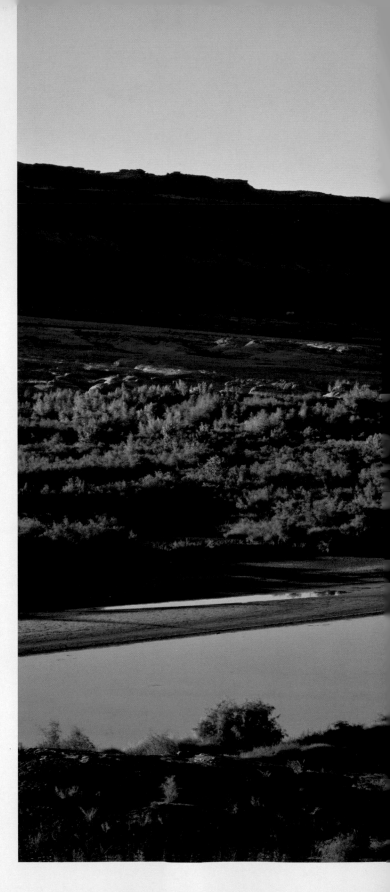

Downstream view at sunrise of the now free-flowing Colorado River just below its confluence with the Dirty Devil River. When Lake Powell was last full in 1999, the reservoir surface was 95 feet above the river level shown here. October 2007.

We spy a handful of granary and dwelling structures—hundreds of inaccessible feet above the creek—that are well preserved and obscured by broad brown streaks of desert varnish running down the sandstone walls. But several sites that were near the lake's high-water mark have been destroyed, either by vandals or the reservoir. We can trace the lake's shifting high-water mark over the years by the graffiti scrawled on the canyon walls, perhaps on top of rock art. "If the lake doesn't get the sites, then I guess the boaters will," says Neil in disgust.

After we hike out of Moqui, we set up camp on top of a high ridge with a best-seat-in-the-house view. Neil finds a litter of petrified wood flakes among the creosote bushes and guesses someone sat at this very spot, probably thousands of years ago, to work on making a knife or other sharp tool. "I'm sure they appreciated a good view as much as we do," he says. We sip beer and take in the sunset, making predictions about what this view—which currently includes the trapped blue waters of a reservoir—will look like one thousand years from now.

Vernon Masayesva, a member of the Hopi tribe and leader of the nonprofit Native American environmental advocacy group Black Mesa Trust, has a simple diagram he likes to use to explain all there is to know about life. "This is Hopi science," he says. "For us water is life; our whole view of the world is determined by water."

He draws a figure eight with the "cosmic sea," the clouds, at the top representing the future; in the middle of the eight where the lines intersect is freshwater, flowing rivers and springs, representing the present; and at the bottom of the loop is the ocean, representing the past.

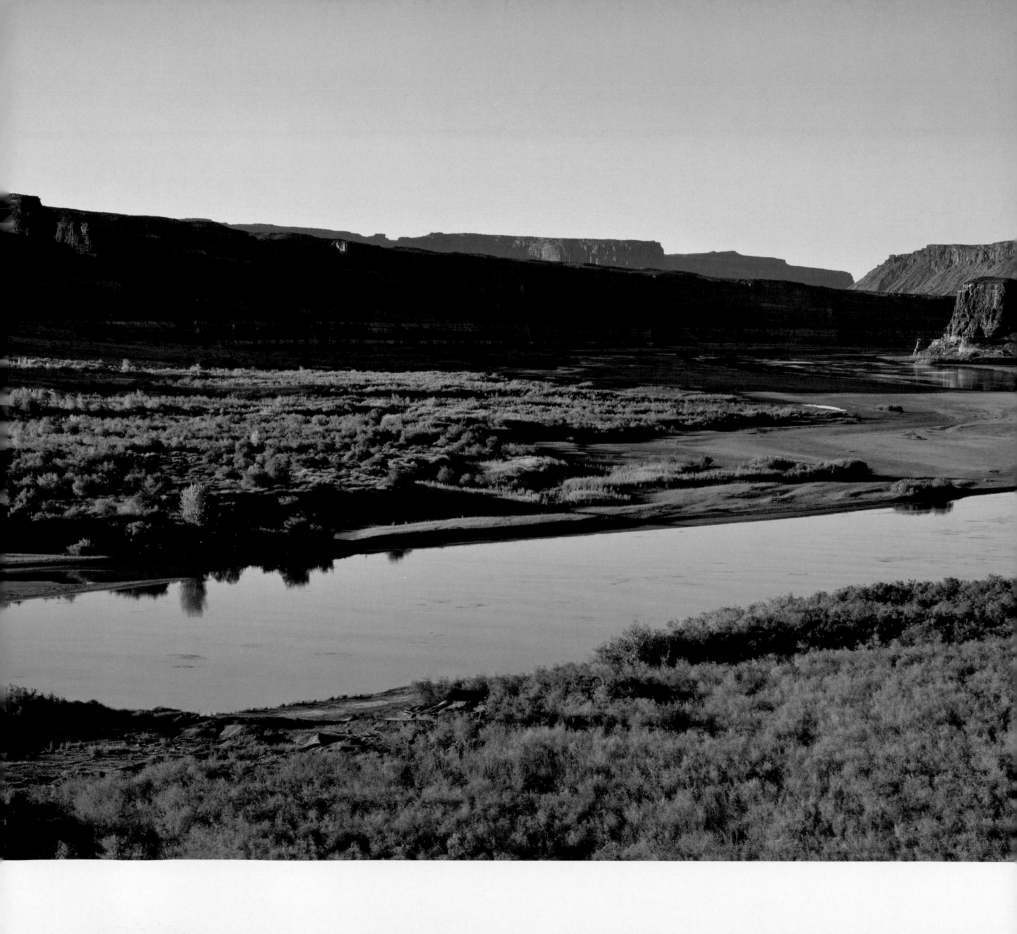

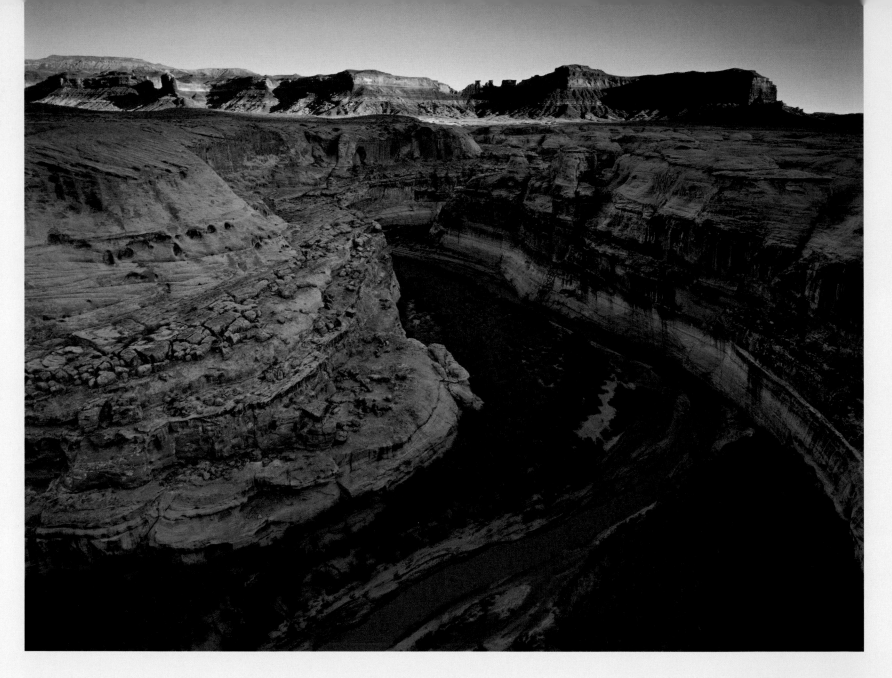

Downstream view of the now free-flowing Dirty Devil River, from a few miles above its confluence with the Colorado River. Lake Powell's white "bathtub ring" rises 80 feet above the stream on the right-hand canyon wall. October 2007.

He redraws the eight over and over. "The past, present, and future all feed each other," he says. "Time and water are all flowing, all connected. Rivers flow to the sea, the sea evaporates to make the clouds that rain down into the rivers. We are all part of this cycle. It's what has sustained the Hopi for thousands of years."

And now? "White people have interfered with the cycle by building these big dams. You have cut off the cycle of life."

For Native American cultures in the Southwest, the reservoir-based infrastructure upon which the modern West is built is a violation of traditional beliefs on many levels. In the broadest sense, trapping free-flowing rivers also traps the natural order of the universe and diminishes the spiritual power inherent in these peoples' belief system. Specifically, in Glen Canyon, many sacred places as well as thousands of prehistoric and historical dwellings and rock-art sites were inundated by Lake Powell.

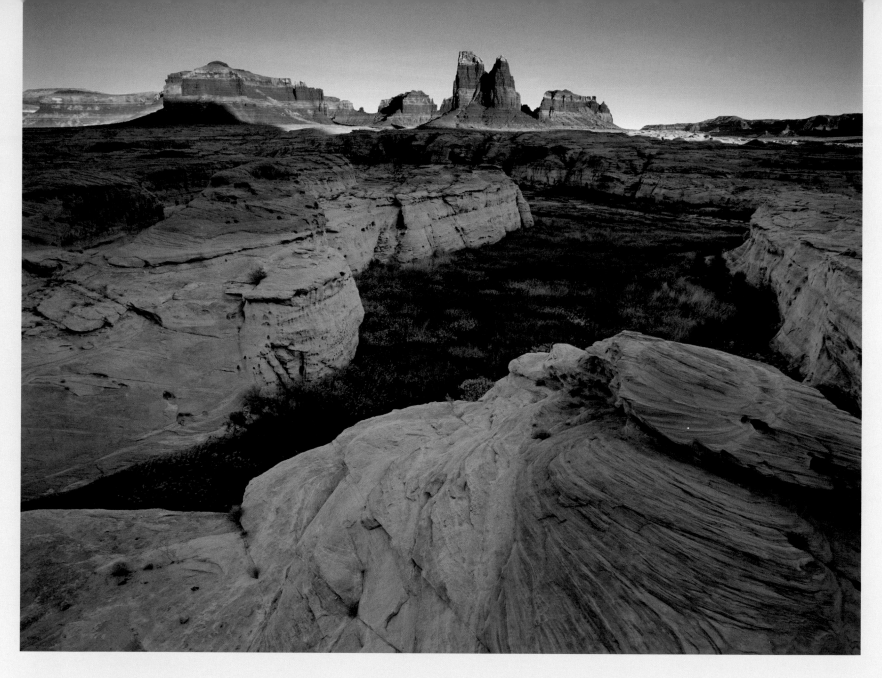

Glen Canyon, with its vortex of major river drainages, was the heartland of the Ancestral Puebloan people from approximately AD 100 to 1300. And, before that, the ecologically rich area supported hunter-gatherer tribes for at least several thousand years. Although many Anasazi would eventually concentrate in urban settings like Chaco Canyon, the fertile folds of Glen Canyon remained among the most heavily populated with rural, agrarian families. Both the Navajo and Hopi (descendents of the Anasazi)

say there are numerous sacred sites critical to their cultural heritage beneath and around Lake Powell.

"A long time ago the Navajo people were deceived to build a dam. No one told them the lake would fill up these sacred areas with water and sediment," says Norris Nez, a longtime traditional Navajo medicine man who speaks only his native language and who visited sacred sites in Glen Canyon in the 1950s before they disappeared under Lake Powell. "These people [Navajo elders], they made

Dirty Devil River canyon. When Lake Powell was last full in 1999, this canyon was submerged beneath 80 feet of water. An expanse of new vegetation takes root atop the 120 feet of sediment that remains after the reservoir receded. October 2007.

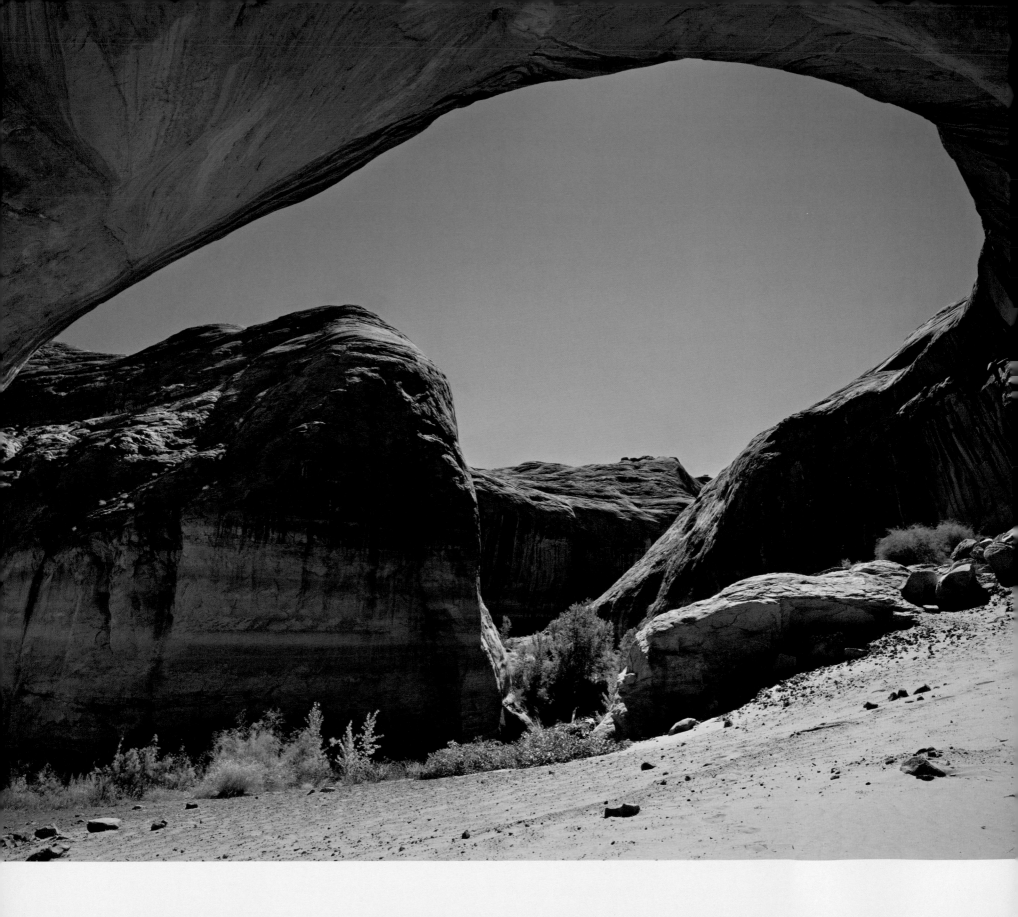

a mistake by allowing the dam. Like all big development projects on our land, it's always presented by the white man in the most positive way. It's always a one-sided analysis to fit their needs. The old Navajo people who made concessions with these white people, they were told lies about the dam.

"Native American people are always bringing up environmental issues," adds Nez. "But it's not until later that people realize that we shouldn't have compromised the resources, we shouldn't have disturbed the spirit of the living system."

Among the biggest cultural losses for the Navajo is Rainbow Bridge, which has long been a primary sacred and ceremonial site for the tribe. According to a provision added to the Colorado River Storage Act after the 1960s fight over the Grand Canyon dams, the reservoir was not to back up across the boundary of Rainbow Bridge National Monument. But when Lake Powell is full, the reservoir not only crosses into the monument, it flows under the massive span. Boats and Jet Skis can zoom right up to the base of the bridge, and camera-toting tourists swarm the slickrock base where Navajo medicine men used to conduct spiritual rituals in private.

"What happened to Rainbow Bridge shows complete disrespect for our beliefs and what is sacred to us," says Phil Bluehouse, a medicine man apprentice whose attempts in recent years to hold traditional ceremonies at the site have been interrupted by motorboats and tourists. "Hearing power boats echoing off the rocks during a ceremony at Rainbow Bridge, it became difficult to perform the ceremonies in the proper way."

In May 2005, when Lake Powell was near an all-time low—more than a quarter mile away from the span of Rainbow Bridge—a coalition of Navajo medicine men appealed to the Department of Interior to change the management of the reservoir to protect Rainbow Bridge as well as ruins and rock art that have been exposed in the many side canyons. But so far, their pleas for preservation have fallen on deaf ears.

"There are a lot of holy places that have been destroyed by the waters of Lake Powell," says Thomas Morris, a Navajo elder and medicine man who lives in Window Rock and is a leader of the Diné Medicine Men's Association. "We have old medicine people who talk about the ceremonies there; they learned how the canyon was made, how we were formed. We don't destroy the white man's altar, we don't destroy their Bible. For us, nature is holy; that's our altar. The symbols on the walls of Glen Canyon that are now underwater, those are our holy words. Our bible has been erased. Now we can't show these words to our young people to teach them where they came from, to make them believe."

Although many Navajo appreciate the economic benefits brought to the reservation by Lake Powell, Morris resents it. Morris and the Diné Medicine Men's Association also oppose the Navajo Nation's involvement in Antelope Point Marina, which they see as an adoption of Anglo values in an attempt to profit from tribal lands rather than holding steadfastly to their native ways. "The young people who work in Page, they know nothing about their spiritual traditions," says Morris. "They just want to make money. They're denying where they came from and who they are."

A QUESTION OF VALUES

The traditional Native American belief systems of the Navajo and Hopi could not be more different from the modern American values that justify the West's reservoir-based water infrastructure and that even view Glen Canyon Dam as a source of national pride. These

OPPOSITE *An enormous alcove in Davis Gulch, once flooded to a depth of 30 feet by Lake Powell, now restored to its prereservoir condition.* October 2007.

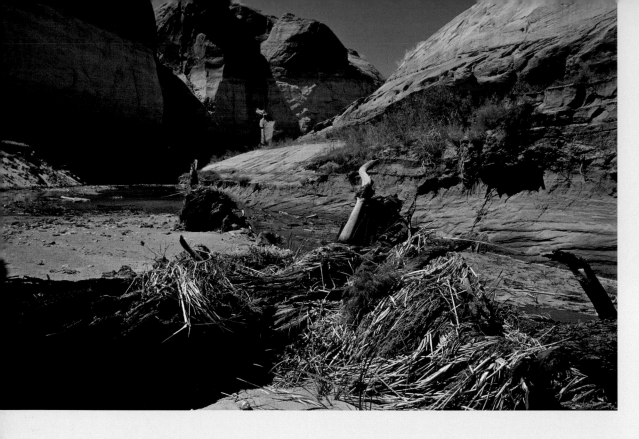

Flash-flood debris litters the floor of Smith Fork Canyon, as stagnant waters of Lake Powell pool in the bottom of the streambed at center left. June 2005.

OPPOSITE *Downstream view of the newly free-flowing Colorado River from just below its confluence with the Dirty Devil River. The dried and cracked mud in the foreground remains from the sediment deposited when the reservoir flooded this valley. Due to that sediment, the river now flows at an elevation 130 feet above its prereservoir bed.* October 2007.

two opposing worldviews are complicated and multifaceted to be sure, but they are rooted at the most basic level in how we view our relationship to nature.

On one side of the spectrum is a biocentric perspective. This view holds that all life on Earth is related and interdependent and that the health of humans is reliant on the health of the larger natural world. A foundation of many traditional Native American beliefs, this holistic view, what Vernon Masayesva calls Hopi science, dictates that humans respect natural cycles and ecosystems for reasons of spiritual significance and also as a means of long-term survival. According to this value system, what happened to Glen Canyon—altering living cycles by stopping the flow of a river and burying a canyon ecosystem with a reservoir—is both unwise and unethical. It is an egregious violation of the balance humans should maintain with the rest of the natural world.

Aldo Leopold was among the first Anglo-Americans to articulate this biocentric view, what he called a *land ethic*. "In short, a land ethic changes the role

of Homo sapiens from conqueror of the land community to plain member and citizen of it," wrote Leopold in *A Sand County Almanac*. "It implies respect for his fellow-members, and also respect for the community as such. In human history we have learned (I hope) that the conqueror role is eventually self-defeating." First published in 1949, Leopold's *A Sand County Almanac* became a seminal text for environmental conservation philosophy in the United States.

The "conqueror role" Leopold speaks of is the opposite worldview, a vision of life that puts humans apart—and above—the natural world. Historically, this has been the dominant view among Anglo-Americans since the Pilgrims landed on Plymouth Rock. This human-centered position insists that the creation of jobs and consumer spending generated by natural resource development is more important than negative impacts to ecosystems caused by that development. This view implies that making money carries a higher moral authority than environmental preservation because financial profit directly benefits humans. And then there's the assumption that any environmental problems caused by human-centered activities can be fixed with technology.

For the first two hundred years of U.S. history, this perceived separation between humans and wild nature derived in large part from the very real struggle of frontier settlers trying to survive in the wilderness without the knowledge and skills of their Native American neighbors. Rather than learn from Native ways, frightened Anglo settlers chose instead to eliminate both indigenous peoples and the wilderness that posed a threat. "Two components figured in the American pioneer's bias against wilderness," observes Roderick Nash in *Wilderness and the American Mind*. "On the direct, physical level, it constituted a formidable threat to his

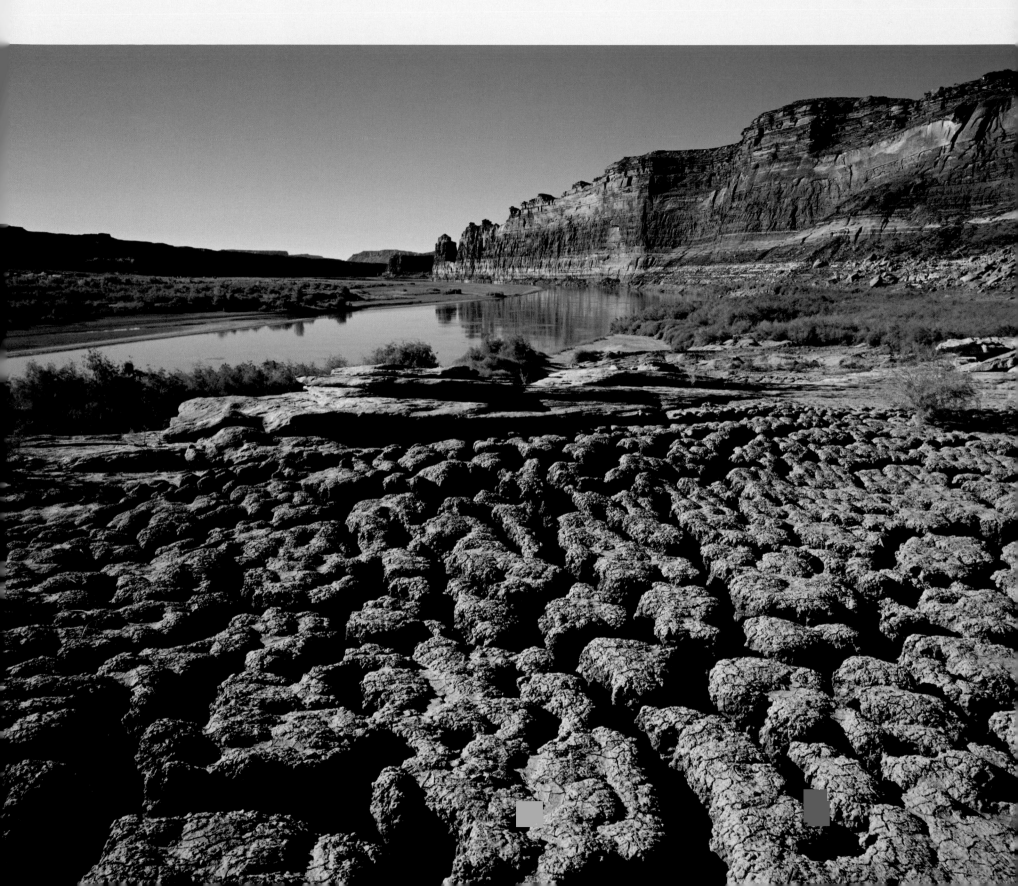

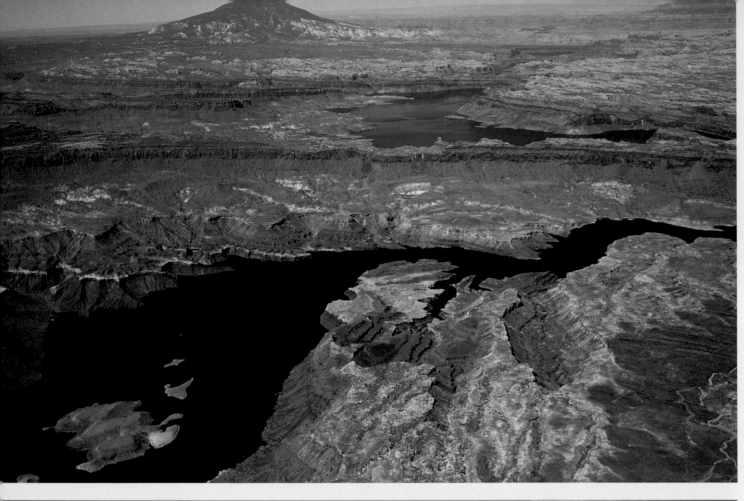

Aerial view looking southwest over the San Juan Arm of Lake Powell at full pool. Navajo Mountain rises above the surrounding red rock at the top left of the image, and Nokai Canyon is just out of view at left. June 1998.

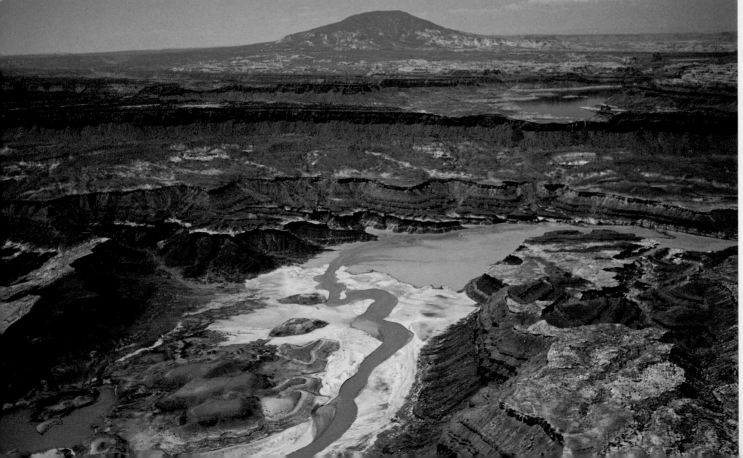

Aerial view of the San Juan River as it empties into the muddy waters of Lake Powell. The dramatic effects of drought can be seen by comparing this image to the one taken in June 1998. The reservoir level is now at 95 feet below full pool, and the reservoir has lost 50 percent of its total water volume. The delta of the San Juan River occurs 30 miles upstream of this location when the reservoir is full. June 2003.

very survival. In addition, civilized man faced the danger of succumbing to the wildness of his surroundings and reverting to savagery himself. The pioneer, in short, lived too close to wilderness for appreciation."

Moving into the twentieth century—after the American wilderness and Native cultures had been conquered—this bias against wild nature transformed into a drive to consume and destroy ecosystems in the name of economic growth. Post–World War II development was propelled in the western United States by insatiable consumption of natural resources in the form of logging, ranching, mining, and the systematic damming of rivers. Modern society, with its technological conveniences and increasingly urban, nonagrarian lifestyle, rose on the back of western wildlands and the replacement of natural systems with human-created mechanical ones. Dams, more than any other consumptive use, came to represent this transition to a technology-centered, mechanical view of the natural environment. Witness a sign hung in the hydropower plant at Glen Canyon Dam in 1965, still there in 2006: "The process of generating power from the energy of falling water is one of the technological wonders that has made civilization as we know it possible."

BIOPHILIA AND OUR LOVE OF LIFE

Yet no matter how human-centered our worldview may be, there is always a deep desire to connect in some way with the natural world around us. This has been borne out by broad support among U.S. citizens for environmental protection laws such as the Endangered Species Act and by social research investigating cultural attitudes toward the environment. A large Gallup Poll in the mid-1990s surveyed citizens in the United States and in sixteen European countries and found that 70 percent of study participants said they "strongly approved" of protecting wildlife and the environment.

Biologist and author Edward O. Wilson coined the term *biophilia* to describe this desire for connection to the natural world—"the innately emotional affiliation of human beings to other living organisms." Wilson argues that without this connection, humans are physically and spiritually impoverished. "Humanity did not descend as

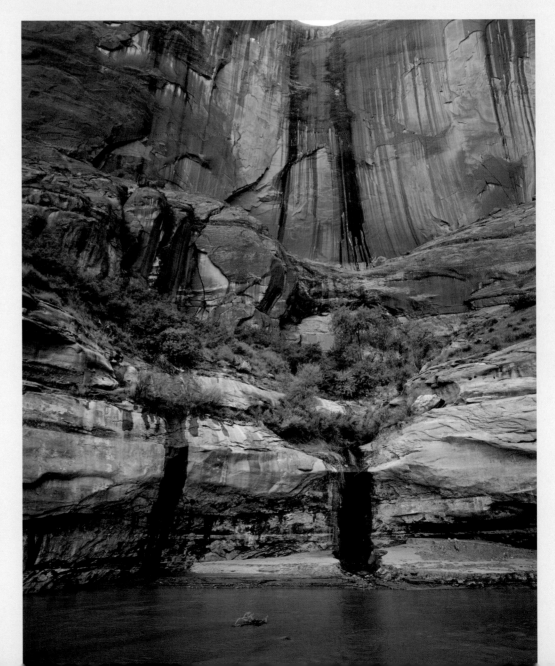

A restored waterfall drops into the now free-flowing Escalante River 2 miles upstream of Cow Canyon. When Lake Powell was last full in 1999, it flooded this section of the canyon to a depth of 80 feet, up to the base of the large cottonwood trees at center right. April 2007.

angelic beings into this world," he writes in *The Future of Life*. "We evolved here, one among many species, across millions of years, and exist as one organic miracle linked to others. The natural environment we treat with such unnecessary ignorance and recklessness was our cradle and nursery, our school, and remains our one and only home. To its special conditions we are intimately adapted in every one of the bodily fibers and biochemical transactions that give us life."

Before it was dammed, Glen Canyon—with its rich ecological diversity and spectacular canyon scenery—was a biophile's paradise. Popular nature writers such as Wallace Stegner and Edward Abbey chronicled their experiences in Glen Canyon, describing it as an unparalleled escape from the mechanized madhouse of modern society, an oasis of solitude, solace, and beauty. Experiencing that innate connection to wild nature is what inspired Abbey to call Glen Canyon the "living heart" of canyon country; he and seemingly all pre-dam hikers and river runners in Glen Canyon were profoundly affected by the awesome yet nurturing qualities of the wild landscape. And for those who did not see the canyon before it was flooded by Lake Powell, the dramatic photos in *The Place No One Knew* established a biophilic relationship to the doomed wilderness, albeit a vicarious one.

A FAKE NATURE FIX

JULY 2005—My eight-year-old son Austin has had his fill of Lake Powell: the nauseating boat-engine exhaust, the desert of open water, the lifeless shoreline of sizzling sand and rock. "Where are we going now?" he asks, skeptical about this place his parents are making him hike to called Smith Fork. He scans the barren sea of slickrock around us and scowls. Where is the fun? I point to the glowing green riparian area some 300 feet below that's nestled in the folds of a twisting orange canyon. "Just wait," I tell him.

We step into the drainage at the lake's old high-water mark. Upcanyon are sinuous narrows and a tunnel-like inlet that harbors a dark swimming hole, but we head downcanyon to explore the resurrected section of Smith Fork. We kick through a spring-fed stream that sparkles in the sunlight and is lined with young cottonwood and willow trees and towering alcoves sheltering fine, cool sand. "I love this place,"

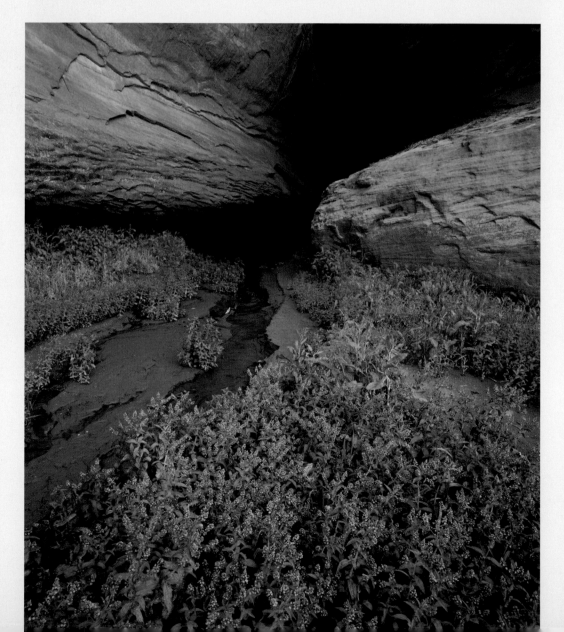

Wildflowers reclaim the floor of Smith Fork Canyon, formerly 100 feet below the surface of Lake Powell when it was last full in 1999. May 2004.

Austin proclaims after all of five minutes, scooping up tadpoles from the stream.

Compared to the one-dimensional landscape of the reservoir, exposed and recovering canyons like Smith Fork are a bottomless toy box of natural wonders. Before the dam, biologists chronicled some 500 species of plants and animals in Glen Canyon, including more than 150 different species of birds. It was an oasis in the desert, an orgy of ecological diversity. From where I sit in Smith Fork, it appears much of that life has returned, flocking like us to the ribbons of green.

We spend the day lazing about in this new Eden, watching the parade of life. Hummingbirds dive-bomb around our ears; a fat beaver slips into the stream; a bobcat bolts across a sandy terrace; we make toys out of willow twigs and lie flat on our backs watching "water music" shimmer its reflected light on the overhang above us. In search of the perfect lunch spot, we step through a curtain of cattails and discover a side drainage of algae-slick sandstone chutes that tumble into green pools where dragon-flies dance.

Eventually, our ramble downstream collides with the lake. We never actually make it to the reservoir, though. The stench of stagnant water, polluted sediment, and rotting fish stops us in our tracks. Death. We promptly turn around and follow Austin back to the land of the living.

Ironically, the marketing for modern-day Lake Powell attempts to tap into our most basic desires for an intimate connection to the natural world. A brochure produced by the national recreation area's concessionaire, Aramark, features a large people-less photo of sandstone

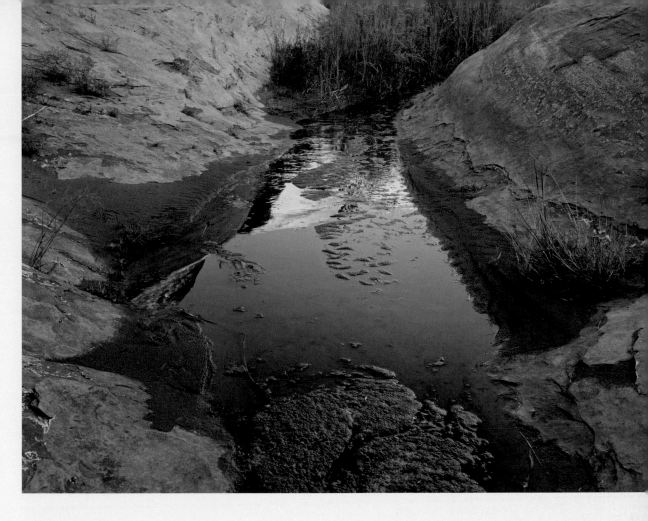

buttes rising from a placid sea, beckoning with adjective-laden text: "Brilliant blue water. Spectacular red rock. Vivid pink sunsets and nights full of stars. Stake out a spot on fine-grain, salmon-colored sand. Explore the lake's surreal formations in a powerboat or by personal watercraft or kayak…Lake Powell is extraordinary. Chart your own adventure."

However, there is not much in Lake Powell beyond stocked sport fish to satisfy a true biophile; the web of life that nourished the rich ecosystem of Glen Canyon has been covered with hundreds of feet of water. In the immediate vicinity of the reservoir (the lake itself and within about 500 feet of the shoreline) nothing lives—no soil, no songbirds, no springs, no ferns, no mammals, no flowing river—only rock, sky, and trapped water. None-theless, many people who never experienced pre-dam

A stream once 75 feet below the surface of Lake Powell flows through a water-sculpted bowl in Smith Fork Canyon. October 2007.

Fiftymile Creek. As the water level of Lake Powell dropped, flash floods swept away 30 feet of accumulated sediment to reveal this small waterfall and sandstone bowl. October 2007.

Glen Canyon have developed a strong connection to Lake Powell and regularly visit the reservoir for their version of a nature fix.

In a world where truly wild nature is increasingly hard to come by, Lake Powell may very well be the equivalent of a wilderness experience for people who live in places far more developed than the reservoir. "I have never lived a day without Lake Powell. I didn't even know that there was such a thing as Glen Canyon until years after I had first been there," noted environmental writer Kathryn Miles in the summer 2006 issue of the journal *Reconstruction.* Miles described with deep sentimentality her connection to Lake Powell based on many family trips there during her childhood. For her, it was a place of natural beauty and sanctuary. "My notion of 'natural' was created on the lake long before I could read or understand its creation…What I remember most about Lake Powell: silence of the sort that only wilderness can provide. That is what I, as a young child, took away from the once-canyon, and that part of my history is what defines me today."

Increasingly, our society's encounters with nature are manufactured ones and, compared to our pioneer ances-tors, we are less and less familiar with what constitutes true wilderness. We begin to believe that houseboating amid the dead landscape of Lake Powell is a legitimate replacement for the authentic wilderness and abundant ecological diversity of pre-dam Glen Canyon. We rob ourselves of a relationship with nature because we have forgotten what nature—in terms of a fully functioning ecosystem—really is. The value of practicing Hopi science and protecting natural cycles, like a free-flowing Colorado River, is lost on us.

"The more we rely on technology to mediate our relationship to nature, the more we encounter the same trade-off: we have more power to process what we need from nature more conveniently for more people, but the sense of awe and reverence that used to be present in our relationship to nature is often left behind," writes Al Gore in *Earth in the Balance.* "This is a primary reason that so many people now view the natural world merely as a collection of resources…But the cost of such perceptions is high, and much of our success in rescuing the global ecological system will depend on whether we can find a new reverence for the environment as a whole—not just its parts."

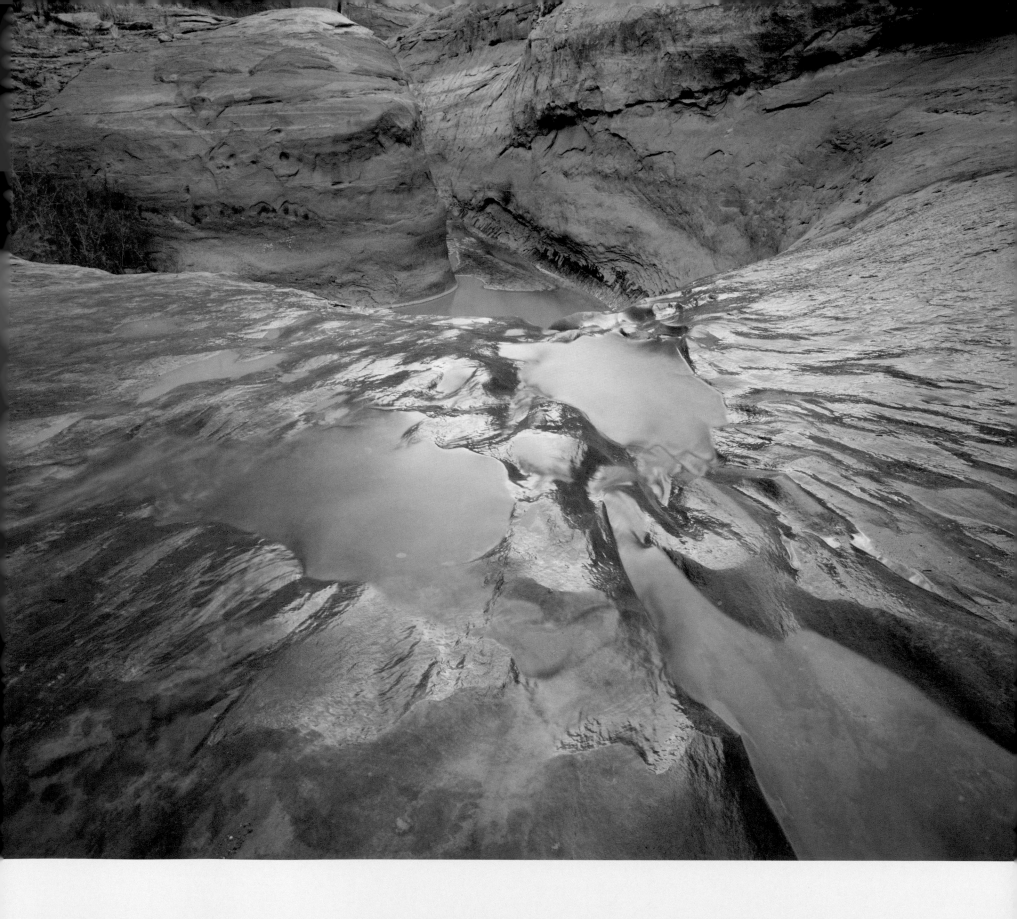

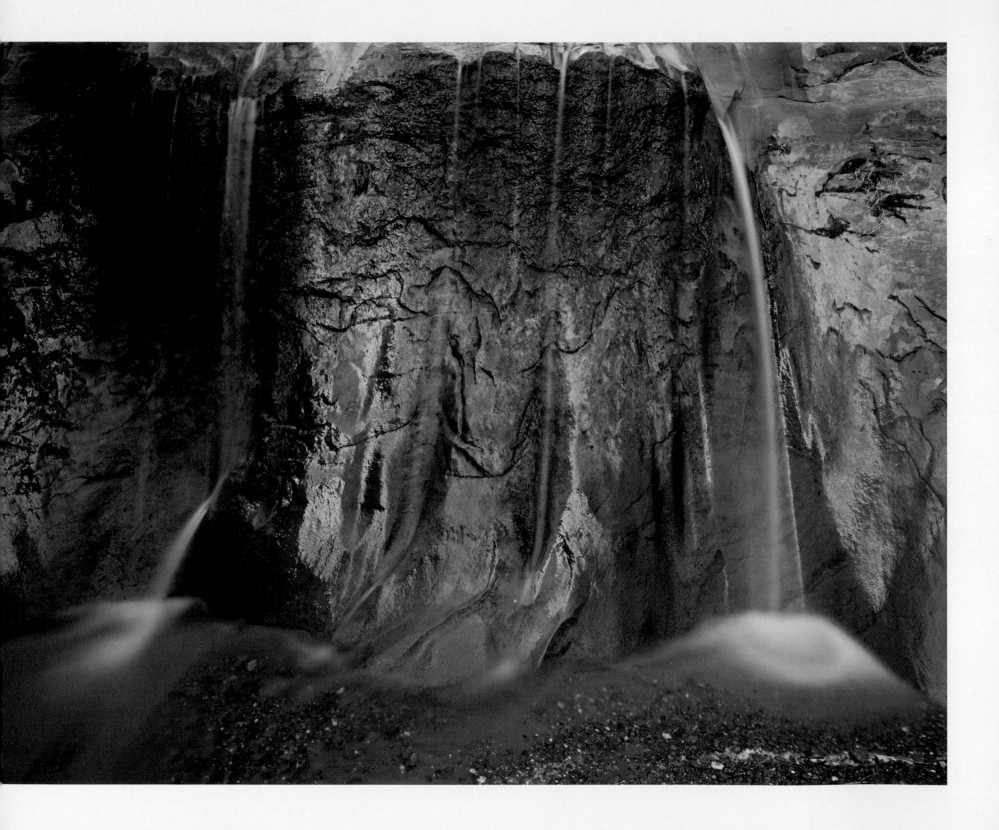

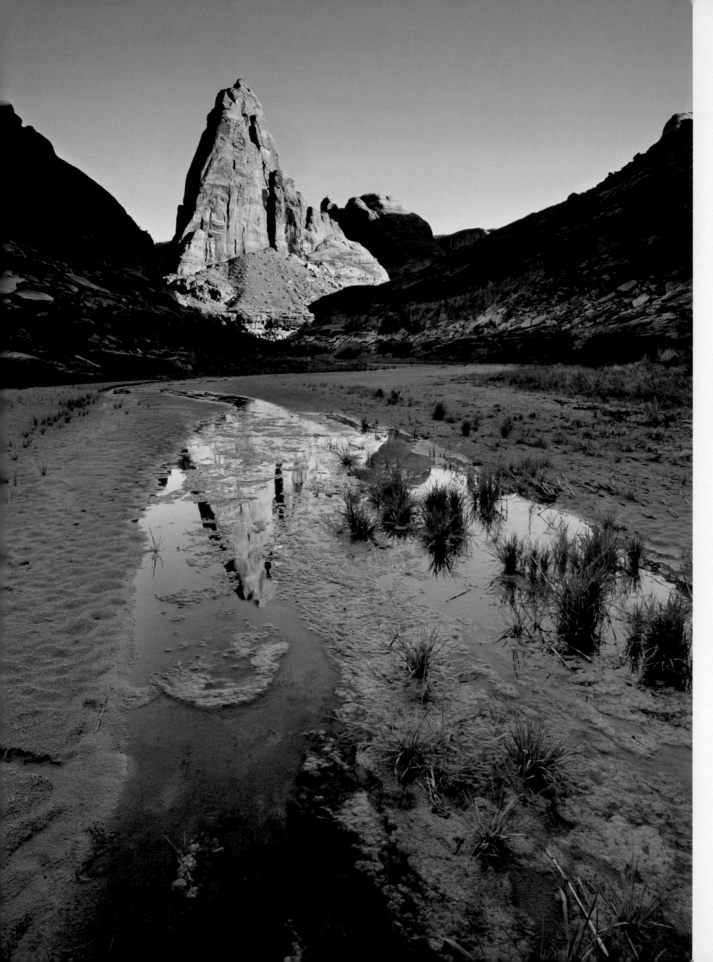

OPPOSITE *A recently revealed waterfall in Davis Gulch. Once 70 feet below the surface of Lake Powell and smothered beneath 20 feet of sediment, this waterfall was restored after a flood in October 2006. October 2007.*

Moonlight Spire rises in the middle of Escalante Canyon just upstream of Cow Canyon. The Escalante River flows along the foot of the spire, out of view. The flat, sandy area in the foreground is river-deposited sediment, which is slowly being washed out by flash floods. April 2007.

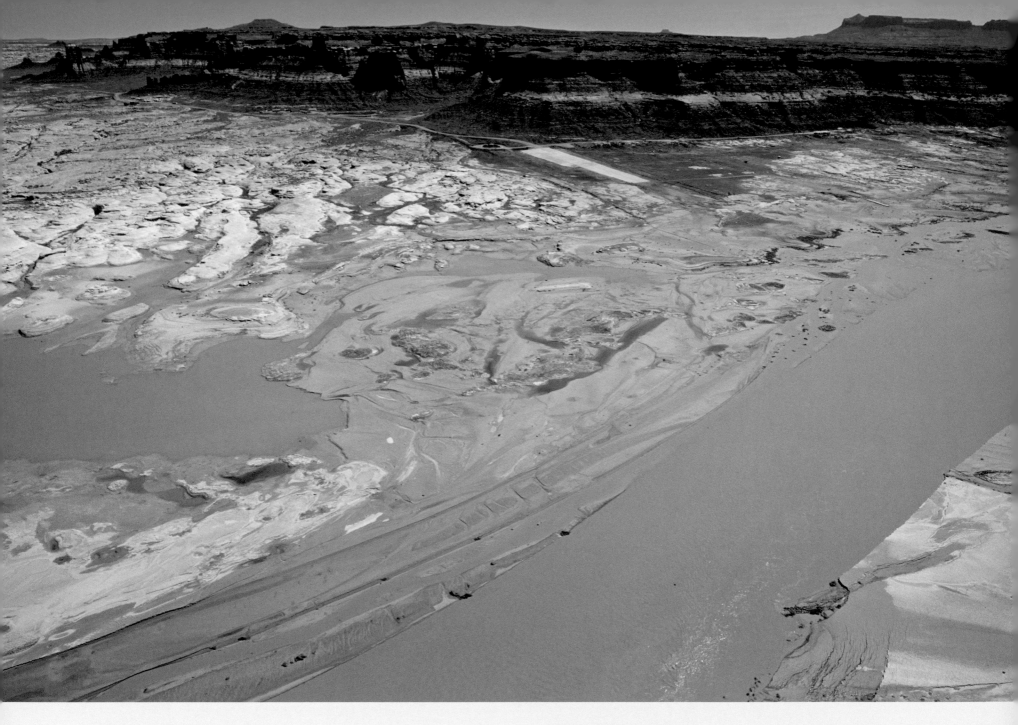

View from Hite Overlook of the high-and-dry Hite Marina boat ramp (upper center of image). The reservoir had drained out of this valley the previous winter season to half a mile downstream. April 2003.

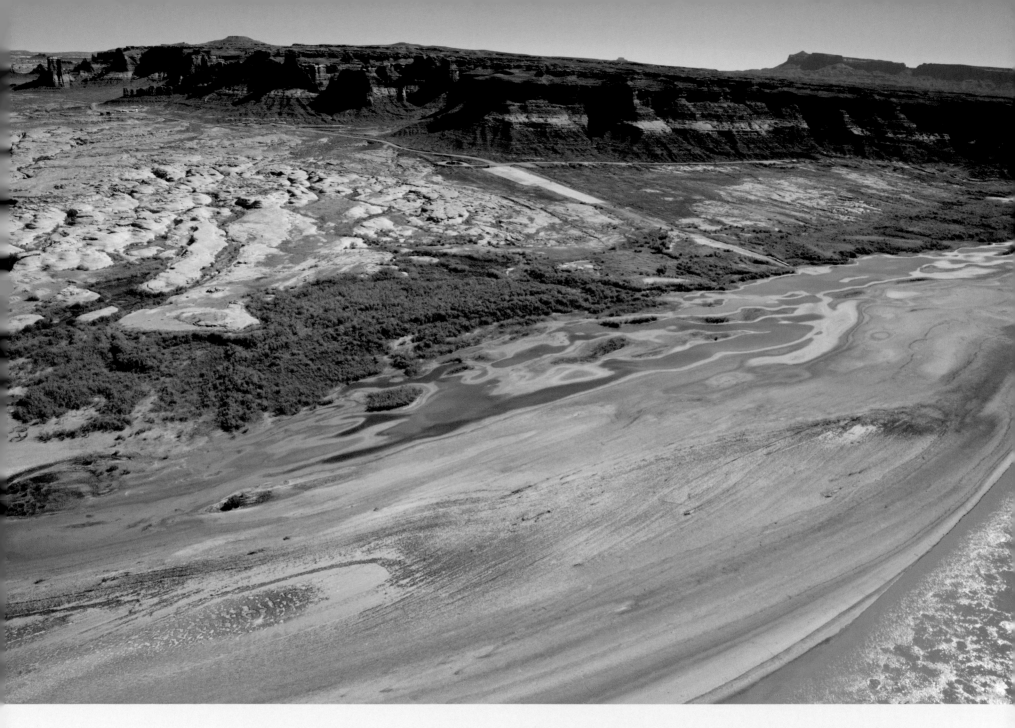

High-and-dry Hite Marina boat ramp (top center) viewed from Hite Overlook. Compared to the image taken in April 2003, the Colorado River has shifted far to the lower right and now runs along the base of the cliffs, where it is barely visible. Vegetation now carpets the valley floor. At one time, the reservoir filled this valley to a depth of 230 feet above the original riverbed. October 2007.

LIVING FOR THE FUTURE

MAY 2003—AFTER SEVEN HOURS OF HARD DRIVING, I'm tired and perhaps a bit delusional. My friend Eli and I are pulling into Hite Marina on the northern end of Lake Powell around 10:00 PM. Listening to heartbroken Katie Lee ballads through the car speakers, I drift in velvety blackness down the marina road looking for a campsite. It is so dark that even the high beams don't help much.

I squint into the tunnel of light, continuing down the blacktop. We don't want to pay to stay at the park campground, so we keep driving toward the lake. The road abruptly becomes white and broad—it looks like rippled concrete. "Are we driving down the boat ramp?" I ask Eli, not believing my tired eyes.

It's too dark to see what lies far ahead or around us. But we are definitely on the boat ramp. "Keep going!" urges Eli, excited that the drought has lowered Lake Powell much more than we expected. Then, at the end of the high beams, we see what looks like brown dirt, not black lake. We keep driving, off the end of the boat ramp and onto the lakebed where boats once docked far above our heads. Certain the lake must be nearby and waiting to swallow my car, we park and set out on foot.

The fully exposed length of the Wahweap Marina boat ramp leads down to the waterline of Lake Powell after the reservoir has lost nearly 70 percent of its capacity. April 2005.

We follow the narrow shafts from our headlamps and leap from one hardened silt island to the next, across a parched lakebed that was at the bottom of deep blue waters a few years before. The scene is surreal and I don't trust my senses. I hear a roaring sound, like a wind gust in a forest. Eli hears it too.

We have walked perhaps a quarter mile and the sound is growing louder. I tell myself it must be some kind of boat generator or machinery at the dock. But where is the dock? Where are the boats? Our head-lamps illuminate buoys and old boat anchors stranded on the lake floor.

The sound is so loud now I can barely hear what Eli—100 yards ahead of me—is saying. "What?" I shout. He has reached the source. It's something I thought I'd never see or hear.

"It's the Colorado!" he shouts back incredulously. "It's flowing!"

I love the soothing sound of water rushing over rock, especially when it's water from the Colorado River. As I wait at a stoplight at the intersection of Interstate 17 and Anthem Way, I roll down my car window to listen to the fake waterfall marking the entrance to one of Arizona's most successful master-planned communities. Over the hum of some fifty idling engines, the giant cascade roars, sounding neither like the rapids in the Grand Canyon nor the gentle slickrock streams of Glen Canyon, but more like a fire hydrant flooding onto a street.

I have zoomed past Anthem scores of times en route between Flagstaff and Phoenix, scorning this booming suburb from afar for the way it bladed pristine desert and contributed to sprawl, smog, and for the hubris of building yet another city where there is no natural water supply. But in September 2006, I decided it was finally time to visit Anthem, if only out of curiosity about what draws people to this massive incarnation of suburbia 30 miles from Phoenix, invented by real-estate specula-tors and kept alive by a preposterously long umbilical cord to Colorado River reservoirs. The remote and wild sandstone chasms of Glen Canyon may seem a long way from the fake waterfalls and stucco facades of Anthem, but these two places are intimately intertwined. The prevailing logic among business and government inter-ests in western boomtowns from Los Angeles to Phoenix goes something like this: the existence (and financial success) of giant desert suburbs like Anthem justifies the existence of giant reservoirs like Lake Powell, and vice versa.

Recent census data shows that Phoenix is now the fifth-largest U.S. city; Los Angeles is number two and San Diego is number seven. All three of these cities are in desert environments with anemic groundwater supplies;

Lake Powell's white "bathtub ring" stains the cliff behind a four-year-old, 30-foot-tall cottonwood in Lake Canyon. The soil at the base of this tree first dried out four years before this image was taken, as the reservoir retreated downcanyon. April 2006.

An old cottonwood log provides shade for new grass shoots growing in the recently restored streambed in Smith Fork Canyon. October 2007.

their main source of water is the Colorado River, pumped out of reservoirs from hundreds of miles away. And nine of the nation's ten fastest growing cities are suburbs of these arid metropolises, located in the deserts of California, Nevada, and Arizona. All nine of these fastest growing cities have no local municipal water source and rely completely on a manufactured supply that is pumped through canals from Colorado River reservoirs.

Established in 1998 by Del Webb, a subsidiary of Fortune 500 megabuilder Pulte Homes, Anthem now claims more than 20,000 residents living in 12,000 households. The city materialized virtually overnight on 6,000 acres of rural land that had been home to a few dozen families who drew their water from deep wells or trucked it in. To create Anthem, Del Webb signed a hundred-year lease with the eight-hundred-member Ak Chin Indian community located on a small reservation south of Phoenix, who sold their Colorado River rights

to the developer because this proved more lucrative than using the water for farming.

Now, snowmelt from the Rocky Mountains flows down the Colorado River thousands of miles through Lake Powell, Lake Mead, and into Lake Havasu, from where it is pumped 330 miles through the Central Arizona Project canals to Phoenix. Then, instead of going south to the rural Ak Chin reservation, the flow is sent 50 miles north through a massive pipeline to the manufactured oasis of Anthem, feeding the waterfall, thousands of homes, as well as a wonderland of parks and pools. (When I inquired about water supply at the Pulte Homes sales office, two different real estate agents insisted Anthem's water came from a "huge aquifer underground.")

Del Webb's marketing slogan for Anthem is: "We built the place. You build the life." The showcase of this "place" revolves around a seemingly limitless supply of

Yellow evening primrose blooms in Forgotten Canyon, at a location last inundated by Lake Powell three and a half years prior. October 2005.

water. There is the Big Splash Water Park where 400,000 gallons spill from a huge bucket into a swimming pool; there are three community swimming pools, a large man-made lake, two eighteen-hole golf courses, and 50-plus acres of irrigated ball fields. All of Anthem's brochures, billboards, and commercials steer clear of acknowledging the community's Sonoran Desert environment. Photographs show smiling children and parents frolicking in the water park and on the putting greens, but never among the cacti and rocky hills that encircle Anthem. While Del Webb spent millions of dollars building schools, a community center, playgrounds, and picnic ramadas, the master plan does not include a single acre of desert preserve beyond the alleylike washes necessary for storm runoff. There are no hiking trails leading into the surrounding wild landscape, no bridge between Del

Webb's blatantly fake, manufactured vision of place and the authentic place, the waterpoor yet ecologically rich Sonoran Desert.

As I walk the winding white cement paths around Anthem's catch-and-release fish pond, past the water slides and through the grassy ball fields, I feel I have stepped into the Frankenstein version of the American Dream. The Central Arizona Project was originally presented to taxpayers as a means to support agriculture in a largely rural state, but instead the massive irrigation program has created an environmental monster. In the midday heat, the water park is packed, full of screaming children, but the ball fields are empty; it's just me and dozens of rabbits hopping about through the steady mist of sprinklers. I venture across the street and into a neighborhood called Jubilation, where cookie-cutter houses are crammed onto tiny lots. These homes are only five years old, but the stucco facades are already fading from the desert sun—and almost one of every ten houses is for sale, and some are in foreclosure.

It appears that "the life" people tried to build according to Del Webb's alluring sales pitch didn't pan out in this neighborhood. For whatever reason—the commute was too long, the mortgage was too high, the summer was too hot—many homeowners in Anthem are moving on, and probably to another new home in another sparkling desert subdivision fed by an artificial water supply. This is what many have been socialized to see as the American Dream in the same way they see Lake Powell as wild nature.

In December 2005, the *Arizona Republic* marked the twenty-year anniversary of the Central Arizona Project, celebrating the engineering feat but acknowledging its dark side. "The $3.6 billion CAP is the mightiest of mighty acts that allowed modern civilization to exist in

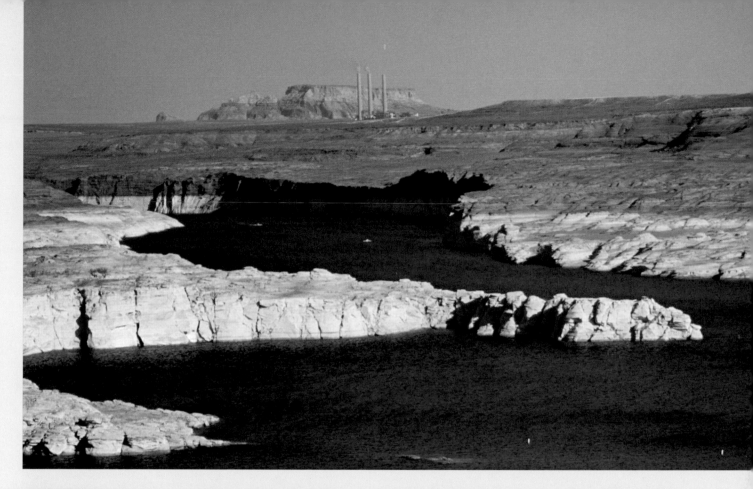

Lower Wahweap Bay with the water level of Lake Powell 95 feet below its full-pool elevation. At this level, the reservoir has lost 50 percent of its total water volume. At full pool, the water would fill the entire frame except for the area across the lake above the white "bathtub ring" of the reservoir. April 2003.

Two years later, the water level in Lower Wahweap Bay had dropped another 50 feet. At this water level, the reservoir has lost nearly 70 percent of its total volume. The 775-foot-tall stacks of the coal-fired Navajo Generation Station dominate the desert skyline near Page, Arizona. April 2005.

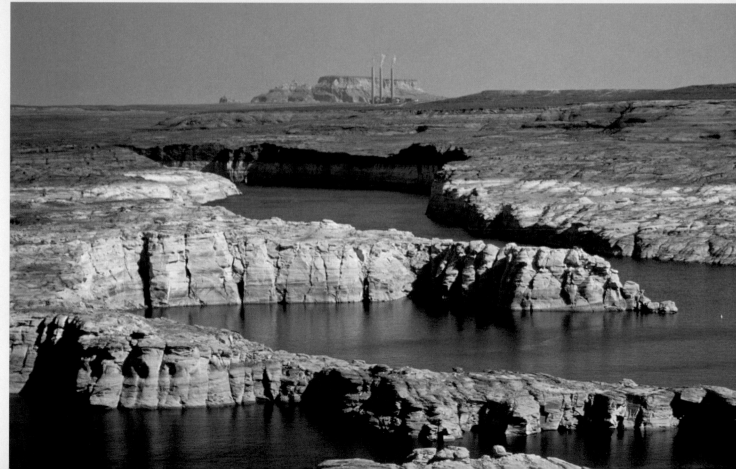

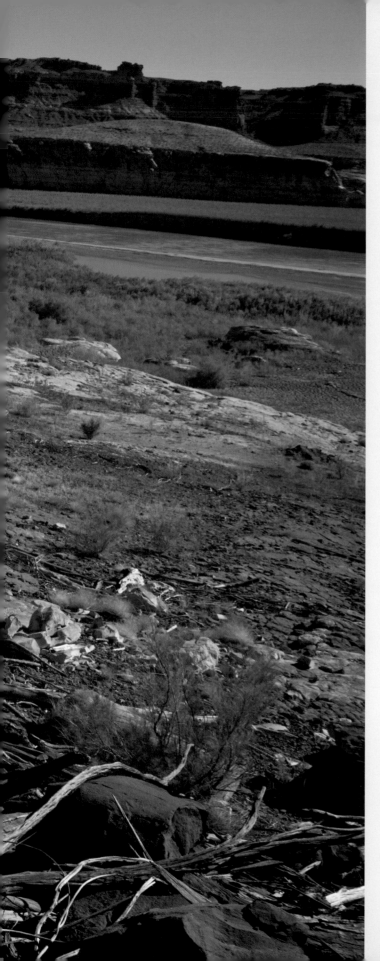

a hostile desert, an audacious denial of the limits of the West," wrote columnist Jon Talton. In two decades the CAP enabled Greater Phoenix to grow from 500,000 to 3.5 million people. Talton interviewed Jack August, director of the Arizona Historical Foundation, about the CAP's impact on Phoenix. August remarked, "If it had never been built, we'd have a smaller population and, psychologically, people here would be living within certain environmental limits." Instead, the attitude among Phoenicians is just the opposite. "We think there's always going to be water. It's like having a rich grandfather and we don't have to work."

The "rich grandfather" myth works well for large home builders like Del Webb that need to turn a quick profit on enormously expensive speculative investments such as Anthem. But it doesn't work well for the taxpayer who must pay for the utilities, roads, and freeway improvements as well as for social costs like commuter-generated smog and the loss of desert wildlands. Carol Erwin, manager of the Bureau of Reclamation's CAP office in Phoenix, admits that the use of water resources has gone terribly awry in her desert metropolis. "You could argue that bringing CAP water into Phoenix did nothing but eliminate the need for the Phoenix area to make the hard decisions about whether or not they were going to continue to grow and how they were going to do it," she observes. "The question now is, what do we do with it? It was supposed to be for agriculture but the farmers couldn't afford it, so now we're selling the water to home builders."

The difference between using CAP water for homes instead of agriculture (aside from facilitating sprawl and its associated environmental problems) is that if drought significantly decreases supply, then the consequences are much greater—taps running dry rather than fields lying

Driftwood deposited along the old shoreline of Lake Powell when it was last full in 1999. The Colorado River is visible in the upper right. October 2007.

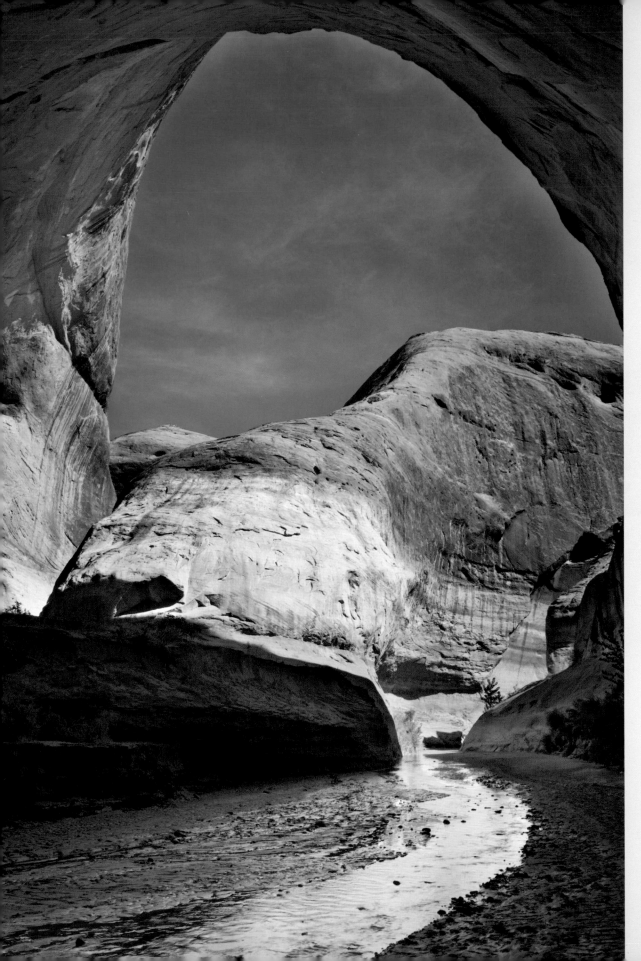

fallow. Unlike the upper Colorado River basin, which has yet to utilize its full allotment of water under the Law of the River, the lower basin is exceeding its share and Arizona is a junior partner to California. There is simply not enough water to sustain the lower basin's sprawling desert cities given climate change and current patterns of consumption.

Regardless of how long the current drought continues, communities like Anthem that rely on distant reservoirs are ultimately doomed, according to University of Utah professor and water policy expert Daniel McCool. "Lake Mead and Lake Powell will fill up with sediment eventually. All these dams are temporary," he says. "If we build a society based on a water supply from behind dams, we are destined for catastrophe—that's the definition of a society that has outconsumed its habitat. It's like quitting your job and living off savings."

Flaunting its image as a manufactured oasis, the slogan adopted in 2005 by the Phoenix Convention and Visitors Bureau is "the desert is a myth." It doesn't take much—hike any direction from Anthem in July or take a look at Southwest climate predictions—to realize that the desert is, in fact, very real. Isn't Anthem and the golf-course-in-the-desert lifestyle the myth? And yet, Americans keep buying into this version of the American Dream in droves. In December 2007, the U.S. Census Bureau reported that Nevada—the state with the least amount of rainfall—experienced the nation's largest percentage increase in annual population growth.

How is such a twisted reality possible? Anthropologist and author Jared Diamond attributes our blind acceptance of such circumstances to "creeping normalcy," along with a bad case of "landscape amnesia." In his book *Collapse*, Diamond analyzes the demise of numerous civilizations throughout human history. He writes that these

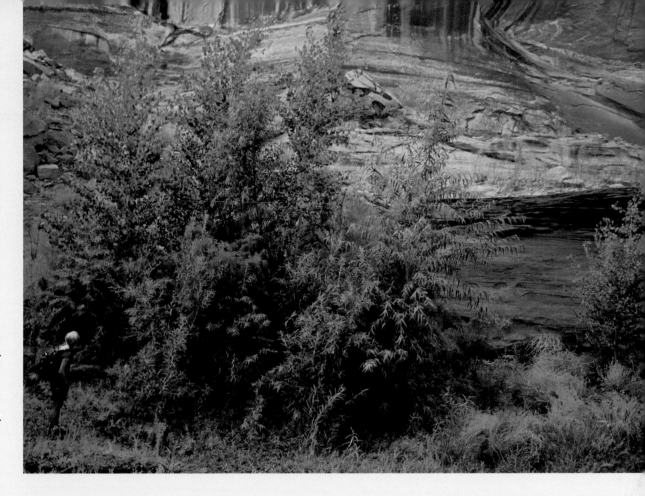

societies ultimately failed for a variety of reasons, but in almost every scenario circumstances gradually worsened over successive generations, and people were unable or unwilling to perceive the pending collapse because they had become used to their unhealthy surroundings.

Creeping normalcy, as described by Diamond, is a "shifting baseline" whereby people adjust to environmental conditions that are deteriorating so gradually that nothing seems amiss. Likewise, landscape amnesia also encroaches over a series of generations so that, for example, if Lake Powell were to exist at full capacity for several hundred years, there would be no memory of Glen Canyon's original landscape or of what was lost. Likewise, with fifty-plus years of artificial water supplies piped from the Colorado River, many residents of southern California, Nevada, and Arizona have no idea what the original desert around their homes looked like.

More broadly, many Americans have been lulled into thinking that smog, sprawl, desert water parks, insatiable consumerism, and throwing much of what they buy into a landfill within five years is normal. It is not—at least not for the natural ecosystems being affected by this activity. The toll that this unsustainable yet widely accepted lifestyle is taking on the global environment is potentially catastrophic, causing climate change, mass species extinction, and the pilfering of what's left of the world's natural resources to support America's shopping habit.

Based on assertions from the majority of the Western world's scientific community that the planet is in dire straits, we live in a frightening time—but it is also an important time. Western civilization has reached a fork in the road and the choices we make (or don't make) in the near future will likely determine the long-term survival of the United States and, perhaps, of all humanity.

As Diamond points out in *Collapse*, the choices we face are highly controversial, even painful, but are absolutely necessary if we are to change what he calls "a bad status quo" that threatens our society more than most of us realize. "It appears to me that much of the rigid opposition to environmental concerns in the First World nowadays involves values acquired early in life and never again reexamined," he writes. "Perhaps a crux of success or failure as a society is to know which core values to hold on to, and which ones to discard and replace with new values when times change."

THE GLEN CANYON SOLUTION

But how do we identify which "core values" to keep and which to abandon, as Diamond suggests, in the interest of our collective survival? The best place to start is to take a hard look at the human-centered values that have been

Three-year-old cottonwood trees growing along the streambed in Seven-mile Canyon, at a location once 75 feet below the surface of Lake Powell. October 2005.

OPPOSITE *Looking upstream along Fiftymile Creek from the floor of a 200-foot-tall undercut. Lake Powell's "bathtub ring" can be seen high on the canyon wall at the center of the image.* October 2007.

A frog reclaims its territory along the newly restored stream in Sevenmile Canyon, where the sound of roaring motorboats has been replaced by croaking frogs. October 2005.

OPPOSITE *Water seeping from a canyon wall along Fiftymile Canyon provides a foothold for new algae growth, at a location once 90 feet below the surface of Lake Powell. The kaleidoscope of color results from the reflection of the brightly sunlit canyon wall across the way.* October 2007.

driving modern culture in general and the United States in particular for centuries.

First is the dominant worldview that humans exist apart from or above the rest of the natural world, that we do not require the aid of Earth's wild, natural systems to survive. Second is the related belief that economic development and the Western world's notion of progress, or improving one's quality of life, can only be accomplished at the expense of the environment through the consumption of natural resources and destruction of wild systems. These are among the core values upon which our nation was founded and that fostered its growth into the most powerful country in human history. These are the values that drove us to settle the wild frontier and to build dams on the mightiest rivers, developing sprawling cities in the desert and creating a comfortable lifestyle that is the envy of the world. And these are the values that threaten to destroy us.

If American society really wants to move forward into a healthy future, we must be willing to leave the crumbling castles of the twentieth century behind—the dams, the Del Webb developments, the freeways, the megamalls. We must be willing to turn creeping

normalcy, our current economic system, and even our own consumer-oriented, car-loving lifestyle on its head.

Rather than living in a world defined by short-term financial gain and immediate benefit for a small but powerful business and political elite, we must adopt a new organizing principle that is infinitely sustainable, organically self-limiting, and naturally supportive of future generations. This new model is actually not new at all, but is as old as the first cell and the first living organism on Earth. This old new way forward is the process of regeneration, the blueprint that all wild systems follow to sustain life. It is happening right now with a vengeance in the far reaches of every twisting side drainage in Glen Canyon.

The process of regeneration relies on natural cycles and the innate resiliency of life. Essentially, any natural cycle that occurs independent of mechanized human interference is part of a cyclical process of regeneration, ranging from the cell reproduction in our own bodies to the way the oceans regulate climate. Unfortunately, it is increasingly difficult to find natural cycles that are not suffering from human impact. The goal of this new standard for living in the American West should be to allow as many of the planet's wild, natural processes to resume or continue without human meddling. This means that rivers, including the Colorado, should flow to the sea and billions of tons of sediment should flow through the Grand Canyon. All species should have adequate habitat. The deserts should stay dry and the swamps wet. And the Earth's web of life should spin according to its own rhythms.

This model demands that we find ways to operate our economic and social infrastructures that are compatible with the Earth's natural cycles of regeneration. As Al Gore notes in *Earth in the Balance,* we must keep the

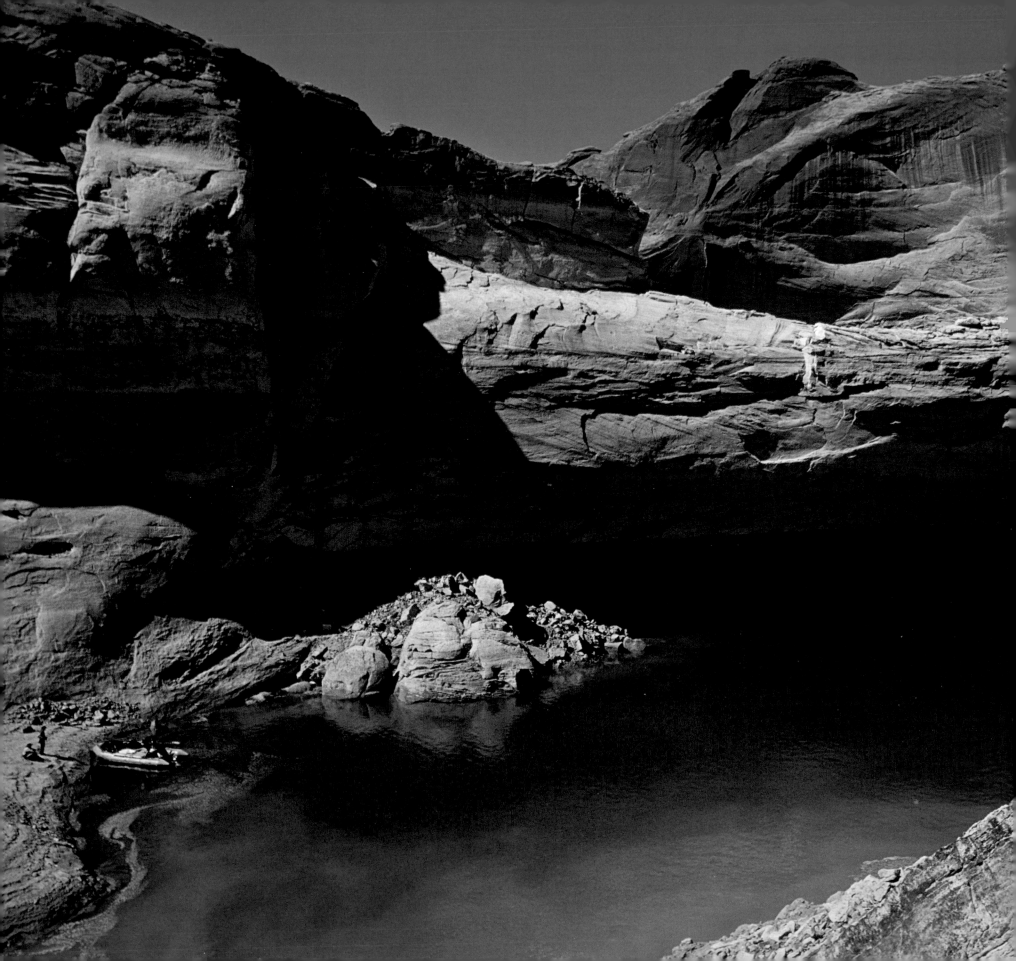

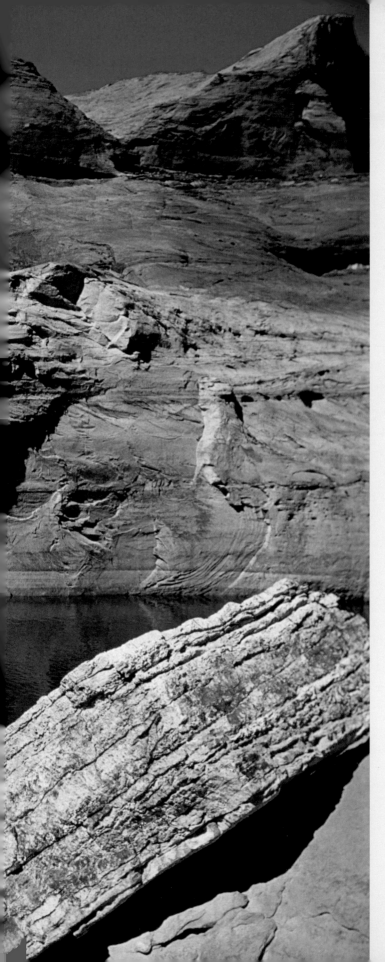

impacts of human ingenuity and material desires in check if we are to survive. "Often," Gore writes, "when we seek to artificially enhance our capacity to acquire what we need from the earth, we do so at the direct expense of the earth's ability to provide naturally what we are seeking."

The task of trying to save human life as we know it may seem overwhelming, but fortunately we have Glen Canyon to show us the way. The "place no one knew" that is coming back to life of its own accord is literally and metaphorically our common ground, our stage for replacing dysfunctional systems and government policies with a new version of the American Dream. Protecting Glen Canyon would not only require owning up to a past mistake, but would by necessity involve revisiting western water policy, which would lead to a review of economic development and the political machine in western states. In short, a public decision to celebrate and protect the regeneration in Glen Canyon would also be a decision to support a new American West that is based on sustainable practices and economic restraint rather than on unchecked growth at the expense of the environment and taxpayers.

After five years of drought, the top of Gregory Bridge in Fiftymile Canyon emerges from the waters of Lake Powell. After losing nearly 70 percent of its total water volume, the reservoir had dropped to 140 feet below full pool. Notice the high-water mark on the canyon wall at far left. April 2005.

A step-by-step guide to saving Glen Canyon and then, perhaps, the world

[ONE]

Incorporate an honest accounting of environmental preservation or destruction in First World economies.

According to Al Gore, the free-market capitalist economy that defines the United States and most Western countries is "partially blind." As he explains in *Earth in the Balance,* our capitalist system only sees commodities that can be bought and sold, but it assigns no value to aspects of our natural world that are critical to a healthy society, not to mention necessary for making all the commodities that are bought and sold. This includes things like a functioning global atmosphere, clean air, freshwater, old-growth forests, fertile topsoil, biodiversity, and, simply, the scenic beauty of wild landscapes.

Gore also notes that in calculating the U.S. gross national product (GNP), industry depreciates machinery and equipment used to make products, but it does not depreciate resources, such as air quality or forests, that were also negatively affected during the manufacturing process. "Classical economics…fails to account properly for all the costs associated with what we call consumption," writes Gore. The waste created in the process of making the products we consume is not factored in to the cost of those products and is "conveniently forgotten" by modern economics as well as by society.

"In the long term, the economy and the environment are the same thing," noted Mollie Beattie, former director of the U.S. Fish and Wildlife Service, in 1996. "If it's unenvironmental, it is uneconomical. That is the rule of nature." Additionally, an environmentally sustainable economy requires that we remove the blinders and account for the cost of natural resource depletion as well as attach value (financial and social) to not depleting resources. Gore argues that "economic rules" must be changed so that the definition of GNP includes environmental costs and benefits. He also says that the definition of productivity should be changed to reflect calculations of environmental improvement or decline.

When Glen Canyon Dam was being considered by Congress in the 1950s, the only value attached to the project was the money that could be made from generating hydropower. All that was buried under the reservoir—the Native American sacred sites, riparian ecosystems, unique species—were deemed to have no value. Today, there are other gains associated with the dam and Lake Powell, including reservoir tourism and the facilitation of more development in the desert, but the 1950s value system that only acknowledges short-term financial profits still dictates government decision making. If we were to apply a more enlightened economic valuation system, the direct costs of Lake Powell—such as sediment backup, water lost to evaporation, the inundation of cultural heritage sites, and the destruction of the Grand Canyon—far outweigh potential benefits. In fact, from the standpoint of water waste alone, the reservoir-based infrastructure in the West is outrageously expensive.

And then there are the indirect costs of what Lake Powell and other Colorado River reservoirs perpetuate: urban sprawl, loss of biodiversity, large-scale agribusiness pushing out family-owned farms, water pollution from industrial agriculture, air pollution, and climate change, to name a few. Meanwhile, a restored Glen Canyon would eliminate direct costs of the dam and would significantly reduce indirect costs by helping to wean the West from its reservoir-based infrastructure. Yet, the new attraction of Glen Canyon would likely contribute equal or even more tourism dollars to the region, not to mention adding immensely to the biodiversity of the Colorado Plateau, especially in terms of saving the riparian ecology of the Grand Canyon.

"Glen Canyon is the future of this region, and Lake Powell is the past," says Glen Canyon Institute's Richard Ingebretsen. He maintains that local economies as well as the environment would be better off if Glen Canyon National Recreation Area shifted to a land- and river-based national park rather than remain dependent on an unsustainable, fake lake. "We are presenting a solution to the people of Page, not a threat. Visitors would come from all over the world to see a restored Glen Canyon."

[TWO]
End corporate welfare in the form of agricultural and water subsidies.

Before the recent drought and the development boom in the Southwest, it was easy for most taxpayers to shrug off excessive irrigation subsidies and the monopoly agribusiness enjoys regarding the West's water supply. But times have changed and, even according to old-style capitalism, it is no longer economically or environmentally sustainable to subsidize wasteful irrigation practices to grow low-value crops like alfalfa at taxpayer expense.

"If we simply quit subsidizing agriculture, it would free up millions of acre feet of water because so much of western agriculture makes no economic sense," says University of Utah political scientist Daniel McCool. "If we just charge market price for the water, then the businesses that survive will be the ones who are providing a product people want and are willing to pay for."

Ending unchecked irrigation subsidies would not only eliminate water waste, but would also level the playing field so that smaller, regional farms could irrigate crops for the same price as large agriculture firms. Ending subsidies would, ironically, restore the family-owned farms that western irrigation projects were first created to support a century ago.

[THREE]
Support policies that fund sustainable communities.

According to the Bureau of Reclamation, about 10 percent of the water in Central Arizona Project canals is lost to evaporation and seepage as it travels hundreds of miles from Lake Havasu to the Phoenix area. On top of that, an average of 40 percent of the water used in sprinkler-style irrigation (the prevailing method of agribusiness) on central Arizona farms is lost through evaporation in the searing desert heat.

In a new economic paradigm following the regeneration model of Glen Canyon, massive transbasin irrigation schemes like the CAP would be too expensive to support agribusiness or real-estate development the way such practices do now. Businesses would be forced to live within the limits of their own watersheds, and the false pretenses of economic necessity that are often held up to justify Lake Powell would disappear. There could still be irrigation operations in the desert, but on a much smaller scale and without violating the natural cycles of rivers—more like the traditional, drip-style systems of the Pima and other Sonoran Desert tribes and like what John Wesley Powell recommended to Congress in 1878. In this more honest economic regime, there would be no Anthem and it would be economically viable for the Ak Chin community to use Gila River water flowing through their reservation to grow food for the Phoenix area.

The millions of tax dollars saved each year by stopping agribusiness subsidies could be invested in developing environmentally sustainable energy and water infrastructure systems for western states. The hydropower as well as the water storage given as justifications for Lake Powell could be replaced by government-funded initiatives to develop more

efficient technologies such as solar and wind power for electricity, and ocean desalinization and underground storage for water.

Liberated tax dollars could also be invested in public services like parks and schools, so that people would no longer rely on private developers like Del Webb to build the perfect community. And public funds could reinvigorate our public lands, including Glen Canyon and Grand Canyon, as well as help towns like Page convert to a new kind of tourism. In this new paradigm, our tax dollars would be used to support regenerating local communities and the environment, instead of impoverishing them.

[FOUR]

Learn to live with less.

A national decision to protect Glen Canyon means a decision to live with less water in Colorado River reservoirs. Drought and climate change will eventually force westerners to live with less water, but choosing Glen Canyon over Lake Powell right now means choosing conservation and planning over the insatiable consumption that will likely spell disaster for desert cities like Las Vegas and Phoenix. Average per household consumption of water in the United States is 180 gallons per day; in all European countries it is less than 50 gallons per day. And in western states, where there is often no natural municipal water supply, water consumption is three times that of eastern states.

Although pork-barrel policies and the politicians who love them assume the West can't survive without Lake Powell, water stored in the giant reservoir could easily be replaced by conservation programs and the elimination of wasteful irrigation practices. According to Peter Gleick of the nonprofit Pacific Institute, if all the homeowners in Greater Los Angeles converted to low-flow toilets (toilets being the largest municipal water use), the water conserved would meet the needs of 1.5 million people. Or if California farmers converted to efficient irrigation methods, enough water for 3.6 million people would be saved.

In addition to changing personal lifestyle habits to conserve natural resources at home and at work, individuals must also advocate for such changes on a larger scale, working through organizations that encourage sustainable practices that range from establishing habitat for endangered species to lobbying for stricter emissions standards.

[FIVE]

Respect Native American cultures and their right to uninhibited access to sacred sites and traditional lands.

A decision to protect Glen Canyon should also involve atonement for cultural losses suffered by Native American tribes in the Four Corners region. Though many archaeological sites may have been permanently destroyed by the reservoir, aggressive government inventories should identify which sites have emerged.

Tribes should be involved in all aspects of Glen Canyon preservation efforts, including the establishment of a Glen Canyon National Park and cultural programs related to the new crown jewel. "The Navajo medicine men support the efforts to make the land a national park," says Phil Bluehouse, a member of the Diné Medicine Men's Association. Such a designation for the recovered canyon would legally bind land managers to protect archaeological resources instead of favoring motorized recreationists. "I believe the sacredness in Glen Canyon could be restored," says Bluehouse. "We could use it as a teaching place. We could

show younger generations the sacredness."

Specifically, Rainbow Bridge should be freed of any influence from the reservoir as was originally promised by the U.S. government, and management of the sacred site should be returned to the Navajo tribe. Savings from the elimination of agricultural subsidies could be used to fund all these efforts and more. In general, the values reflected in "Hopi science"—a respect for natural systems and the innate connections between humans and all other species—should play a large part in the West's cultural shift toward embracing a restored Glen Canyon.

"In our paradigm, our thinking, we have stories of emergence in canyons [in Glen Canyon]," says Navajo medicine man Norris Nez. "The archaeologists and the western scientists putting dates on our history and migration, that's their paradigm. We came from here [the Glen Canyon drainage]. Western man, he writes his history and his laws. These laws compromise nature to benefit a new need. And they change the laws to fit the need. But the law of the land never changes."

[SIX]

Accept the moral responsibility to provide for the well-being of future generations.

"In drawing a circle around those things we consider important enough to measure in our economic system, we not only exclude a great deal that is important in the environment, we also discriminate against future generations," explains Al Gore in *Earth in the Balance*. "The accepted formulas of conventional economic analysis contain short-sighted and arguably illogical assumptions about what is valuable in the future as opposed to the present." A perfect example of such discrimination is the economic status quo that keeps future generations from experiencing

Glen Canyon because Lake Powell is more valuable to current business and political interests.

More than fifty years ago, David Brower told writer John McPhee in an article for *The New Yorker*, "We have to drop our standard of living, so that people a thousand years from now can have any standard at all." Certainly, the average standard of living for Americans has dramatically increased (in terms of consumption of resources) rather than decreased over last five decades.

A national decision to protect Glen Canyon and reform western water policy would be a statement that we care about those who come after us. It is perhaps the best opportunity we have to demonstrate through one simple action that our present society is, indeed, hopeful and forward looking rather than cynical and selfish. Brower's 1963 "idea" on the back cover of *The Place No One Knew*—"that Americans, here, now, determine that a wide, spacious, untrammeled freedom shall remain in the midst of the American earth as living testimony that this generation, our own, had love for the next"—is more relevant today than ever.

"Future generations will look at the sins of their fathers," warns Glen Canyon Institute founder Richard Ingebretsen. "Future generations are not going to hold the builders of Glen Canyon Dam responsible, because they didn't know any better. But they are going to hold the people that are in charge right now responsible. We have to act while we still have the chance. Our children and grandchildren are going to look at extinct species and a silted-in Glen Canyon and a dead Grand Canyon, and they're going to ask what were we thinking. History will not be kind."

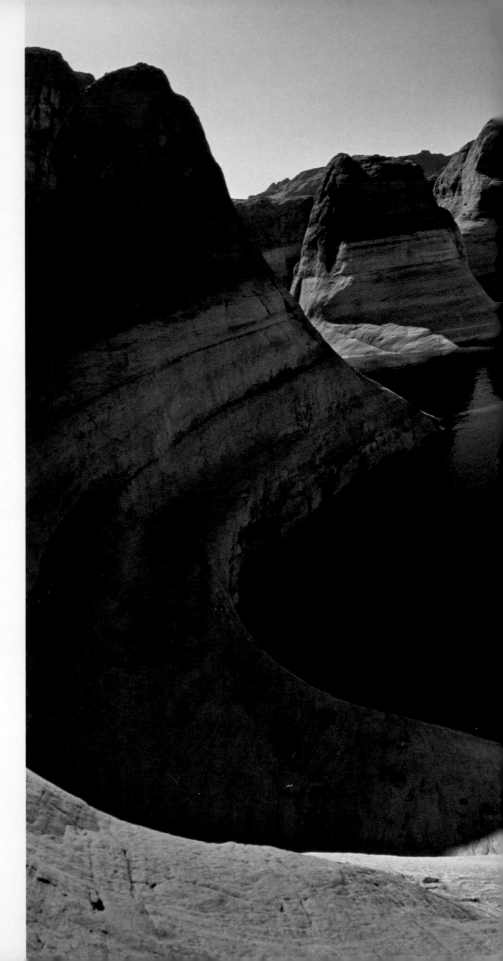

A kayaker (center right) on Lake Powell in Reflection Canyon, beneath the reservoir's 110-foot-tall "bathtub ring." At this level, the reservoir has lost 55 percent of its total water volume. April 2006.

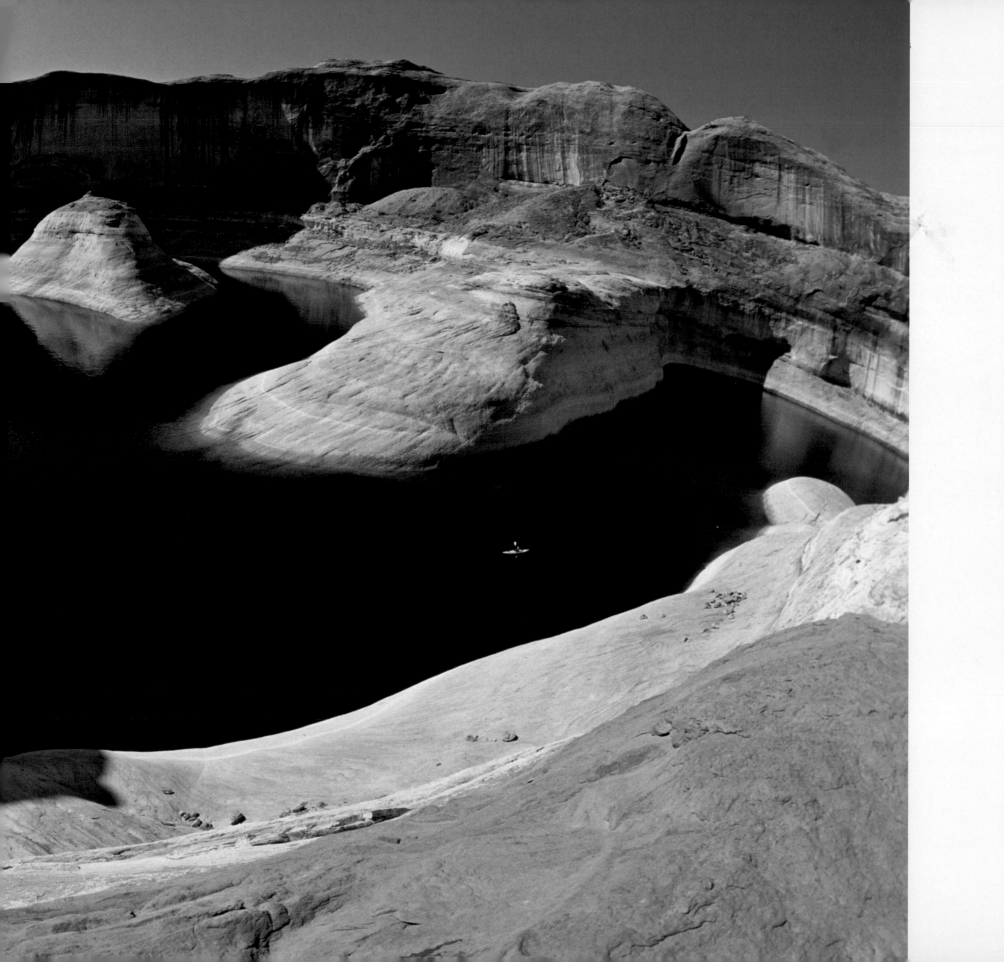

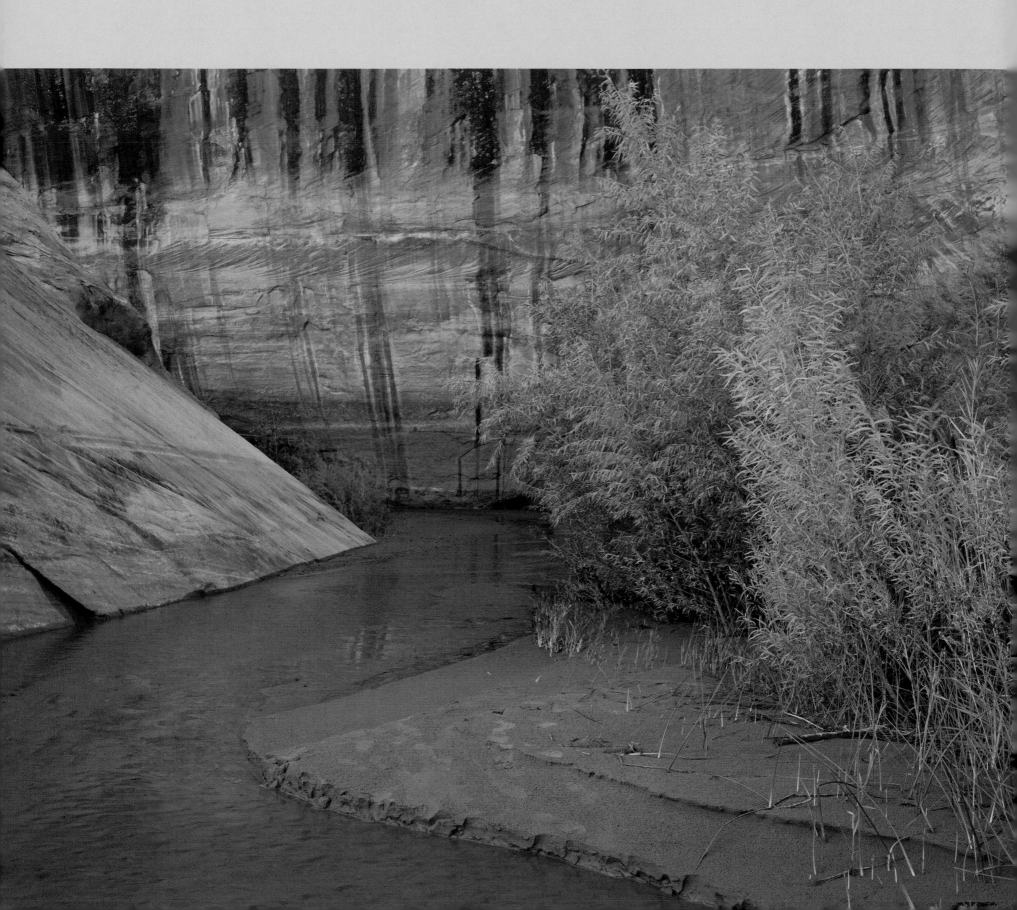

[EPILOGUE]

A NEW ERA BLOOMS

BETWEEN MAY 2003 AND SEPTEMBER 2007, I made numerous trips to Glen Canyon and explored dozens of restored drainages. What began as reporting for one story turned into a life-changing journey through a place that was not supposed to exist. I witnessed creeks quickly emerging when Lake Powell retreated, returning to their historical, meandering flows. In just four years, I saw cottonwood saplings sprout along these restored streams and grow to 12 feet tall. Waterfalls, plunge pools, and trickling springs returned; so did neotropical birds, insects, mountain lions, and beavers. Even in the narrowest, darkest restored slot canyons, the water was profuse with crayfish and the walls sang with a tapestry of tiny frogs. On ridges 100 feet above flowing streams, I stumbled upon sunglasses and boat awnings from a previous era. As I witnessed Lake Powell retreat and Glen Canyon regenerate, the native ecosystems—the natural cycles that had been buried for more than thirty years—exploded back to life so vigorously and thoroughly that it made human restoration ecology (what is happening in the Grand Canyon) look like child's play.

As I explored the many thriving canyons of Glen Canyon and researched the politics behind western water policy, I became convinced that America does not need Lake Powell. What we need is Glen Canyon. A resurrected Glen Canyon serves as a new kind of symbol, not of environmental

Native willows reclaim the floor of Davis Gulch, a location once 80 feet beneath the surface of Lake Powell. Since the reservoir began to recede in 2000, flash floods have cut down as much as 25 feet into the sediment as the stream tries to reclaim its prereservoir bed. October 2007.

New plants flourish on the stream-bank along Iceberg Canyon, at a location flooded by Lake Powell three and a half years prior. When the reservoir was last full in 1999, this streambed was submerged beneath 50 feet of water. October 2005.

destruction or of economic might, but of something much greater. It represents the resiliency of life and the hope for a better future. It represents, quite literally, a chance for redemption.

Although a variety of far-reaching water policy and lifestyle changes should parallel the protection of Glen Canyon, keeping the emerged landscape from being inundated again actually boils down to simply using Lake Mead instead of Lake Powell for reservoir storage. The Glen Canyon Institute and other environmental groups argue that if the West's reservoirs are all going to be half empty from now on, why not just keep Lake Mead full and Lake Powell much lower? This simple change in policy does not mean the dam has to be decommissioned or that lake recreation or hydropower would disappear. These things would just take a backseat to the preservation of natural and archaeological resources in Glen Canyon.

The logistics of restoring Glen Canyon may not seem complicated, but deciding to save the canyon opens a Pandora's box of possibility and change that causes politicians and agency bureaucrats to freeze. We as a society must have the courage and will to open the box for them; citizens must lead their government in achieving positive environmental and social change rather than the other way around. Were it not for citizen resistance to Colorado River dams in the 1950s and 1960s, and the public's refusal to believe these dams were necessary as was claimed by the federal government, the Grand Canyon and Dinosaur National Monument would be flooded today.

Just as *The Place No One Knew* helped motivate Americans in the 1960s to fight dams and environmental destruction, my hope is that this book will inspire readers

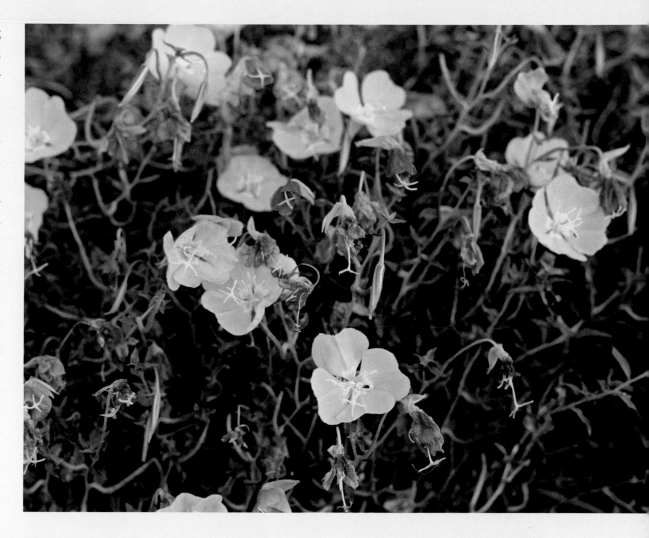

to give Glen Canyon the protection is deserves. The evidence supporting the case for Glen Canyon is here in these pages, but proof is not enough. There will no doubt be convincing arguments levied from the other side, insisting that the American West will collapse without Lake Powell. Many powerful politicians and businesspeople will continue to insist that Glen Canyon is dead, as is the idea of saving it.

If you believe otherwise and want to counter their claims, there are resources to help you take action. Go to the websites we provide and get educated on water

A profusion of pale evening primrose grow along the streambed in Lake Canyon, at a location last inundated by Lake Powell three and a half years prior. October 2005.

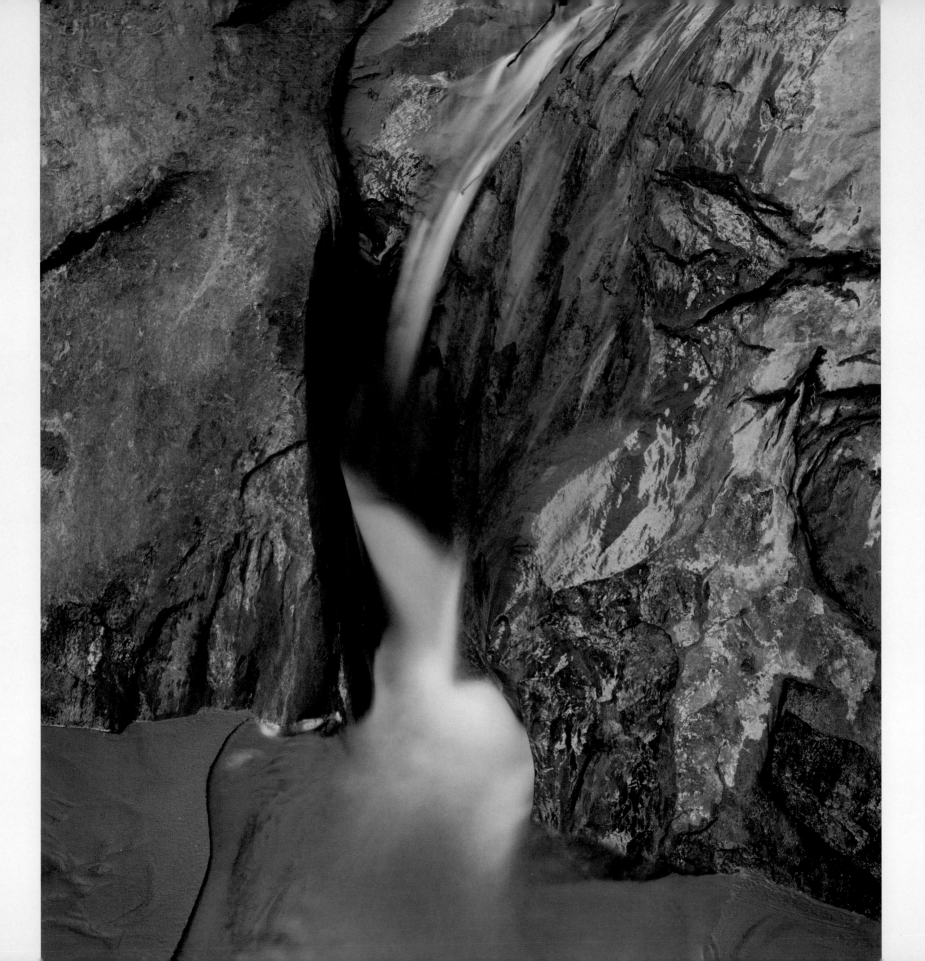

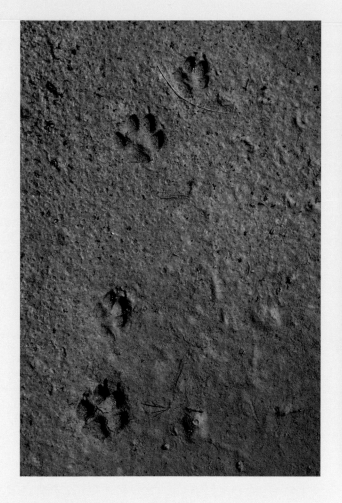

THIS PAGE LEFT *Coyote tracks pressed into the mud along Lake Canyon at a location once 50 feet below the surface of Lake Powell.* October 2005.

THIS PAGE RIGHT *Author Annette McGivney's son Austin finds tadpoles along a restored section of Smith Fork Canyon, where new life now thrives.* June 2005.

OPPOSITE *A recently revealed waterfall in Davis Gulch, which once lay 70 feet below the surface of Lake Powell.* October 2007.

policy; lobby your congressional representatives in support of Glen Canyon National Park; contribute your time and money to campaigns advocating for the protection of Glen Canyon and the rest of the world's wild lands. The last page of this book is not the end of the story: it continues with you.

So many things are uncertain in this life. People and places and the by-products of our mechanized world all cycle in and out like shifting winds. We truly do not know what tomorrow will bring until it arrives. But I know this: Glen Canyon is alive. The heart of Southwest canyon country is beating through every new bud, every returning songbird, every resurrected stream, and every resuscitated spring. In the twisting orange sandstone narrows where a new era blooms, we can find a way out of the mess we are in. We can find beauty, truth, and a solution. The "place no one knew" beckons to us now. For the sake of my son and all those coming after us who deserve to experience being alive in Glen Canyon, and to live in a world that values Glen Canyon, I hope we answer its call.

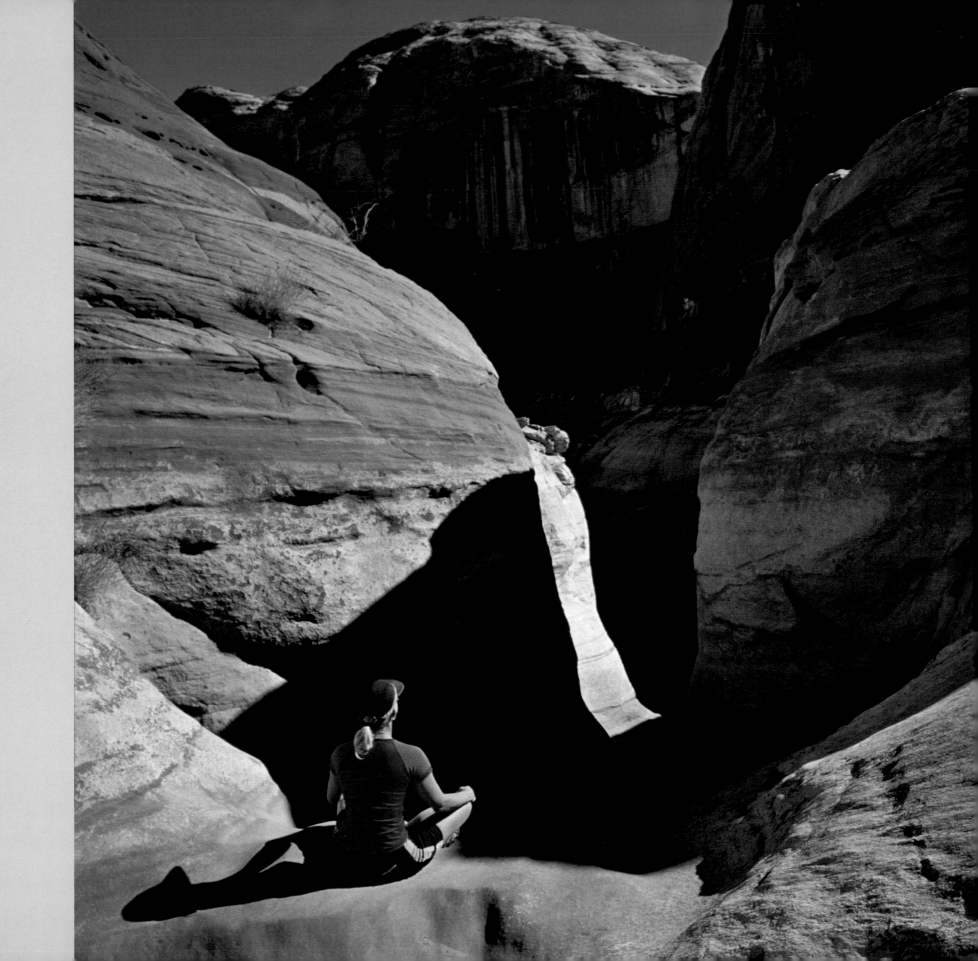

[HIKING GLEN CANYON]

SEVEN SPECTACULAR TREKS INTO A RECOVERING PARADISE

Susie Kay meditating in the narrows of Annies Canyon just below the old high-water mark of Lake Powell. Once dominated by the roar of motorboat engines, this beautiful grotto is now pervaded by silence. October 2005.

You don't need to rent a boat to explore Glen Canyon's resurrected landscape. Here are seven hikes you can access by car and be on terra firma all the way.

Always prepare for weather, and use caution and sound judgment when hiking in canyons. A sudden rainstorm—especially during the summer monsoon season—can quickly flood slot canyons, and shifting boulders can cause injury or block access. Protect yourself from exposure to UV rays and carry plenty of water.

Detailed maps with GPS waypoints can be found at *Backpacker* magazine online (www.Backpacker.com/glencanyon), or you can contact Glen Canyon National Recreation Area directly (928-608-6200).

144

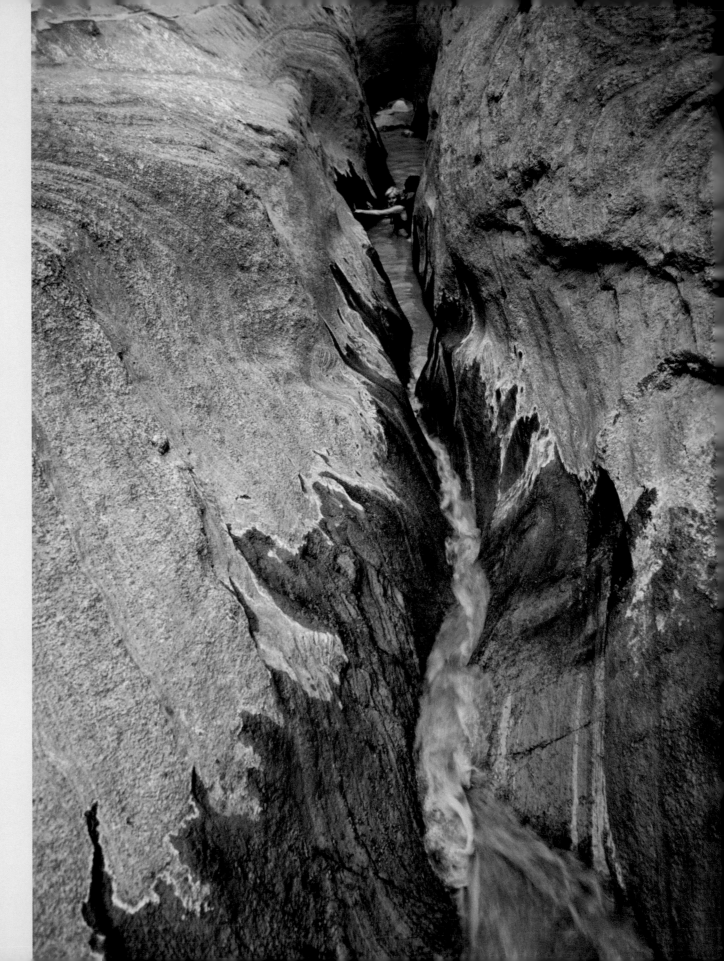

*A hiker negotiates the narrows of
Fortymile Gulch just upstream from
its confluence with Willow Gulch.
This section was never inundated by
Lake Powell.* April 2000.

[HIKE ONE]

Fortymile Canyon

GETTING THERE: From UT 12, between Boulder and Escalante, turn south on Hole-in-the-Rock Road. Drive the 4WD dirt road for about 42 miles to Sooner Wash. There is a small parking pullout across the road from the wash and the footpath into the canyon.

THE ROUTE: After a 1-mile hike down the sandy path of Sooner Wash, scramble over and under several SUV-sized chockstones on a class 3 descent (no ropes required) to emerge at Fortymile Canyon. Then it's a leisurely amble for about 3.5 miles through the broad, burnt-orange canyon. Lush groves of giant cottonwoods line Fortymile Creek, and their brilliant green leaves sound like rain as they rattle in the wind. The canyon abruptly narrows at a 12-foot-tall waterfall splashing into an icy swimming hole. Set up camp here on the sandy flats above the falls, where water and shade are abundant. Around the next bend is a superb slot that is 300 feet tall, 4 to 10 feet wide, and adorned with hanging gardens of maidenhair ferns. Wade and swim (or body-stem if you're so inclined) across emerald pools for about 1.5 miles to the junction with Willow Canyon. Double back to your car, or continue up Willow to complete a 10-mile loop.

USGS QUADS: Sooner Bench, Davis Gulch

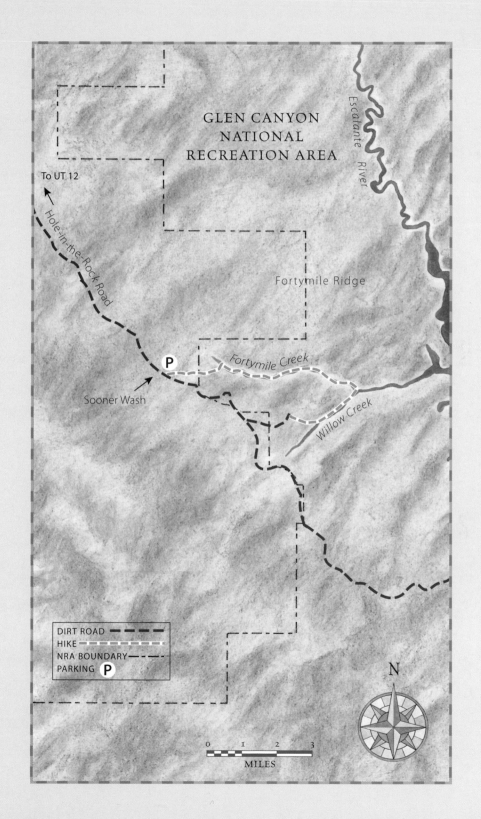

GLEN CANYON
NATIONAL
RECREATION AREA

Escalante River

To UT 12

Hole-in-the-Rock Road

Fortymile Ridge

Fortymile Creek

P

Sooner Wash

Willow Creek

DIRT ROAD	- - -
HIKE	-----
NRA BOUNDARY	-·-·-
PARKING	P

N

0 1 2 3
MILES

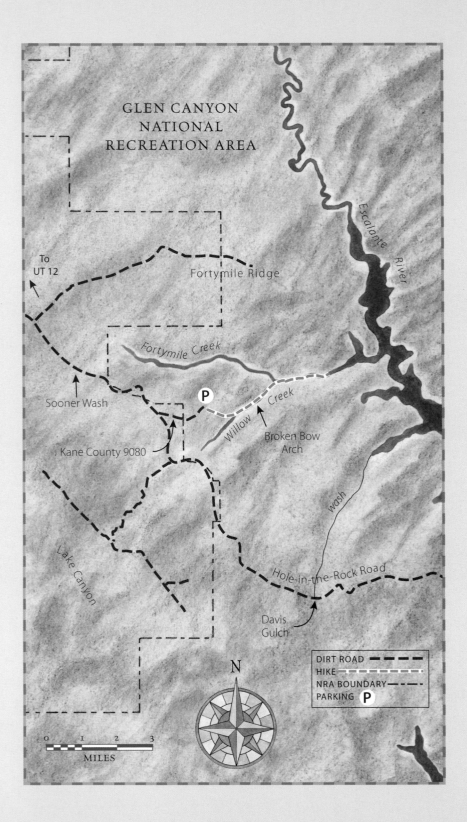

GLEN CANYON
NATIONAL
RECREATION AREA

Escalante River

To
UT 12

Fortymile Ridge

Fortymile Creek

Sooner Wash

P

Willow Creek

Broken Bow
Arch

Kane County 9080

wash

Lake Canyon

Hole-in-the-Rock Road

Davis
Gulch

DIRT ROAD ━ ━ ━
HIKE ┄┄┄┄
NRA BOUNDARY ━ ‧ ━ ‧
PARKING P

N

0 1 2 3
MILES

[HIKE TWO]

Willow Canyon

GETTING THERE: From UT 12, between Boulder and Escalante, turn south on Hole-in-the-Rock Road. Drive the 4WD dirt road 43 miles and turn left onto Kane County 9080 about 1.2 miles past Sooner Wash. Drive east 1.7 miles down this road to the trailhead parking lot.

THE ROUTE: From the trailhead, it's only 1.7 miles downcanyon to Broken Bow Arch (on the left/west side of the stream), the second-largest span in North America. There is a great alcove for camping across and just upcanyon about 700 feet from the arch. Downstream from the arch, the canyon narrows into a slickrock channel dotted with crystal-clear pools excellent for swimming. Approximately 1 mile below Broken Bow is the confluence with the twisting narrows of Fortymile Canyon. Continue down Willow Canyon to explore its recovered section, including a 12-foot waterfall that emerged from the depths of Lake Powell. Native vegetation—especially willow—explodes here, as does all the wildlife that has recovered with the canyon.

USGS QUADS: Sooner Bench, Davis Gulch

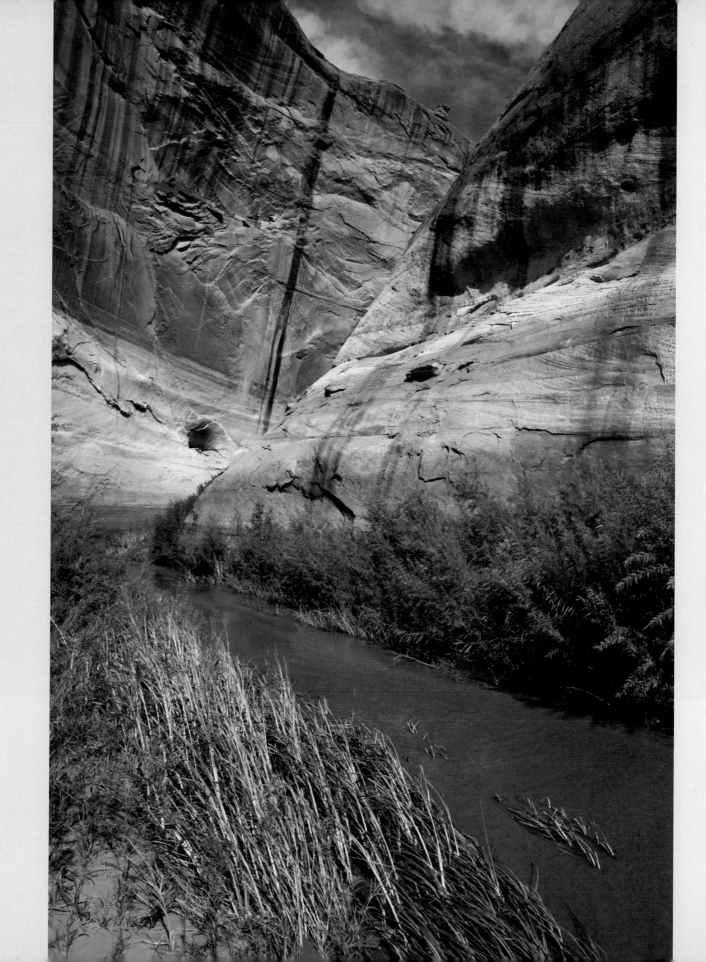

Willows and cattails reclaim the streambank in Willow Gulch. October 2007.

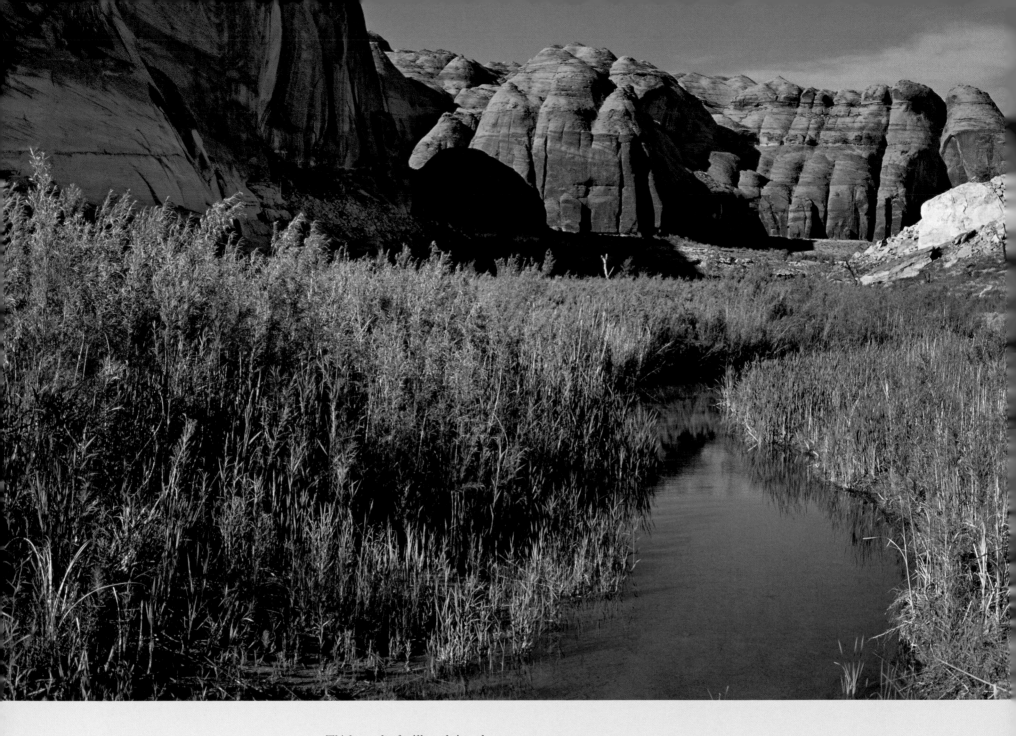

Thick stands of willow thrive along Llewellyn Gulch. Lake Powell's waters receded downcanyon from this location approximately three years before this image was taken. May 2005.

[HIKE THREE]

Llewellyn Loop

GETTING THERE: From UT 12, between Boulder and Escalante, turn south on Hole-in-the-Rock Road. Continue on the 4WD dirt road for about 50 miles to where the road crosses Davis Wash. Park just past the wash.

THE ROUTE: To hike this 3-day, 18-mile, cross-country loop, walk south along the base of Fiftymile Point about 2 miles, then scramble down the narrows of the south fork of Llewellyn Gulch. After 2 miles, you'll reach the first spring (where the creek starts). There's good camping in the next 3 miles. Just before you reach Lake Powell, scout the south wall of the canyon for a place to climb out. Hike the benches above Llewellyn, then continue along the main Colorado River canyon for about 2 miles beneath high cliffs until they end and you can climb up onto an expansive dome to camp. Complete the loop by hiking northwest up the large slickrock ramp behind camp (right under the word "Glen" on the USGS topo) to reach the top of the ridge between Cottonwood and Llewellyn Gulches. Continue northwest for about 7.5 miles to your car.

USGS QUADS: Davis Gulch, Nasja Mesa

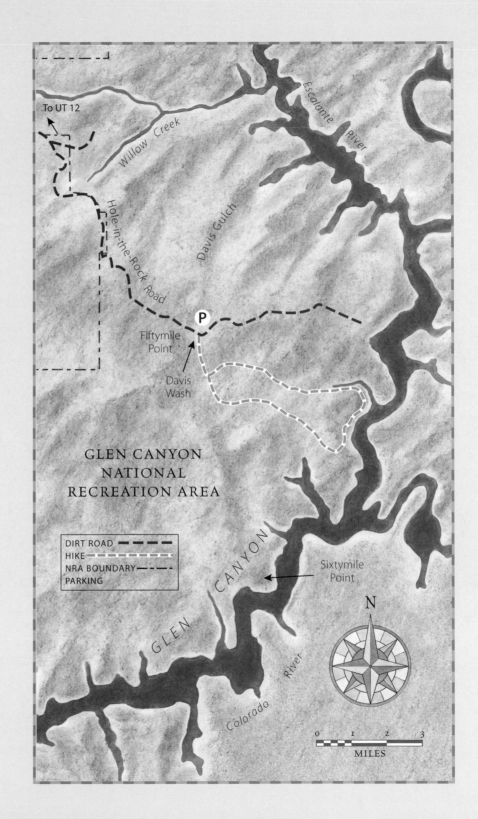

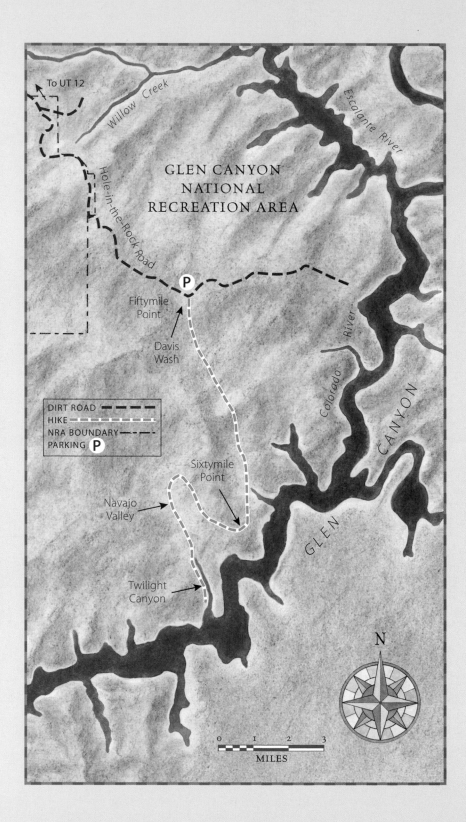

To UT 12

Willow Creek

Escalante River

GLEN CANYON
NATIONAL
RECREATION AREA

Hole-in-the-Rock Road

P

Fiftymile
Point

Davis
Wash

Colorado River

GLEN CANYON

DIRT ROAD — — —
HIKE
NRA BOUNDARY — · — ·
PARKING P

Sixtymile
Point

Navajo
Valley

Twilight
Canyon

N

0 1 2 3
MILES

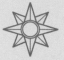

[HIKE FOUR]

Twilight Canyon

GETTING THERE: From UT 12, between Boulder and
Escalante, turn south on Hole-in-the-Rock Road. Continue
on the 4WD dirt road for about 50 miles to where the road
crosses Davis Wash. Park just past the wash.

THE ROUTE: This is a difficult hike that requires a rope
and should only be attempted by experienced canyoneers.
Allow 3 days for this out-and-back. Twilight Canyon
itself can be done as a day hike, but getting to the canyon
requires an additional day without any guaranteed water;
don't attempt this trip in summer. From Davis Wash to the
Twilight drop-in, hike a 9-mile traverse south along the
east side of Fiftymile and then Sixtymile Points. (Sixtymile
is not named on USGS maps, but it's the southern tip of
the high cliffs that continue south from Fiftymile Point.)
Wrap around the southern tip of Sixtymile and continue
northwest along the west side for 1.75 miles until you arrive
at the elevation benchmark "4147 T" indicated on the
USGS topo. The entrance to Twilight Canyon is between
this benchmark and the "T" in Twilight on the map. Hike
around the northwest side and drop down toward the
canyon, looking for a solitary 20-foot-tall juniper. There's
good camping in this area. From the tree, walk south for
about 220 yards along a series of narrow, vegetated ledges
until the slickrock begins to fall away to the right. At a
point 40 feet above the canyon floor, where it becomes too

steep to continue walking, look for a notch cut into the top of a rock by a climbing rope. Bring two 60-foot ropes and a harness to descend the steep friction slab to the floor of the canyon. This is also your exit route; it's easier to go up (a 5.2 climb) than down. You may want to leave a rope in place to get up, or let the experienced climber go first and throw the rope down.

USGS QUADS: Davis Gulch, Nasja Mesa

NOTE: The only guaranteed water is at Lake Powell, a few miles down Twilight Canyon. You might find water en route to Twilight by descending an easy slickrock ramp to the east of Sixtymile Point just east of benchmark "4198 T" on the USGS topo.

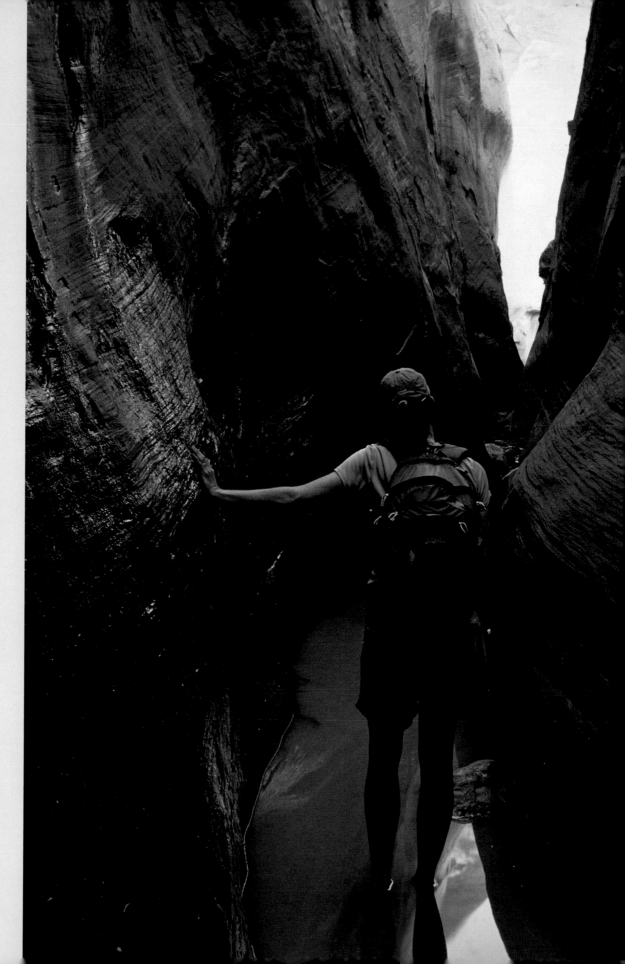

Author Annette McGivney hiking in Twilight Canyon at a location once 110 feet below the surface of the reservoir. May 2005.

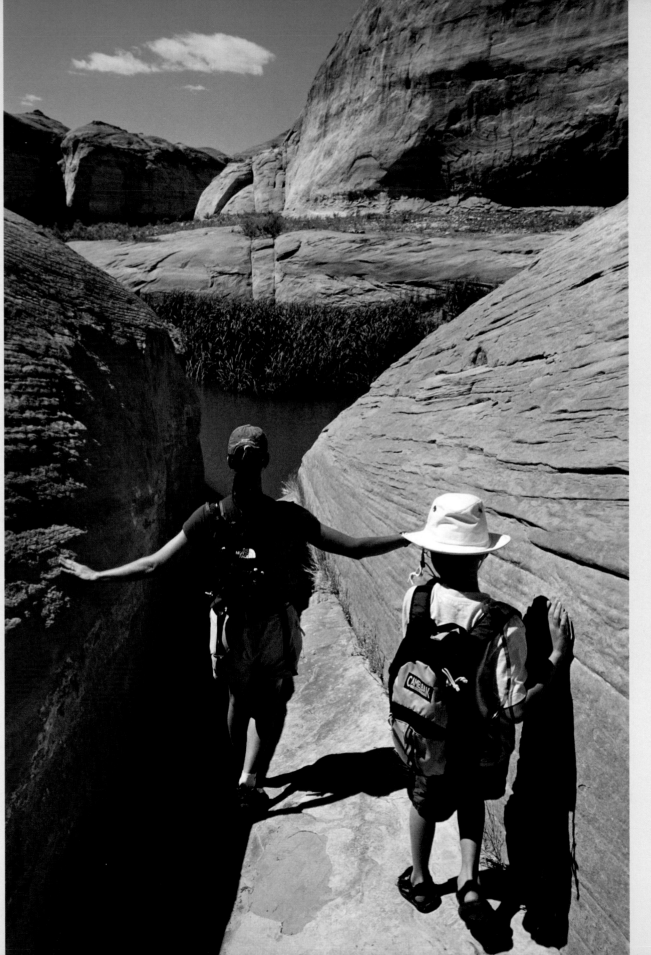

Author Annette McGivney and her son Austin explore a newly restored section of Smith Fork Canyon. May 2005.

[HIKE FIVE]

Smith Fork

GETTING THERE: From the north (Hanksville), take UT 95 and then drive south on UT 276 toward Bullfrog Marina. Turn left/east at milepost 32 onto an unsigned dirt road. To reach this point from the south (Blanding), drive west on UT 95 and turn left/south on UT 276 toward Halls Crossing. Take the ferry to Bullfrog Marina, drive north on UT 276 to milepost 32, and turn right/east. In 1 mile, go left at a fork, cross a dry wash, and continue east on a 4WD road for 1.9 miles to a T west of Danish Knoll. Turn right and drive 1.3 miles, staying right at the fork, to a great car-camping spot atop the ridge. From here, take the right fork just down the road and continue southeast another 1.5 miles to the bottom of a small valley. Park where the road crosses the low point.

THE ROUTE: From the car, hike east along a blackbrush-covered flat, staying on the south side of the small dry wash for about 0.4 mile until you arrive on the south rim of a slickrock canyon. Continue hiking east to the end of the rim, about 0.1 mile. Descend off the north side of this point down a 20-foot-high slope with stairstep ledges that offer good holds. This class 4 scramble may require a rope for people with no climbing experience. Zigzag down the smooth slickrock, heading southeast for another 0.3 mile to the creek.

USGS QUAD: Bullfrog

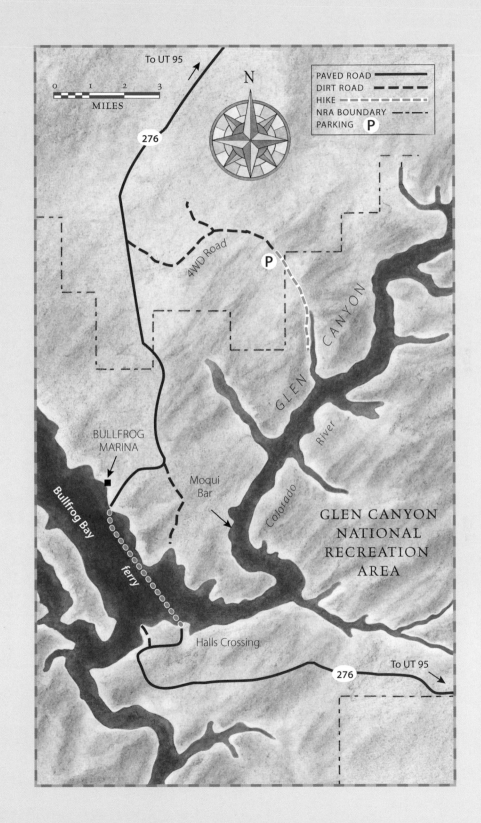

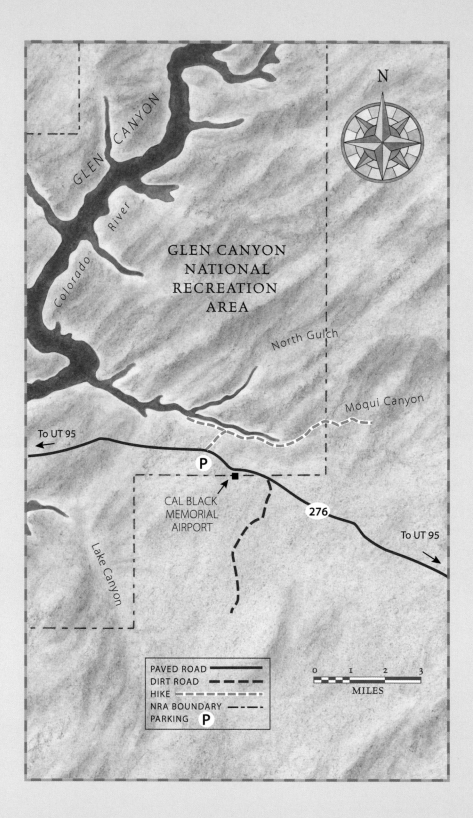

Moqui Canyon

GETTING THERE: From the north (Hanksville), take UT 95 and then UT 276 south to the Bullfrog/Halls Crossing ferry at Bullfrog Marina. Once across the lake, drive 10 miles to a pullout on the left that is exactly 2 miles west of Cal Black Memorial Airport. From the south (Blanding), drive west on UT 95 and turn left/south on UT 276 toward Halls Crossing. Park at the same spot along UT 276.

THE ROUTE: From the road, hike approximately 1 mile cross-country in a northeasterly direction to the lip of Moqui Canyon. Look for a 500-foot-tall sand slide below the canyon rim; this is a lot more fun to go down than to come up, but it is the best way in and out of the canyon. Occasional cairns mark the way down sandstone benches to the top of the slide. Once you reach the streambed, miles of exploration await both upcanyon and downcanyon.

USGS QUAD: Burnt Spring

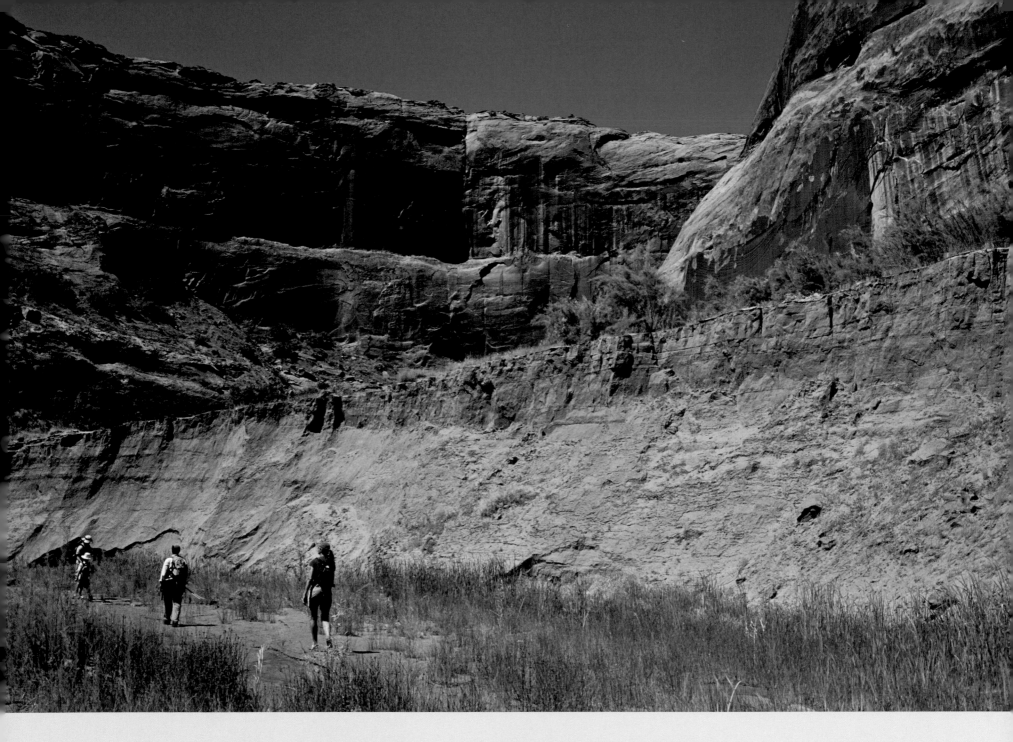

In Moqui Canyon, 25-foot-tall crumbling
sediment banks line the streambed. Flash
floods have scoured the canyon floor down
to the prereservoir bedrock, and willows
and grasses quickly reclaim the exposed
ground. June 2005.

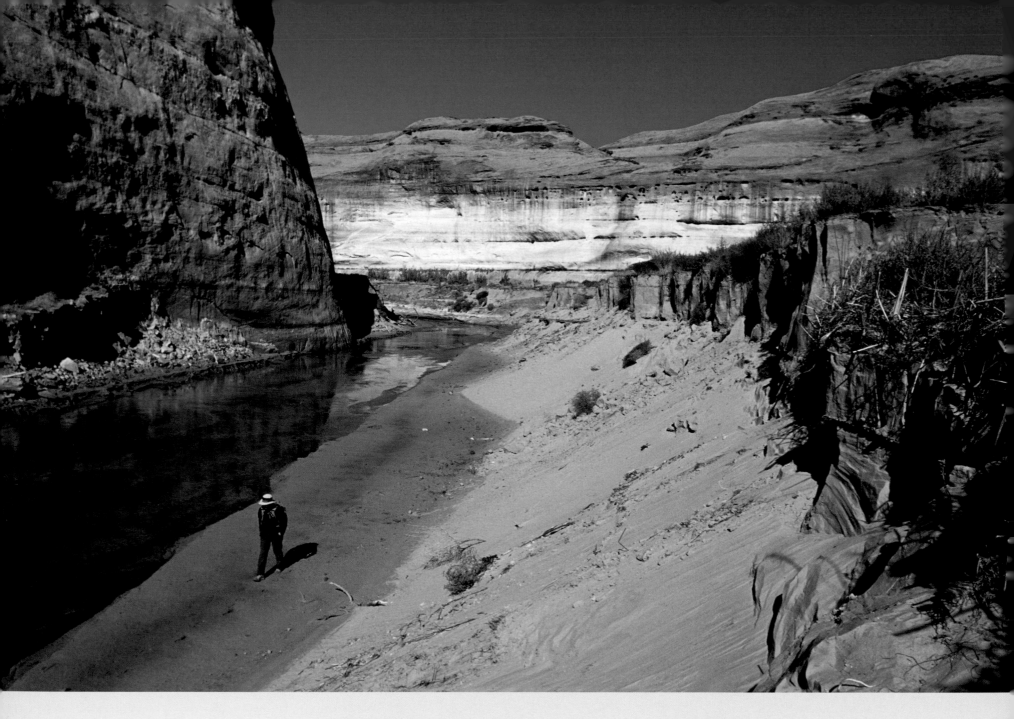

*Hiker in a recently scoured-out section
of Lake Canyon, at a location once 95
feet below the surface of Lake Powell.
The remaining sediment layer fills the
right half of the image and continues
to crumble into the stream.*
October 2005.

[HIKE SEVEN]

Lake Canyon

GETTING THERE: From the north (Hanksville), take UT 95 and 276 south to the Bullfrog/Halls Crossing ferry at Bullfrog Marina. Once across the lake, proceed east approximately 10 miles on UT 276 to Cal Black Memorial Airport. To reach this point from the south (Blanding), drive west on UT 95 and turn left/south on UT 276 toward Halls Crossing. Turn right onto the dirt road running south along the airport's west boundary road, and drive south (this eventually becomes Rec. Road 450) approximately 6 miles to where the road crosses just above Lake Canyon.

THE ROUTE: From your parking spot, hike down Lake Canyon drainage about 4.5 miles to an excellent campsite in a large grove of cottonwood trees near the reservoir's old high-water mark. Below this spot, you can explore about 2.5 miles of restored canyon before reaching the reservoir. Along the way you'll encounter a perennial stream that gurgles over scoured slickrock, varnished sandstone walls rising 500 feet, and the remains of groves of old cottonwood trees. Perched high on ledges are numerous ancient Anasazi ruins—now mostly jumbles of rock. Near the top of the drainage, on the west side of the canyon, is a large scooped-out depression where Lake Pagahrit (the canyon's namesake) once existed. This natural reservoir was plugged up by a sand-dune dam that was destroyed by a flood in the early 1900s.

USGS QUAD: Burnt Spring

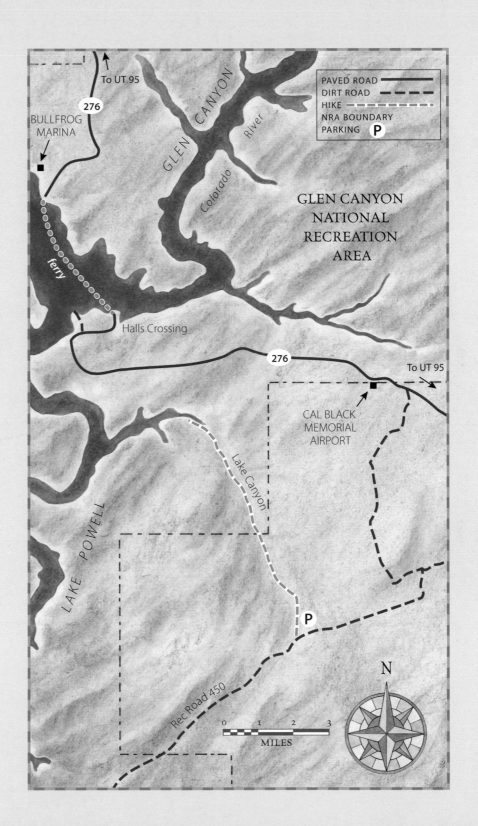

Photographer's Notes

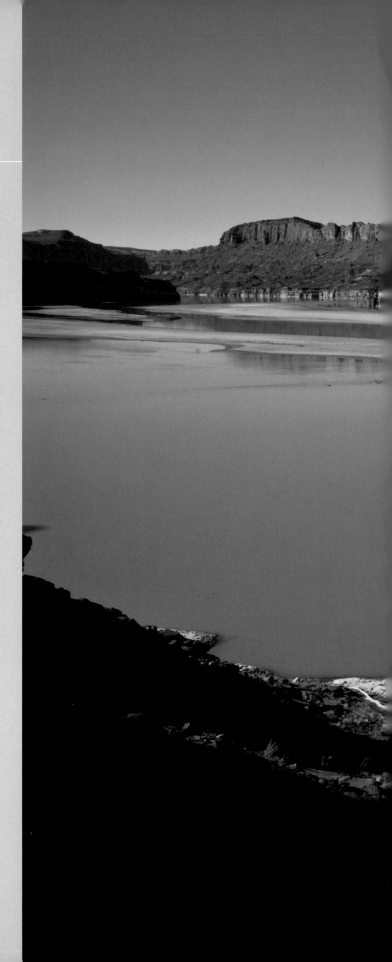

I feel as though I'm traveling back through time as I round yet another bend in Davis Gulch. I'm descending deeper and deeper into a canyon labyrinth that has only recently emerged into the light of day after being submerged beneath the dark waters of Lake Powell for more than thirty years. Each twist in the canyon walls reveals a succession of young plant communities quickly reclaiming the newly exposed ground. Buried beneath 60 feet of reservoir water just four years ago, the small, clear stream at my feet now gurgles beneath a profusion of willows and 30-foot-tall cottonwood trees swaying in the breeze.

As I proceed downstream, the plants become smaller and smaller, until only a fuzzy green carpet of grass covers the canyon floor several hundred feet upstream from the receding waters of Lake Powell. While ongoing drought challenges life throughout the West, here along the alcoves and sinuous narrows below the canyon rims, a lost world is being reborn. Where devastation zones of crumbling sediment banks and oozing mud filled these canyons several years ago, darting lizards, croaking frogs, hanging gardens, and lush streamside vegetation now restake their claims.

By the time I arrived in the West in 1972, these alcoves and narrows had already slipped beneath the waves. As my obsession with exploring and photographing the canyonlands of southern Utah began to evolve in the early 1980s, the sad reality and sheer magnitude of what had been lost by the drowning of Glen Canyon began to sink in.

The upper end of Lake Powell fills this valley near the abandoned Hite Marina as photographer James Kay stands on a pinnacle 100 feet above the drastically lowered reservoir surface. When the reservoir was last full in 1999, the water would have been lapping at his feet, and it would have reached 35 miles upriver. October 2007.

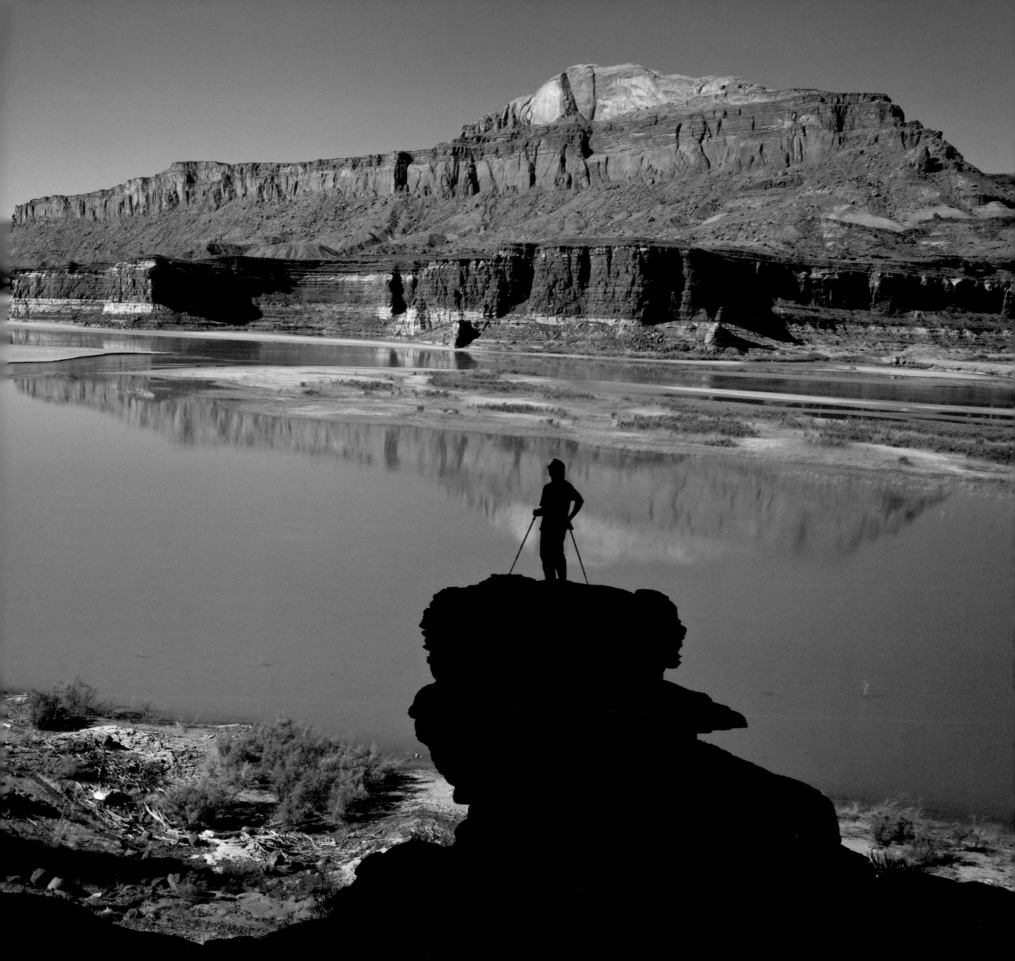

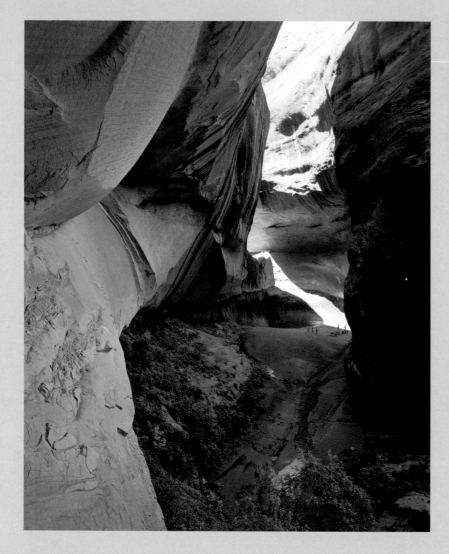

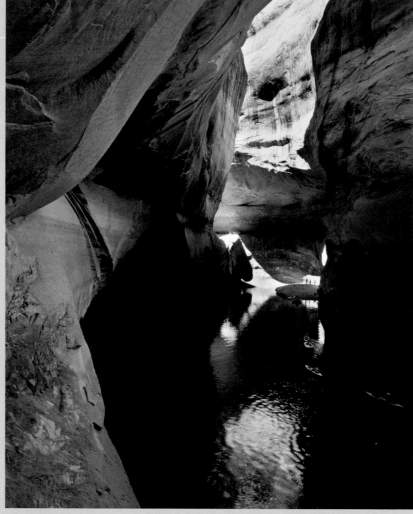

Quintessential image of Cathedral in the Desert, made by Philip Hyde before it was flooded by Lake Powell. 1964. University of California Santa Cruz Special Collections, Philip Hyde Archive.

Cathedral in the Desert, with the water level of Lake Powell near its low point, 140 feet below its full-pool elevation. This image was taken from the same location as the image made by Philip Hyde before Lake Powell inundated the area. The high-water "bathtub ring" can be seen on the wall at upper right. April 2005.

When the U.S. Bureau of Reclamation announced its plans in the early 1950s to install a ten-million-ton concrete plug across the river, photographers such as Philip Hyde, Eliot Porter, and Tad Nichols began documenting the canyons of Glen Canyon before they were swallowed by the rising waters of the reservoir. The body of work they created provided me a portal to the past. One such book, *The Place No One Knew,* was published in 1963 in an effort to focus the nation's attention on what was about to be sacrificed in the name of progress. The book contained page after page of haunting images of the doomed canyons. Treating these books as sacred texts, I would slowly leaf through them in a feeble attempt to absorb the beauty of what was once the most sensuous landscape on the face of the Earth.

The most enchanting canyon, it seemed, was called Cathedral in the Desert. Those fortunate few who had experienced the glories of pre-dam Glen Canyon considered the Cathedral the most breathtaking canyon of all. Once the bypass tunnels around the dam were slammed shut in 1963, the fate of these canyons was sealed. As the roiling waters of the Colorado River began to pool at the base of the coffer dam, everyone knew it was only a matter of time before the reservoir filled with sediment and the Cathedral became entombed beneath 150 feet of mud. It would be lost to humanity for countless generations. As for me, I had long since accepted that I would never lay claim to it with my own eyes.

So, perhaps you can grasp my sense of sheer wonder when, in the spring of 2005, with the reservoir at its historic lowest level because of five years of drought, I found myself motoring across its smooth surface on my way to a place called Clear Creek Canyon. With the water level 145 feet below its "normal" full-pool elevation, I rounded the last bend at the end of the canyon and slowly nudged my boat up onto a small spit of sand. With a quick turn of the key, the sound of the sputtering motor was replaced with silence.

I hoisted my camera pack to my shoulder and stepped off the bow onto the sandy floor of Cathedral in the Desert. With an overwhelming sense of awe, I lowered my pack to the ground and stood silently as the glowing, luminous womb of the Cathedral enveloped me. Recognizing it from those old photographs, I stared up at the newly restored waterfall trickling into the small pool at its base. The six hours I passed on that sandy fragment of dry land will be forever etched in my soul. With a healthy snowpack in the Rockies that year, I knew the Cathedral's resurrection was only a temporary reprieve from its watery grave. One month later, the sandy floor of the chamber slipped silently beneath the dark waters of the reservoir once again.

Only now that I have witnessed the upper reaches of these canyons for myself can I even begin to understand how gut wrenching it must have been for people to have watched Glen Canyon slowly drown. For those of us who have been offered this recent glimpse, perhaps the words of Edward Abbey can provide solace as we temporarily watch the canyons slip beneath the surface again. While bemoaning their loss, he commented that the canyons weren't really gone at all. "They're simply in liquid storage"—just waiting…

How the Images Were Captured

OPPOSITE LEFT *Our boat barely squeezes through Driftwood Canyon on Lake Powell during a trip to explore the newly revealed canyons. This narrow groove would be flooded to the rim were the reservoir full.* May 2005.

OPPOSITE RIGHT *Pontoon boat used to explore and photograph newly exposed canyons as Lake Powell recedes, seen here tied up in Pothole Canyon. When the reservoir is full, the only rock above water in this image is the dark red tower in the distant background.* April 2005.

The photographs in this book were made with various cameras over the course of five years beginning in 2002. For the "beauty" images of the restored canyons, I primarily used a Pentax 67 medium-format camera loaded with Fuji Velvia film. For the narrow, claustrophobic canyons, the lens I turned to the most was a 45mm wide-angle for the expansive view it captured. I also used a Nikon F4s film camera for most of the images that show the negative, ugly impacts of the reservoir. Later on, I exchanged my Nikon for a Canon 5D digital camera. To a much lesser degree, I also employed my Fuji GX617 panorama camera. A Panasonic digital spot meter was used to take reflected light readings, and the cameras were mounted on a carbon-fiber Gitzo tripod.

I used filters to a minimal degree, mostly to correct for color casts in the bottom of deep canyons caused by the blue sky overhead. I also occasionally used neutral-density split-image filters to reduce a high-contrast scene to values within the range of the film or digital sensor. The medium-format film images were then scanned on an Imacon scanner, while the 35mm film images were scanned on a Nikon Super CoolScan 9000 ED. Once scanned, I used Photoshop to match the tonality and color of the digitized image to the original film version as closely as possible.

Accessing the remote canyons throughout the expansive region of Glen Canyon proved one of the most challenging aspects of this endeavor. I backpacked into most of the canyons, which were reasonably accessible via overland routes, and spent several days exploring each one in search of "ideal" lighting conditions. These canyons were mostly located between Hite Marina and the Escalante River. For most of the more difficult-to-access canyons between the Escalante and Glen Canyon Dam, I used an 18-foot motorized pontoon boat, the type used to run rapids in the Grand Canyon. This small boat allowed me to squeeze into the narrow upper reaches of these canyons before setting off on foot to explore their depths. I strapped a touring kayak to the deck of the boat and used it to enter canyons that were too narrow even for the pontoon boat. In addition to the pontoon boat, on several occasions I also rented the small 19-foot boats available at the marinas at Bullfrog and Wahweap.

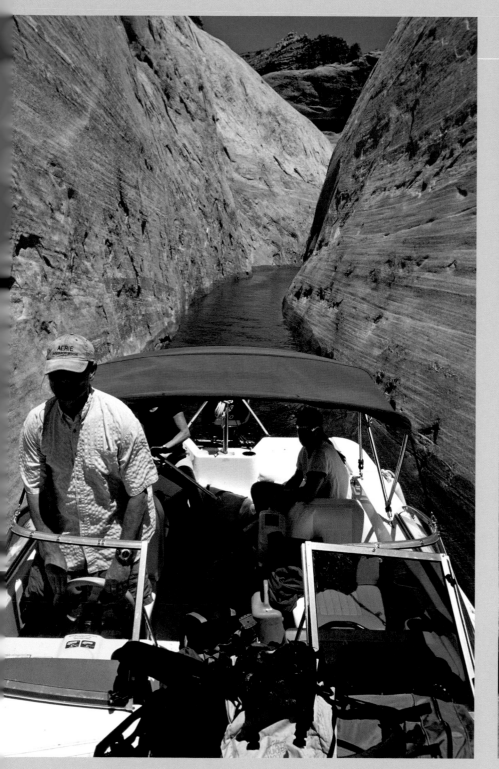

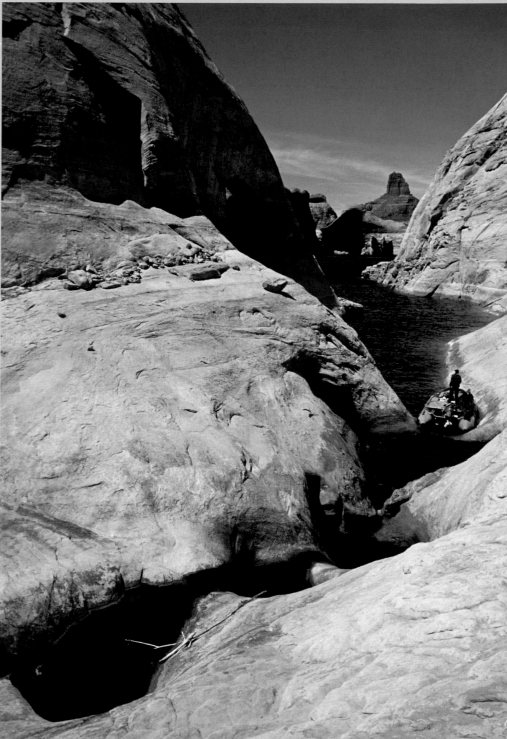

Acknowledgments

OPPOSITE *Recently emerged small waterfall in Davis Gulch. Once buried beneath 25 feet of mud and sand, the streambed has been restored to its prereservoir condition.* October 2007.

ANNETTE MCGIVNEY

At the top of a long list of people who have helped and inspired me in this project is *Backpacker* editor in chief Jon Dorn. This book began six years ago with Jon agreeing to let me pursue an atypical story assignment for *Backpacker* about the controversial topic of Glen Canyon and western water policy. Thanks to Jon's courageous editorial leadership and passion for wild places, that story blossomed into an ongoing series for *Backpacker* about Glen Canyon which set me on the path to write this book. Jon, along with Peter Flax and other *Backpacker* editors, have been invaluable over the years in helping me craft magazine stories that grew into something much bigger.

I am also deeply indebted to my colleagues at Northern Arizona University—specifically, professors Pam Foti, Sandra Lubarsky, David Schlosberg, and Gioia Woods—who helped me develop the larger message of my narrative about environmental sustainability. There are many individuals—all highly regarded experts in their fields—who were generous with their time in my quest for information, including Dan Beard, Richard Ingebretsen, and Daniel McCool. However, I especially appreciate the patience of Bureau of Reclamation hydrologist Tom Ryan, who, despite his love for Lake Powell, kept taking my calls. Also many thanks to brilliant landscape photographer James Kay, as well as the staff at Braided River and The Mountaineers Books who made this book possible: Kerry Smith, Julie Van Pelt, Jane Jeszeck, Kathleen Cubley, and, especially, Helen Cherullo.

JAMES KAY

Over the course of this project, I benefited from a vast pool of knowledge on Glen Canyon accumulated during the lifetimes of many individuals. Specifically, I would like to thank Dr. Richard Ingebretsen, whose profound reverence for the canyons along with his boundless enthusiasm provided me with inspiration at every step of the process. Dr. Wade Graham's prodigious store of technical knowledge of the Colorado River Compact, Glen Canyon Dam, and the politics surrounding this issue proved invaluable. For the sheer pleasure of her company as we wandered the canyons in search of images and ideas and for her extraordinary command of the English language, I express a heartfelt thank-you to writer Annette McGivney. I owe a large debt of gratitude to my wife Susie who throughout this project served as my photo assistant, business partner, and very cooperative model for many of the images in this book. It was a pleasure collaborating with Kerry Smith of Braided River as she worked through the overwhelming task of organizing the photographs and text for this book. Without the unwavering commitment and sheer determination of Helen Cherullo of Braided River and The Mountaineers Books this book would never have been published. Thank you.

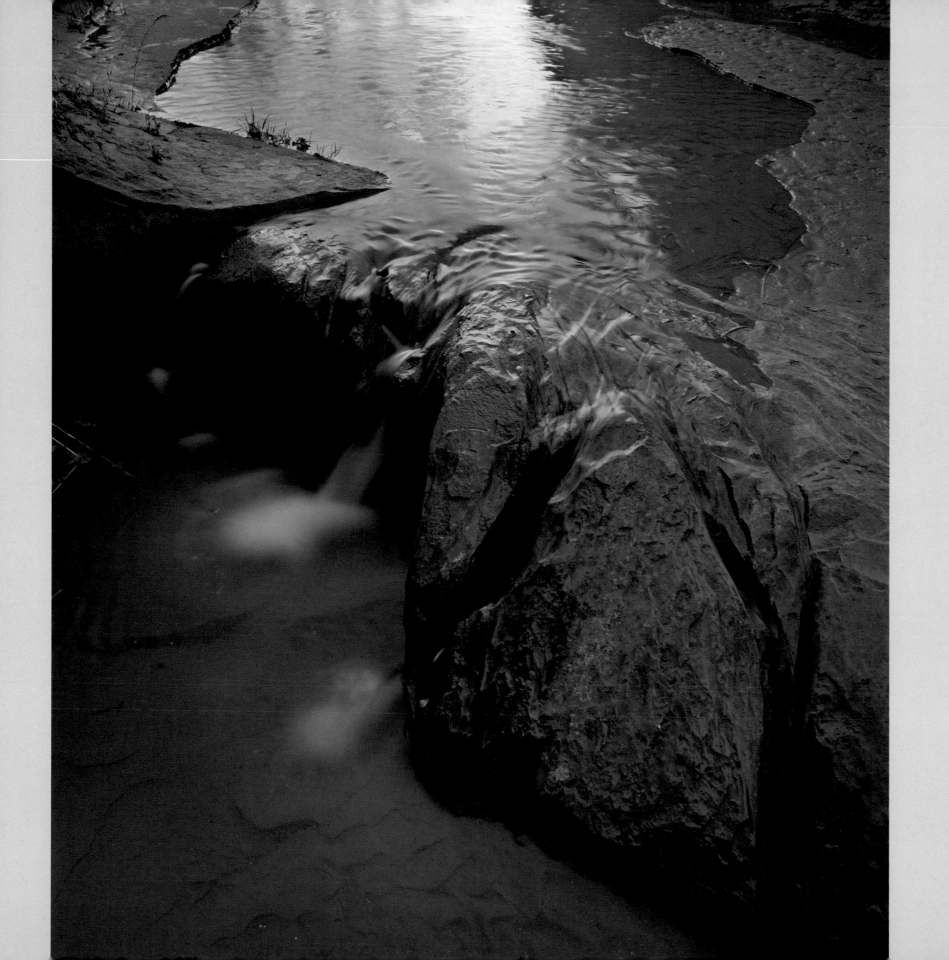

Selected Reading

Abbey, Edward. *Desert Solitaire: A Season in the Wilderness.* New York: McGraw-Hill, 1968.

——. *The Monkey Wrench Gang.* Philadelphia: Lippincott, Williams & Wilkins, 1975.

Brower, David, and Eliot Porter. *The Place No One Knew.* Commemorative ed. Salt Lake City: Gibbs Smith, 2000. Originally published 1963 by the Sierra Club, San Francisco.

Cadillac Desert: Water and the Transformation of Nature. Public Broadcasting Service and Columbia TriStar Television, 1997. Four-part documentary.

Childs, Craig. *House of Rain: Tracking a Vanished Civilization across the American Southwest.* New York: Little, Brown and Co., 2007.

Diamond, Jared. *Collapse: How Societies Choose to Fail or Succeed.* New York: Penguin, 2005.

Farmer, Jared. *Glen Canyon Dammed: Inventing Lake Powell and the Canyon Country.* Tucson: University of Arizona Press, 1999.

Gaskill, David, and Gudy Gaskill. *Peaceful Canyon, Golden River: A Photographic Journey through Fabled Glen Canyon.* Golden, CO: The Colorado Mountain Club Press, 2002.

Gore, Al. *An Inconvenient Truth: The Planetary Emergency of Global Warming and What We Can Do About It.* New York: Rodale, 2006.

——. *Earth in the Balance.* New York: Houghton Mifflin, 1992.

Lee, Katie. *All My Rivers Are Gone: A Journey of Discovery through Glen Canyon.* Boulder, CO: Johnson Books, 1998.

Leopold, Aldo. *A Sand County Almanac.* New York: Ballantine, 1966.

Martin, Russell. *A Story That Stands Like a Dam.* New York: Henry Holt, 1989.

McKibben, Bill. *Deep Economy: The Wealth of Communities and the Durable Future.* New York: Henry Holt, 2007.

——. *The End of Nature.* New York: Random House, 1989.

McPhee, John. *Encounters with the Archdruid.* New York: Farrar, Straus and Giroux, 1971.

Nash, Roderick. *Wilderness and the American Mind.* 3rd ed. New Haven, CT: Yale University Press, 1982.

Nichols, Tad. *Glen Canyon: Images of a Lost World.* Santa Fe: Museum of New Mexico Press, 1999.

Powell, John Wesley. *The Exploration of the Colorado River and Its Canyons.* Mineola, NY: Dover, 1961.

Reisner, Marc. *Cadillac Desert: The American West and Its Disappearing Water.* New York: Viking, 1986.

Rusho, W. L. *Everett Ruess: A Vagabond for Beauty.* Salt Lake City: Gibbs Smith, 1983.

Stegner, Wallace. *Beyond the Hundredth Meridian: John Wesley Powell and the Second Opening of the West.* Lincoln: University of Nebraska Press, 1982.

U.S. Bureau of Reclamation. *Lake Powell: Jewel of the Colorado.* Washington, DC: Government Printing Office, 1965. The accompanying film is available at Open Video Project, www.open-video.org/details. php?videoid=642.

Wilson, Edward O. *Biophilia.* Cambridge, MA: Harvard University Press, 1984.

——. *The Future of Life.* New York: Knopf, 2002.

SUPPORTING RESEARCH

Barnett, T. P., and D. W. Pierce. "When Will Lake Mead Go Dry?" *Water Resources Research,* doi:10.1029/2007WR006704 (2008). Press release at American Geophysical Union, www.agu.org/sci_soc/prrl/2008-06.html.

Christensen, Niklas. "The Effects of Climate Change on the Hydrology and Water Resources of the Colorado River Basin." *Climatic Change* 62, nos. 1–3 (January 2004): 337–63. www.springerlink.com/content/t66120x0hw672395.

Glen Canyon Institute. *Citizens' Environmental Assessment Report on Initial Studies: Report on the Decommissioning of Glen Canyon Dam.* Flagstaff, AZ: Glen Canyon Institute, 2001.

Glick, Daniel, with photographs by Michael Melford. "A Dry Red Season: Uncovering the Glory of Glen Canyon." *National Geographic,* April 2006. http://ngm.nationalgeographic.com/ngm/0604/feature3/index.html.

Miller, Scott. "Undamming Glen Canyon: Lunacy, Rationality, or Prophecy?" *Stanford Environmental Law Journal* 19, no. 1 (January 2000): 127–207.

Stynes, Daniel. *Economic Impacts of Visitor Spending in Parks. 2003.* Related economic impacts of visitor spending at Glen Canyon NRA and other national park units are available at Michigan State University's Economic Impacts of Recreation and Tourism website, http://web4.canr.msu.edu/mgm2/econ/index.htm.

U.S. Bureau of Reclamation. *Operation of Glen Canyon Dam: Final Environmental Impact Statement.* Salt Lake City: U.S. Bureau of Reclamation, 1995. www.usbr.gov/uc/library/envdocs/eis/gc/gcdOpsFEIS.html.

U.S. Bureau of Reclamation. Upper Colorado Region website, www.usbr.gov/uc.

RELATED WORK BY THE AUTHOR AND PHOTOGRAPHER

Kay, James. *"Glen Canyon, a Rebirth?" Cerca,* Summer 2004.

——. "The Lost World of Glen Canyon." *Outdoor Photographer,* October 2005. www.outdoorphotographer.com/content/2005/oct/lostworld.shtml.

McGivney, Annette. "The Case for Glen Canyon." *Backpacker,* December 2005. www.backpacker.com/article/10025.

——. "Glen Canyon Restored." *Backpacker,* June 2005. www.backpacker.com/article/9365.

——. "Paradise Found." *Backpacker,* April 2004. www.backpacker.com/article/6905.

McGivney, Annette, and Jon Dorn, Andrew Mastranga, Chris Peterson, and Kris Wagner. "The New Glen Canyon: An Exclusive Map and Guide." *Backpacker,* February 2006.

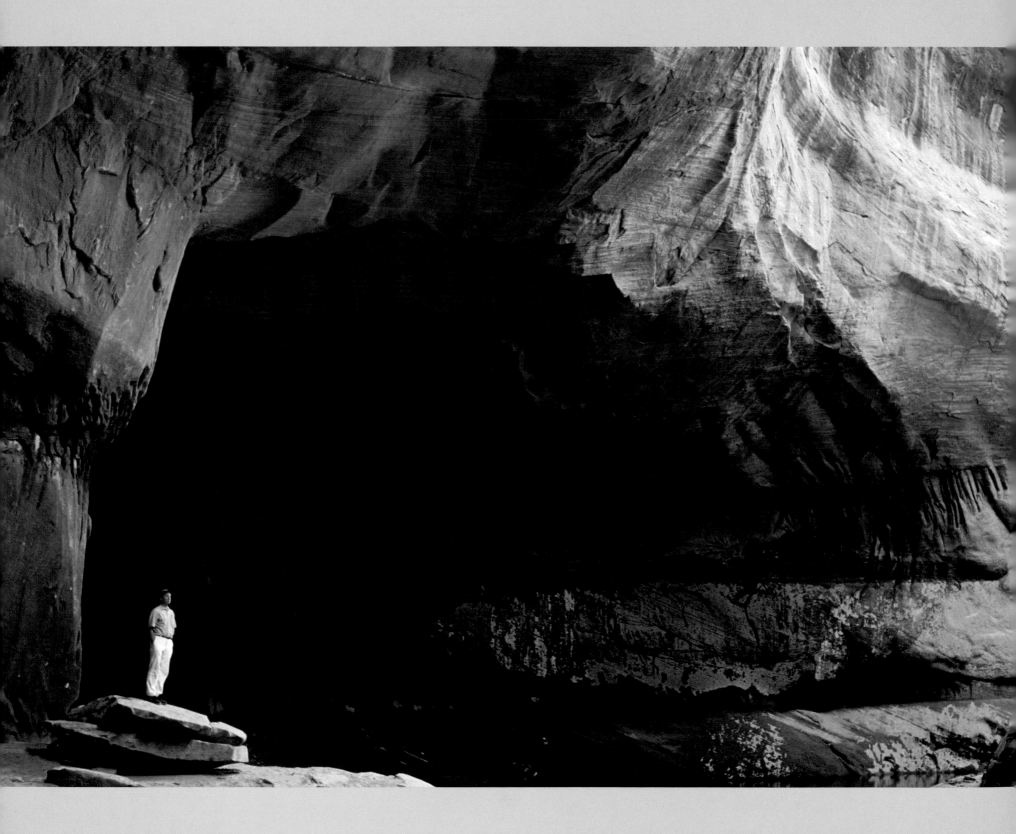

Resources

Hundreds of organizations, businesses, and foundations are advocating for environmental protection and working to educate the public and find solutions to ensure a healthy planet. Below are some organizations that offer more information about conservation issues, climate change, and Glen Canyon. We encourage you to familiarize yourself with the issues. Many of these organizations depend on membership donations and volunteers to support their work. Contact them to find out how you can become involved.

The Glen Canyon Institute is a proud sponsor of *Resurrection: Glen Canyon and a New Vision for the American West.*

Richard Ingebretsen of the Glen Canyon Institute stands on a ledge in Clear Creek Canyon, above the chamber known as Cathedral in the Desert. The floor of the Cathedral lies submerged beneath approximately 50 feet of water. May 2003.

ADVOCACY ORGANIZATIONS

The Alliance for Climate Protection,
www.climateprotect.org
Backpacker magazine, www.backpacker.com
Defenders of Wildlife, www.defenders.org
Grand Canyon Trust, www.grandcanyontrust.org
Living Rivers, www.livingrivers.net
National Parks Conservation Association,
www.npca.org
National Wildlife Federation, www.nwf.org
Natural Resources Defense Council, www.nrdc.org
Sierra Club, www.sierraclub.org
Southern Utah Wilderness Alliance, www.suwa.org

EDUCATIONAL AND SCIENTIFIC ORGANIZATIONS

Climate Ark, www.climateark.org
Climate Change Education,
http://climatechangeeducation.org
Earth Day Network, www.earthday.net
Environmental Literacy Council,
www.enviroliteracy.org
Glen Canyon Institute, www.glencanyon.org
Glen Canyon Natural History Association,
www.glencanyonnha.org
Intergovernmental Panel on Climate Change,
www.ipcc.ch
Pacific Institute, www.pacinst.org
Pew Center on Global Climate Change,
www.pewclimate.org
Union of Concerned Scientists, www.ucsusa.org

HIKING

National Park Service, Glen Canyon National
Recreation Area, www.nps.gov/glca/planyourvisit/
hiking.htm
Backpacker magazine, www.backpacker.com/glencanyon

About the Author and Photographer

PHOTO BY LAURA L. CAMDEN

ANNETTE MCGIVNEY

A native of Texas, Annette has long been drawn to remote, wild places. She has spent the last fifteen years exploring the desert Southwest and writing scores of articles about her wilderness encounters for *Backpacker* and other outdoor and environmental magazines. Her favorite hiking destinations are the Grand Canyon and the canyons of southern Utah.

Annette has been Southwest editor for *Backpacker* since 1997, and she is the author of *Leave No Trace* (The Mountaineers Books, 1997). She also teaches journalism and wilderness courses at Northern Arizona University.

Annette lives in Flagstaff, Arizona, with her son Austin, who did his first rim-to-river hike in the Grand Canyon at age four.

OPPOSITE *At sunrise, the Colorado River flows freely once again downstream of the US 95 bridge near Hite after being inundated by Lake Powell for thirty-plus years. Due to accumulated sediment, the Colorado now flows 130 feet above its prereservoir bed.* October 2007.

PHOTO BY SUSIE KAY

JAMES KAY

Born in Morristown, New Jersey, Jim moved to Utah in 1972 to study meteorology at the University of Utah. He graduated with a degree in mechanical engineering in 1980 and hired on at a local design firm, but quickly realized he was smothering in his windowless cubicle. Determined to find a way out, he picked up a camera and set out to earn his living by merging his love of the outdoors with his newfound passion for photography. By 1982, he was able to leave his engineering job behind to pursue his photography full-time.

Jim's photographic passions center on his deep reverence for untrammeled wild country. He currently serves as a professional advisor to *Outdoor Photographer* magazine, and his work has been featured in the Nikon Legends Collection. His photographs have been published worldwide in countless magazines, books, calendars, and commercial advertising projects.

Jim and his wife Susie live in the Wasatch Mountains of northern Utah. He produces and distributes fine-art framed prints via his website, www.jameskay.com.

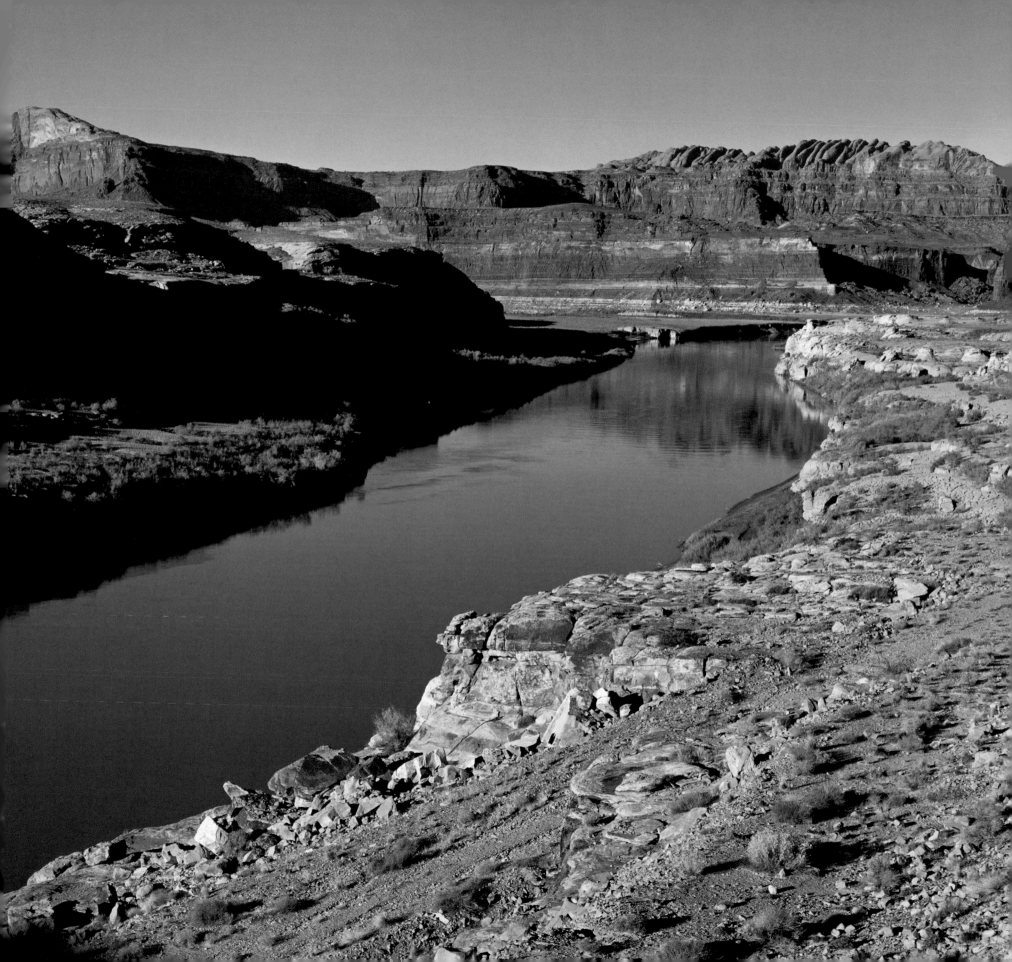

Index

Environmental Sponsor

Braided River gratefully acknowledges the support of Glen Canyon Institute in the production of this book and corresponding public outreach.

Founded in 1996, Glen Canyon Institute leads the effort to restore a healthy Colorado River through Glen and Grand Canyons. Backed by an ongoing series of scientific studies conducted by independent experts on the impacts of Glen Canyon Dam, GCI engages citizens, shares resources, educates the public, collaborates with other organizations, and provides a voice for the revealed landscape of Glen Canyon. Please visit www.glencanyon.org for up-to-date information on Glen Canyon and learn what you can do to ensure that one of our nation's greatest natural treasures will be protected and the restoration will continue.

For more information on booking a multimedia event based upon *Resurrection*, please inquire at info@BraidedRiver.org.

COVER PHOTOGRAPH *Morning sun illuminates the cliffs above drying mud at the foot of Lake Powell's abandoned Hite Marina boat ramp. The reservoir's white "bathtub ring" is visible along the base of the reflected cliff. When the reservoir was last full in 1999, this location was 95 feet below its surface.* October 2007.

FRONTISPIECE *Recently restored streambed in Ticaboo Canyon. Springwater flows in a horizontal seep line out of the exposed wall, staining the sandstone with white mineral deposits as it evaporates.* October 2007.

PAGE 2 *When Lake Powell was last full in 1999, these sensuously sculpted narrows in Face Canyon were 100 feet below the reservoir surface and entombed in a deep layer of sediment. As the waters of Lake Powell receded, the sediment was washed away by flash floods down to the prereservoir streambed.* April 2006.

Braided River, founded in 2008, is a nonprofit organization
that combines the arts of photography, literature, and journalism
to build broader public support for wilderness preservation campaigns—
and to inspire public action—through books, multimedia presentations,
and museum exhibits. Please visit www.BraidedRiver.org for more
information on projects, events, exhibits, speakers, and how to
contribute to this work.

Braided River books are published as an imprint of The
Mountaineers Books. Information on the imprint may be found
at www.BraidedRiverBooks.org. Braided River books may be
purchased for corporate, educational, or other promotional sales.
For special discounts and information, contact our sales department
at (800) 553-4453 or mbooks@mountaineersbooks.org

BRAIDED RIVER
CHANGING PERSPECTIVES

1001 SW Klickitat Way, Suite 201
Seattle, WA 98134
www.BraidedRiver.org
www.BraidedRiverBooks.org

Manufactured in China

Project Manager and Educational Outreach Director: Kerry Smith
Acquisitions Editor: Helen Cherullo
Director of Editorial and Production: Kathleen Cubley
Developmental Editors: Deb Easter, Laura Case, Kerry Smith
Copy Editor: Julie Van Pelt
Proofreaders: Laura Case, Erin Moore
Indexer: Cheryl Landes
Book design and layout: Jane Jeszeck/Jigsaw, www.jigsawseattle.com
Map art: Jane Shasky, www.janeshasky.com
Map composition and diagram art: Marge Mueller, Gray Mouse Graphics

All photographs by James Kay, www.jameskay.com, unless otherwise noted.

Library of Congress Cataloging-in-Publication Data

McGivney, Annette.
 Resurrection : Glen Canyon and a New Vision for the American West /
by Annette McGivney ; with photographs by James Kay. – 1st ed.
 p. cm.
 Includes bibliographical references and index.
 ISBN 978-0-89886-771-8 (pbk.)
 1. Glen Canyon (Utah and Ariz.)–Environmental conditions. 2. Powell, Lake
(Utah and Ariz.)–Environmental conditions. 3. Glen Canyon Dam (Ariz.)–
Environmental conditions. 4. Restoration ecology–Glen Canyon (Utah and
Ariz.) 5. Glen Canyon (Utah and Ariz.)–Pictorial works. 6. McGivney,
Annette–Travel–Glen Canyon (Utah and Ariz.) 7. Glen Canyon (Utah and
Ariz.)–Description and travel. 8. Restoration ecology–West (U.S.)–Case
studies. 9. Landscape protection–West (U.S.)–Case studies. 10. West
(U.S.)–Environmental conditions–Case studies. I. Kay, James. II. Title.

 GE155.G58M38 2009

 333.78'20979259--dc22

 2008035389